WOMEN AND DEVELOPMENT
IN THE MIDDLE EAST
AND NORTH AFRICA

INTERNATIONAL STUDIES IN SOCIOLOGY AND SOCIAL ANTHROPOLOGY

General Editor

K. ISHWARAN

VOLUME LIX

JOSEPH G. JABBRA
AND
NANCY W. JABBRA

WOMEN AND DEVELOPMENT IN THE MIDDLE EAST AND NORTH AFRICA

WOMEN AND DEVELOPMENT IN THE MIDDLE EAST AND NORTH AFRICA

EDITED BY

JOSEPH G. JABBRA

AND

NANCY W. JABBRA

E.J. BRILL

LEIDEN · NEW YORK · KØBENHAVN · KÖLN

1992

The paper in this book meets the guidelines for permanence and durability of the Committee on Production Guidelines for Book Longevity of the Council on Library Resources.

Library of Congress Cataloging-in-Publication Data

Women and development in the Middle East and North Africa / edited by
Joseph G. Jabbra and Nancy W. Jabbra.
 p. cm.—(International studies in sociology and social
anthropology; ISSN 0074-8684; v. 59)
 Includes bibliographical references and index.
 ISBN 90-04-09529-2 (alk. paper)
 1. Women in development—Middle East. 2. Women in development—
Africa, North. I. Jabbra, Joseph G. II. Jabbra, Nancy Walstrom.
III. Series.
HQ1240.5.M628W66 1992
305.42'0956—dc20 91-26417
 CIP

ISSN 0074-8684
ISBN 90 04 09529 2

PRINTED IN THE NETHERLANDS

CONTENTS

Introduction
Women and Development in the
Middle East and North Africa

NANCY W. JABBRA and JOSEPH G. JABBRA*

DEVELOPMENT IS NECESSARILY an evaluative or normative concept, unlike most of those we use in the social sciences. It refers not simply to change across time, but moreover to change that brings about improvements of some sort. In this sense, it means much the same thing as progress, which refers to directional or goal-directed change. The questions then arise: what is the direction of the change we are discussing, what improvements do we mean, and for whom are they improvements?

The direction of developmental change must necessarily lead to greater "human ability to influence and control the natural and social environment" (Charlton 1984:8). In other words, human beings can no longer be at the mercy of forces external to themselves; they must acquire some power over events. For this empowerment to take place, scientific and technological development is needed. As Charlton (1984:9) suggests, role specialization accompanies development; it is a concomitant of scientific and technological development. Role specialization in turn implies education and training. But development lies not simply in technological improvements; it also has social, political, economic, and cultural dimensions. And thus we come to our last question. It asks who is to benefit from development. It seems to us that all three questions can be subsumed under this heading, as can be seen in the answer. If improvements benefit only some people, or if only some people are in control of events, then by implication other people are not benefiting, or are not in control. Thus, development implies social, political, and economic equality (see also Sen and Grown 1987:11-14). By this criterion, even the prosperous societies of the First World are not fully developed.

By this same criterion, women must be involved in development; they must benefit equally with men. Worldwide experience shows us, however, that this is not always the case. Barbara Rogers (1980), Ester Boserup (1970), Elizabeth Fernea (1986), and Fatima Mernissi (1976) have documented in detail the ways in which both the colonial enterprise and the development projects which followed it have excluded Third World women.

Focussing on post-colonial development, Eva Rathgeber (whose article leads off this volume) has described the three main theoretical views of the relationship between women and Third World development. The first, WID

* Loyola Marymount University, Los Angeles, CA 90045, U.S.A.

(Women in Development), is closely related to American liberal feminism and modernization theory. It does not address existing gender structures, but, concentrating on technology, looks toward incorporating women into conventional projects. Its successor, WAD (Women and Development), is a Marxist feminist approach which focusses on women's economic roles and on class and international inequalities. Like WID, it ignores women's domestic roles; like other Marxist approaches, it overemphasizes class. GAD (Gender and Development) represents the socialist feminist approach (like that of Sen and Grown 1985). Socialist feminists scrutinize the intersection of household and public structures to discover why women are systematically discriminated against (Rathgeber 1989). Thus, "...the solution to women's oppression rests both on their full participation in nonhome production under conditions of equality between the sexes, and the transformation of household relations and gender asymmetries so that relations of dominance and subordination between the sexes are eliminated" (Benería 1982:xiii).

Development in the Middle East and North Africa has been uneven with regard to ethnic, religious, regional (including rural-urban), class, and national cleavages. Leaving these aside, we will simply examine gender here. To what extent are women empowered within the home or outside of it? To answer this question we will survey some quantitative data in order to gain a general overview of the situation. We will employ the following indices: fertility rates, mortality (as reflected in life expectancy), education (as measured by percent literate), labor force participation, and political participation. Readers should be aware that some of the data presented are not very recent, and that for a variety of reasons they may not be very reliable. Therefore, they should be taken as rather rough descriptors of a complex reality.

Fertility rates do not simply reflect the level of birth control technology; they also, and more importantly, derive from people's motivations and the social structural constraints of their lives. Blumberg (1976) has commented that Third World women who want as many children as Providence wills usually contribute little to family subsistence, gain prestige and power from having many childlren, and have no social welfare system other than family on which to rely. They are likely to have little education and not to be employed outside the home. Infant mortality rates may also be high. These statements describe women with even less power than men of their class. Table 1 shows rather imperfectly that women in most Middle Eastern countries (Cyprus is a notable exception) tend to approximate Blumberg's model although, as Chamie's (1985) discussion suggests, changes are under way and rural-urban and other variations exist.

Life expectancies are projections from mortality rates and reflect general health conditions, including public sanitation, nutrition, and availability of medical care. Gender specific life expectancy rates are important social indicators because, where health conditions are good (as they are for example, for most North Americans), female life expectancies exceed those for males. Thus, if male life expectancies are greater than or equal to those for females, we may suspect that women and girls do not have equal access with men and

Table 1

Crude Birth Rates and Total Fertility Rates, Middle East and North Africa

Country	Date or Period	CBR	TFR
Afghanistan	1978-1979	48	7.08
Algeria	1980	44	6.97
Cyprus	1981	21	2.47
Egypt	1981	39	6.13
Iran	1973-1976	42	6.26
Iraq	1974	43	7.13
Jordan	1975-1976	49	7.34
Lebanon	1970	34	5.54
Morocco	1972	44	6.88
Syria	1976-1979	46	7.47
Tunisia	1980	34	6.10
Turkey	1974-1975	37	5.17
Yemen Arab Republic	1972	45	6.94

Adapted from Table 6.1 in Chamie (1985); see this source for details. Note: The crude birth rate (CBR) refers to the average number of births per 1000 persons (at midyear), regardless of sex, age, or other population variables. The total fertility rate (TFR) refers to the average number of children that would be born per woman if each survived her reproductive years and bore children according to established age specific rates.

boys to nutritious food and adequate medical care. The figures in Table 2 suggest that health conditions in general in Afghanistan are not very good, and that they are worse for women than for men. In Iran the figures are about equal, suggesting again a degree of discrimination against females. The remaining countries in the table show patterns more characteristic of the developed countries, although (except for Cyprus) overall life expectancies tend to be shorter.

Table 2

Life Expectancy at Birth, Middle East and North Africa

Country	Year or Period	Life Expectancy Females	Males
Afghanistan	1979	40.1	41.8
Algeria	1978	58.1	55.8
Cyprus	1979-1981	76.0	72.3
Egypt	1975	55.0	53.1
Iran	1973-1976	57.4	57.6
Morocco	1972	51.5	50.6
Syria	1974-1978	62.3	61.4
Turkey	1974-1975	58.3	55.2

Adapted from Table 7.1 in Chamie (1985).

Gender differences in education attainment and literacy are very obviously related to gender differences in power and social valuation. If it is not considered important to educate girls, then women will be unable to find prestigious and well-paying jobs and they will not be aware of their legal rights. Moreover, uneducated women are more likely than educated women to bear many children; thus, women's educational levels have a direct bearing on a society's fertility rate (see al-Kadhi 1985).

Table 3
Percent Literate by Age, Sex, and Rural/Urban Residence, for the Middle East and North Africa

Country/ Period	Sex	Rural			Urban		
		15-24	25-34	35 +	15-24	25-34	35 +
Afghanistan	males	30.0%	15.8	11.9	55.6	42.8	34.2
(1972-1973)	females	1.5%	0.4	0.1	31.4	13.9	3.7
Iran	males	51.2%	29.7	13.2	84.8	73.3	47.4
(1976)	females	15.5	4.0	1.1	68.2	45.4	19.2
Lebanon	males	90.1%	-	-	90.6	-	-
(1970)	females	68.4	-	-	80.5	-	-
Morocco	males	36.0%	20.6	12.9	81.4	59.4	34.7
(1971)	females	3.7	0.8	0.4	50.6	18.3	7.6
Syria	males	72.7%	57.7	31.0	84.6	80.7	57.0
(1970)	females	15.6	5.9	1.7	60.6	42.1	17.1
Tunisia	males	74.9%	37.2	13.9	95.8	74.7	38.5
(1975)	females	28.2	5.0	0.5	77.1	40.5	7.4
Turkey	males	81.8%	72.4	45.7	92.7	88.6	72.8
(1970)	females	47.2	28.3	11.4	75.6	59.0	38.4

Adapted from Tables 3.4 and 3.5 in Chamie (1985). Note: not all data are available for Lebanon.

Significant differences in educational achievement by age and rural-urban cleavages, as well as by gender, may be found in the Middle East. Generally speaking (for adults), younger people or urban residents are more likely to be literate than are older people or rural residents. Moreover, men are more likely than women to be literate (see Table 3). One can be optimistic, and note that women's literacy has improved over time, or pessimistic, and note that men are still better educated than women. Certainly, if established trends in educational development continue, then the male-female gap will eventually decrease. However, governments will have to do their part to make sure that the gap closes.

Labor force participation rates may not adequately measure women's economic contributions (nowhere in the world is housework counted in the Gross National Product, even though it is of economic value). Figures on women's labor force participation may not fully reflect their non-domestic work. Moreover, we know from all over the world (including North America) that even when women engage in salaried labor their wages average less than

those of men. Women may also not benefit commensurately with their domestic economic contributions.

Only the levels of female labor force participation in Turkey approach those for North America. The remainder can be classified as either low (Iraq or Lebanon, for example), or minuscule (Algeria or Saudi Arabia). The figures strongly suggest that most Middle Eastern women remain dependent upon their husbands or family members for their subsistence. If Western experience is a guide, they are thus likely to have limited influence upon household decision-making and little direct economic power. On the other hand, given the pronounced segregation of the sexes and the importance of kinship in the region, they may have more domestic power than similarly dependent women in the West. Moreover, given that unpaid family labor in agricultural and small manufacturing enterprises is unlikely to be included in the figures presented in the table, Middle Eastern women may be making larger economic contributions than they seem. However, because they are not salaried, they may not control the fruits of their labors.

Table 4

Labor Force Participation Rates by Sex and Percent Female, Middle East and North Africa

Country	Year	Male	Female	% Female
Afghanistan	1979	76.8	6.9	7.8
Algeria	1975	43.4	1.9	4.3
Egypt	1976	70.5	6.2	7.9
Iran	1976	70.8	12.9	14.0
Iraq	1977	65.5	14.6	17.4
Jordan	1979	77.8	6.7	3.2
Lebanon	1970	62.1	13.3	17.2
Morocco	1971	65.9	11.5	15.0
Saudi Arabia	1974	75.5	5.5	5.6
Syria	1970	68.5	8.6	10.7
Tunisia	1975	64.0	6.1	8.5
Turkey	1980	76.2	45.1	36.8
Yemen	1975	73.8	8.6	12.1

Adapted from Table 4.2 in Chamie (1985) and Table 7 in Azzam, Abu Nasr, and Lorfing (1985). The figures for Algeria are unspecified for age, those for Jordan refer to 15 and over, those for Saudi Arabia for 15 and over, and the remainder for 10 and over.

Political participation is our last index of women's empowerment. Women's political power may be direct, in the form of voting and holding public office. It may also be exercised in an indirect fashion, through influence upon the political decisions of others (men), or exercised primarily in a domestic and kinship context.

We do not have any detailed information on women holding political office in the Middle East but we suspect that not many women hold political office

in the region, even in the socialist states on record as favoring equality for women. We do have information on voting rights in the region (see Table 5). No one, male or female, votes in the monarchies of the Arabian peninsula save in Kuwait, where a limited number of males may do so. In the remaining Middle Eastern countries, men and women have the same rights to the franchise. However, in countries controlled by one party or one person, or in which elections have been suppressed for many years, the suffrage rights of men and women alike mean little. Of course, the ruling circles are exclusively male.

Women may exercise more political power in the non-state political arena. For example, our own research in rural Lebanon has shown that at least in some contexts women do affect village political decisions even where they do not (by tradition, not law) hold political office. They also play an important part in non-formal processes of dispute settlement (Jabbra and Jabbra 1978). We doubt that our findings are exceptional.

The quantitative survey just presented shows that although some progress has been made toward the empowerment of Middle Eastern women, further changes need to take place. Women's fertility, although decreasing, remains high, indicating that reproduction is among their most valued contributions, and also indicating that state welfare systems are still very weak. The fact that health conditions are worse for women than for men in Afghanistan and Iran suggests that women and girls tend to be valued less than men and boys in those countries; however, more detailed data, including attitudinal surveys and qualitative studies, are needed to confirm or reject this suggestion. Nancy Hatch Dupree's paper in this volume singles out poor nutrition during repeated pregnancies as a factor in women's low health status in Afghanistan.

Education for girls (as for boys) has become much more accessible in recent decades, although much remains to be done. Most Middle Eastern feminists view education as the key to other improvements in women's lives, including knowledge of their legal rights, self-confidence, reduced fertility, greater political strength, and access to better jobs. Mothers' education also affects the sex-role attitudes of their daughters, making them less traditional; it seems, however, to have less effect upon sons (Lorfing and Abu Nasr 1985). For these reasons, then, the gains in girls' education are particularly welcome.

Women's labor force participation remains low, partly reflecting the continued importance of unpaid family labor in agriculture, but also indicating that many women are still economically dependent upon men. The relationship of this economic dependence to women's domestic power is complex, but it is probably the case that women's lack of salaries weakens their power within the household. The state of political development in the region means that all too frequently women and men alike have little political power; women, as elsewhere, have less.

Today in the Middle East, people who had once turned to nationalism and socialism for direction are now turning to religion for guidance. What we in the West term Islamic fundamentalism can indeed have conservative effects upon women, reducing both their domestic and public powers. But Islamic fundamentalism is a modern movement, not a return to the past; its strength

Table 5

Suffrage and Elections in the Middle East and North Africa

Country	Suffrage	Elections
Afghanistan	universal 18 +	none
Algeria	universal 18 +	last held 1988
Bahrain	none	none
Chad	universal 18 +	none planned
Cyprus	universal 18 +	every 5 years
Egypt	universal 18 +	every 5 years to legislature every 6 years for President
Iran	universal 15 +	last held 1989
Israel	universal 18 +	every 4 years
Jordan	universal 20 +	none scheduled
Kuwait	adult males of pre-1920 Kuwaiti descent	last held 1985
Lebanon	universal 21 +	every 4 years
Libya	mandatory universal adult	at local level
Mauritania	universal adult	last presidential 1976
Morocco	universal 20 +	last held 1984
Oman	none	none
Qatar	none	none
Saudi Arabia	none	none
Sudan	universal adult	last held 1986
Syria	universal 18 +	last presidential 1985
Tunisia	universal 21 +	every 5 years
Turkey	universal 19 +	every 5 years
United Arab Emirates	none	none
West Bank and Gaza Strip	no self government	none
Western Sahara	contested territory	none
Yemen Arab Republic	not available	last held 1988
Yemen, People's Republic of	universal 18 +	none

Compiled from the Central Intelligence Agency, World Factbook 1989.

should remind us that Middle Eastern development, including the involvement of women, cannot be equated with Westernization. Middle Eastern women will do things their way, not ours (see also Dearden 1976).

Survey and census data tell us a little about a lot of people. But the papers in this volume go far in filling out the details missing in the survey presented above. The first paper, "Integrating Gender into Development: Research and Action Agendas for the 1990s", by Eva M. Rathgeber, provides a general overview of the issues surrounding women and development. She articulates seven themes: economic integration; women's rights; employment; social participation; environment; technology; and research methodologies. She concludes that during the 1980s women moved closer both toward their empowerment and toward the articulation of a feminist perspective. However, at the same time, feminism lost ground to the environment as a global issue. The challenge will be to keep women's issues at the forefront of development.

In "Afghanistan: Women, Society and Development", Nancy Hatch Dupree presents a sensitive, thoughtful, and knowing account of Afghan women during the recent civil war and their experiences as refugees. She found that as women they were fairly well protected during a harrowing period. The question now becomes: will women's voices be heard during reconstruction, or, as in Algeria, will an opportunity for meaningful change for women be missed?

Yolande Geadah, in "Palestinian Women in View of Gender and Development", focusses on women's empowerment under conditions of war, foreign occupation, and military repression. She concludes that these experiences, and especially the Intifada, have had the effect of enlarging women's powers and changing men's expectations.

Eliz Sanasarian, in "The Politics of Gender and Development in the Islamic Republic of Iran", finds that in the post-revolutionary period the state in effect reduced men's political powers while simultaneously granting them more power over women. However, the public discourse on gender, which has emphasized the equality of women and men in Islam, has had the effect of emboldening many women to question the contemporary situation.

In "The Rise of Algerian Women: Cultural Dualism and Multi-Party Politics", Rachid Tlemçani addresses the problem of why women's participation in the war of independence against France did not lead to greater gains for women after independence had been achieved. He attributes this result to the contradictions between revolutionary rhetoric and Algerian traditions. He concludes that the shift from single-party to multi-party politics will have still more conservative effects for women, as parties vie to be viewed as most deeply Islamic in the eyes of the voters.

Amal Rassam, in "Political Ideology and Women in Iraq: Legislation and Cultural Constraints", also addresses the contradictions between socialist ideologies of equality and cultural traditions which domesticate women. The result in Iraq is very different, however. There, conservatism in family law and personal status has been accompanied by genuine attempts to educate and employ women and to include them in the political process.

Soroya Altorki, in "Women, Development and Employment in Saudi Arabia: The Case of 'Unayzah" turns from considerations of politics to present an economic development case study drawn from a single town's experience. Contrary to what one might expect, women there had long been employed in agriculture, commerce, and craft production. Petroleum-related development altered, but did not create, women's economic participation.

In "Impediments to Empowerment: Moroccan Women and the Agencies", Susan Schaefer Davis supports the findings by Barbara Rogers (1980) and Elizabeth Fernea (1986) that the attitudes of those—men (both foreign and local)—who conceive and implement development projects limit women's involvement in development much more than any cultural constraints of the women themselves. Indeed, she finds that Moroccan women have many strengths which will serve them well when they do obtain adequate opportunities.

In the last paper in this volume, ''The Female Brain Drain, the State, and Development in Egypt'', Mona L. Russell turns to the consequences that may result when a state cannot, or will not, employ its educated women. It not only loses human talent; it also loses a corps of articulate spokeswomen for their less well-educated sisters.

REFERENCES CITED

AL-KADHI, Anne Bragdon
 1985 Women's Education and Its Relation to Fertiliy: Report from Baghdad, in Elizabeth Warnock Fernea, ed., Women and the Family in the Middle East: New Voices of Change, pp. 145-147. Austin: University of Texas Press.

AZZAM, H., J. ABU NASR, and I. LORFING
 1985 An Overview of Arab Women in Population, Employment, and Economic Development, in Julinda Abu Nasr, Nabil F. Khoury, and Henry T. Azzam, eds., Women, Employment and Development in the Arab World, pp. 5-38. Berlin: Mouton Publishers.

BENERÍA, Lourdes
 1982 Introduction, in Lourdes Benería, ed., Women and Development: The Sexual Division of Labor in Rural Societies, pp. xi-xxiii. New York: Praeger Publishers.

BLUMBERG, Rae Lesser
 1976 Fairy Tales and Facts: Economy, Family, Fertility, and the Female, in Irene Tinker and Michèle Bo Bramsen, eds., Women and World Development, pp. 12-21. Washington, D.C.: Overseas Development Council.

BOSERUP, Ester
 1970 Woman's Role in Economic Development. New York: St. Martin's Press.

CHAMIE, Mary
 1985 Women of the World: Near East and North Africa. Washington, D.C.: United States Bureau of the Census and Office of Women in Development

CHARLTON, Sue Ellen M.
 1984 Women in Third World Development. Boulder: Westview Press.

DEARDEN, Ann, ed.
 1976 Arab Women. London: Minority Rights Group (Minority Rights Group Report No. 27).

FERNEA, Elizabeth
 1986 Women and Family in Development Plans in the Arab World. Journal of Asian and African Studies 21 (1-2): 81-88.

JABBRA, Nancy W., and Joseph G. JABBRA
 1978 Local Political Dynamics in Lebanon: The Case of 'Ain al-Qasis. Anthropological Quarterly 51: 137-151.

LORFING, I., and J. ABU NASR
 1985 Sex-Role Orientation of Arab University Students, in Julinda Abu Nasr, Nabil F. Khoury, and Henry T. Azzam, eds., Women, Employment and Development in the Arab World, pp. 131-143. Berlin: Mouton Publishers.

MERNISSI, Fatima
 1976 The Moslem World: Women Excluded from Development, in Irene Tinker and Michèle Bo Bramsen, eds., Women and World Development, pp. 35-44. Washington, D.C.: Overseas Development Council.

RATHGEBER, Eva M.
 1989 WID, WAD, GAD: Trends in Research and Practice. Pearson notes 4(3):2-6 (Dalhousie University, Pearson Institute for International Development).

ROGERS, Barbara
 1980 The Domestication of Women: Discrimination in Developing Societies. London: Tavistock Publications.

SEN, Gita, and Caren GROWN
 1985 Development, Crisis, and Alternative Visions: Third World Women's Perspectives.
 New Delhi: DAWN Secretariat.
 1989 The World Factbook 1989. Washington, D.C.: The Central Intelligence Agency.
YOUSSEF, Nadia Haggag
 1974 Women and Work in Developing Societies. Berkeley: University of California Press
 (Population Monograph Series, No. 15).

Integrating
Gender into Development:
Research and Action Agendas
for the 1990s*

EVA M. RATHGEBER**

ABSTRACT

The research issues surrounding women and development comprise at least seven themes: economic integration; women's rights; employment; social participation; environment; technology; and research methodologies. Increasingly, development research is carried out by Third World women who are trying to bridge the gap between research and action. Women have moved closer toward their own empowerment and toward the articulation of a feminist perspective. However, today Third World countries control less of their own development than formerly, and environmental issues are popular among international agencies. In this climate, feminists must bring women's experience, knowledge and values into the mainstream of global decision-making.

THE PAST TWO DECADES have witnessed the rapid growth of steadily expanding international databanks of information on gender and development. At the beginning of the 1990s, we can look back at 20 years of studies on the roles, contributions, needs, aspirations, perceptions and perspectives of women. What has been learned from all of this activity as we begin a new decade?

In 1990 it is known that women in developing countries work longer hours, earn less money, have greater responsibilities, are less literate and numerate and have lower caloric intake in proportion to body weight than do men. In countries and among social groups where there are few opportunities to escape from poverty, women usually have none. In situations where everyone must work long hours to secure sufficient income to provide for basic needs, women must work even longer for they are faced not only with the necessity to contribute to household income but also must undertake all or most of the reproductive labour, including bearing and caring for children, preparation of food, looking after the elderly, nursing the sick and the multitude of other tasks that are labelled «women's work» in most parts of the world.

* This paper is a revised version of a public address originally delivered at the Summer Institute in Gender and Development, Saint Mary's University, Halifax, Canada, June 1990.
** International Development Research Centre, Ottawa, Canada, K1G 3H9

All of this has been documented through research, but increasingly this knowledge has also been brought into the public arena through the efforts of activist groups. The past two decades have seen a global mushrooming of women's groups, some with local welfare-development mandates, others with broader national or regional mandates. At the same time, during the U.N. Decade for Women (1975-1985), governments in different parts of the world established ministries of women's affairs or women's bureaus to institutionalize and legitimize a concern with the status of women. Although their achievements have been uneven, the very fact that such mechanisms have been established is evidence of a mounting recognition of the needs and concerns of women.

How can one begin to sort out the significance of the multitude of studies that have been done and appreciate and understand the activities of so many diverse action-oriented governmental and non-governmental groups? What have been the achievements of two decades of work on women and by women? Have we gained definitive insights? Are we better prepared and equipped today to integrate women into development strategies? Do women of developing countries define their own needs in the same way as they were earlier defined by international agencies? Has the active participation of developing country feminists changed the focus of development initiatives for women? In addressing these questions, this paper will review the research themes and the action orientations of some developing country groups. It will be shown that the approaches taken to women's issues in different parts of the world have both important similarities and some significant differences in emphases.

New Directions in Feminist Scholarship

By the end of the 1980s, the general notion that development processes have affected men and women differently was accepted to varying degrees by progressive scholars, development activists and international agencies. It was recognized that women systematically have been denied opportunities to benefit for development initiatives, due largely to cultural and social constraints which place them in disadvantageous positions from which to participate in and profit from opportunities that have been made available.

During the past decades there has emerged a global feminist consciousness. There are active women's groups in most parts of the world and they are dealing with some of the same issues, including women's legal rights, reproductive issues, aspects of sexuality, violence against women, economic equality and economic opportunity. It must be recognized, of course, that regional and national priorities and customs vary and that the approaches taken to some of the same problems are markedly different. Nonetheless, one can make a few broad regional generalizations while remembering that there are significant differences among countries within each region. The issues discussed below are brought forward as trends rather than as comprehensive overviews of research concerns. They are based largely although not exclusively on an analysis of projects supported by the International Development Research

Centre's (IDRC) Gender and Development Unit although, in some cases, discussion goes beyond IDRC-supported projects. In this sense, these themes reflect issues for which developing country researchers have sought Canadian donor agency funding during the past several years.

Seven broad themes emerge in a preliminary analysis of developing country feminist research interests in the past decade. They include: i) economic integration; ii) women's rights; iii) employment; iv) social participation; v) environment; vi) technology; and vii) research methodologies. it is clear that these themes are not of equal importance in each region and that some can best be described as emerging trends. It should also be noted that many of the issues identified and discussed below overlap and that a separation of conceptual strands is of necessity somewhat artificial.

i. *Economic Integration*

The impact of the global debt crisis and structural adjustment policies on the condition and status of women has received increasing attention from developing country feminist researchers. A 1990 Report of a Commonwealth Expert Group on Women and Structural Adjustment noted that women have suffered disproportionately from the debt crisis and adjustment policies, not only as producers or workers in formal sector employment but also as reproducers who have been forced to provide on a private and individual basis health and other social services which formerly were provided by the state (Commonwealth Secretariat 1990).

Caribbean feminist researchers have been particularly active in addressing this issue. Economic participation and women's economic survival strategies have been significant recurring themes in their work (Massiah 1990). High levels of female-headed households, combined with male unemployment and migration and relatively high female education participation rates, have led to a substantial integration of women into Caribbean labour markets, although mostly at poorly remunerated levels and frequently within the informal sector. In the face of economic crisis, Caribbean women have been vulnerable not only as principal family income earners who have faced loss of or reduced employment but also as houshold managers who have had to provide for basic family needs with seriously reduced resources and who have had to take on increased domestic work and family obligations. In the 1980s many Caribbean researchers turned their attention to the problems of female-headed households, to the impact of the debt crisis on women, and to a critical examination of structural adjustment policies and the privatization of social services with concomitant increase in women's workloads.

Several Caribbean projects currently being supported by IDRC examine these issues. For example, a project in Barbados is analysing the impact of the recession of the 1980s on women's productive and reproductive work. Preliminary findings suggest that women are being forced to provide, on a private and individual basis, numerous services that formerly were provided by the state, especially with respect to health.

Latin American researchers have focussed on the impact of the debt crisis on women's participation in formal labour markets. Research in Brazil has shown that women have been integrated into formal labour markets at lower salary rates and with little job security. During the economic boom period of the early 1970s, large numbers of Brazilian women entered formal employment in the industrial sector (Cunningham 1987). However, this was accompanied by a marked wage discrimination by gender with women commonly working similar hours but earning substantially smaller salaries than men. In some cases this was justified through task specificity, with women being streamed into certain processes of production, men into others.

In Africa, during the latter half of the 1980s there also emerged a strong feminist critique of the structural adjustment policies imposed by the International Monetary Fund (IMF) and the World Bank (Tibaijuka 1988). Research showed that, as in other regions, women were suffering disproportionately. They tended to be concentrated in the lowest levels of public sector employment, where retrenchment was most profound. Consumption patterns shifted to cheaper basic staples, which required longer preparation time, again immediately affecting women's work. Health services were cut back and women were denied care for themselves and asked to assume greater responsibility for the care of others. In some parts of Africa, this became of increasing importance in the 1980s in face of the AIDS crisis, with families being forced to assume the burden of care for AIDS victims.

In conclusion then, it can be seen that economic issues were a major concern for feminist researchers in three regions of the world that were deeply affected by structural adjustment policies and the debt crisis in the 1980s. The approach taken by feminist researchers differed from that of more traditional economic researchers insofar as they focussed specifically on the impact of structural adjustment policies on women and attempted to assign economic value to the extra burden and stress imposed on women as a result of macroeconomic policy measures. **Engendering Adjustment for the 1990s**, a report of a Commonwealth Expert Group on the effect of structural adjustment policies on women, published early in 1990, provides an excellent overview of the impact of such policies in Commonwealth countries.

ii. *Women's Rights*

In many parts of the world, women continued to suffer from legal discrimination in the 1980s, whether because laws had not been modernized to give them equal rights or because equal rights laws which existed were not applied. This is particularly true with respect to land rights but women are routinely discriminated against on numerous other levels, including employment, wages and pension benefits. In other cases, women have been denied basic human and political rights and virtually everywhere they continue to suffer from domestic violence which often is not recognized by local authorities as a serious, punishable crime.

In Africa, land tenure has been and continues to be an issue of frequent legal contention. Although women are the primary food producers of Africa, they operate at a considerable disadvantage because in most societies they do not own the land they work. Most commonly access to land is through a male family member—husband, father, brother, uncle or son. African researchers have shown that men are often discouraged from selling land to women and that in some cases it is illegal for women to own land. Thus women are kept out of landholding systems not only through poverty but by lack of access to credit, which makes it difficult for them to afford to purchase land. Frequently landholding systems have been structured systematically to exclude them. Their situation is exacerbated by the co-existence of conflicting statutory and customary laws and a tendency for laws to be manipulated by men in such a way as to dispossess women (Manuh 1989; MacKenzie 1989). IDRC projects in Ghana, Nigeria, Senegal, Côte d'Ivoire, Tanzania and Kenya all are examining land tenure systems and women's access to land ownership.

The researchers are studying the extent to which the legal and cultural constraints placed on women's farming capacities hamper their ability to make effective contributions to agricultural production. These studies are beginning to bring to the attention of African policymakers the relationship between women's access to land and food security. While this problem is of particular importance in Africa because of the central role of women in food production in most countries, women equally have been denied land rights in other regions. For example, Madhu Kishwar has noted that Indian women face near total disinheritance in property rights in land (Kishwar and Vanita 1984).

In many African countries, women continue to face strong discrimination in formal employment, including public sector employment, often apparently based on antiquated notions of women's roles which were entrenched during colonial periods. Wariara Mbugua has shown that Kenyan women routinely are excluded from certain jobs through sex-labelling, i.e. some jobs are said to be physically too onerous or otherwise inappropriate for women (Mbugua 1989). Similarly, they commonly are denied seniority benefits because of maternity leave and they are denied certain other benefits, such as housing allowances or pension plans, because they are considered to be supplementary income earners, regardless of their actual family situation.

Another legal area of concern for many feminist researchers in the 1980s was the contradictions between statutory and religious laws with respect to women's rights. Traditional religions and cultures often consider women's roles as a fundamental component of their worldview and strongly resist attempts to change the status of women. This was well-expressed a decade ago by a Sri Lankan lawyer:

> In many ways, the issues of women's rights have accentuated the constant tension between tradition and modernity. Women have been classically regarded as the bearers of tradition from one generation to another. The transformation of their role in society is seen as an erosion of the foundation of traditional cultures. When the alternative to tradition is westernization, there is an in-built cultural prejudice which is often the justification of the denial of equal rights for women (Coomaraswamy 1982, quoted in Cook 1990).

In research on women's rights in Northern Nigeria, Barbara Callaway and Enid Schildkrout found in fieldwork among Muslim women, that for the most part women were unaware that the Constitution provided them with broader legal rights than those accorded through Islamic law. They observed that "law in the Islamic north is a force of conservatism...controlled by men and used to enforce both Islamic and customary rules and traditions" (Callaway and Schildkrout 1986: 194). Other researchers working in Africa similarly have observed that African women often have little knowledge of their legal rights and thus are apt to accept conditions which go against their own self-interest.

During the past decade there has emerged in Asia a strong concern with women's rights and the gaps between legal rights as stated in statutory laws and the implementation of these rights. Statutory laws providing equal rights to women frequently have been in conflict with religious or cultural norms that are disadvantageous to women. The increasing incidence of bride burning in India in the 1980s is an obvious example. Such burnings, which normally have occurred in the homes of in-laws, have usually been linked to the inability or unwillingness of brides' families to pay increased dowry payments after marriage has taken place. Indian activists have charged that in many cases police actively connived with murdering families to cover evidence (Kishnar and Vanita 1984). Lynne Brydon and Sylvia Chant observe, "Dowry is usualy negotiated around the period of betrothal, but many authors have noted that there is an upward spiral of demands over time, reflecting the fact that wives are eminently dispensable and easily replaced. Sometimes brides are murdered by their in-laws and sometimes they commit suicide in the face of systematic physical violence or verbal abuse" (Brydon and Chant, 1989: 41). The growing incidence of bride burnings and dowry disputes in India in the 1980s gave rise to numerous Indian activist groups concerned with basic human rights for women. They focussed national and international attention on the powerlessness of large categories of Indian women. Despite their efforts the custom of dowry has spread and increased during the 1970s and '80s and ethnic groups which previously did not practice it have adopted the dowry system (Kishwar and Vanita 1984).

During the decade, Asian feminists also concerned themselves with land and political rights. For example, an IDRC project in northeastern Thailand is examining the contradictions among statutory laws, customary laws and village practices. Preliminary findings suggest that village women continue to be discouraged from participating in decision-making processes by virtue of their own tradition-based reticence and the continuing observation of customary laws, despite the existence of statutory laws giving them full political rights. A comparative project based in China and India is examining women's access to land tenure within differing social, political, and economic contexts. Early findings suggest that Chinese women are particularly vulnerable with respect to land rights.

In Latin America, feminist scholars during the decade focussed attention on political and human rights, especially in the context of the authoritarian

regimes present in the region at the beginning of the decade. Jane Jacquette has observed that Latin American women tend to be relatively marginalized from formal political systems and that as a consequence they have tended to form alternative networks such as housewives' associations and mothers' clubs to help them to meet their basic daily needs (Jacquette 1986). At the same time, however, Latin American women were actively involved in human rights issues during the decade. Probably the best known example is that of the Mothers of the Plaza de Mayo in Buenos Aires who weekly circled around the plaza in protest against the disappearance of their childlren. Jacquette observes that the strength of this movement lay in the fact that it was not overtly political and that it emphasized the preservation of human life as being more important than politics.

This brief overview suggests strongly that different aspects of women's legal rights have been a major preoccupation of feminist researchers during the decade. This is not surprising, given the centrality of such rights to all aspects of women's integration into social, economic and political systems. However, it is probably also important to note that the number of women legal scholars has increased greatly during the decade and that many countries now have active associations of women lawyers. This is an encouraging sign for the continued enhancement, globally, of women's legal status.

iii. *Employment*

Employment has been a third key concern of feminist researchers during the 1980s, particularly in face of structural adjustment policies and the debt crisis which have considerably reduced real household income levels in the Third World. An important subcomponent of this general theme has been the issue of women's access to technology and integration into industrial workplaces.

In countries like Singapore, Malaysia and the Philippines, female labour increasingly has been integrated into global assembly lines. As formal industrial sectors have rapidly expanded, women have been recruited as sources of cheap and docile labour (Lim 1980). Similarly, women's employment in export processing zones has received increased attention. Helen Safa estimates that there are approximately one million jobs in export processing zones in developing countries, about one-quarter of them in Latin America and the Caribbean (Safa 1990). Safa, Lim and others have suggested that women employed in the formal industrial sector often work in tedious, health-impairing jobs, for lower wages than those paid to men. At the same time their research has shown that, although it suits companies to assume otherwise, female employment often is central to family maintenance. It has been noted too that although wages are low they are somewhat higher than incomes available to poor women through other sources of employment.

During the 1980s, internal rural-urban migration and international labour migration increased substantially on a global level. In the Middle East, the oil rich countries provided employment for male migrants from poorer countries

in the region such as Pakistan, Bangladesh and India. In Africa, countries like South Africa, Ivory Coast and Nigeria were important destinations for male economic migrants from neighbouring countries. In Latin America, migrants from less-developed countries like Paraguay and Bolivia sought employment in richer countries such as Argentina or Brazil. In Asia, Nepali male labour migration to India has been of significance. In most of Asia and Africa, male migration, particularly at an international level, still tends to be more common than female migration but in certain regions, including the Caribbean and the Philippines, female migration has gained in importance (Momsen and Townsend 1987). However, even when women stay behind, their roles often are profoundly affected by male migration. They may become de facto heads of household and have to assume primary responsibility for providing for their children during long periods of male asbence. Male remittances may be irregular or non-existent, particularly if work is not immediately found in the new location.

During the past decade, some researchers began to focus specifically on the working conditions and employment experiences of women in formal sector employment. For example, an IDRC project in Argentina is examining employment opportunities for women in the public sector. The researchers have shown that even when women enter public sector employment with the same or higher qualifications than men, their career histories are inevitably different. Women are systematically ghettoized in lower level positions. This happens even in circumstances where the official ideology of the state equates career mobility with qualifications and performance. Another project has examined the capacity of male-dominated trade unions in female-dominated occupations to represent the interests of female workers. The researchers found that women's concerns usually were not articulated by male trade union representatives but that women themselves were reluctant to become involved in union activities because they felt that they lacked the necessary verbal skills or they were unable to combine time-consuming union activism with their domestic responsibilities. Such research is showing that even when women have achieved high level qualifications or have become members of trade unions which supposedly protect their interests, gender still operates as a powerful intervening variable in the context of actual workplace experiences.

While generally on a global level, women are being integrated into economic systems, research during the decade has shown that overall labour market participation, especially amongst educated women, remains low in most countries in the Middle East and North Africa (Kudat and Abadzi 1989). Even among less educated and illiterate women in the poorer countries of the region there has been an overall decline in labour-market activities during the past decade. As literacy increasingly has become a requirement for many jobs, illiterate women who were denied educational opportunities in early life now are being displaced from employment possibilities.

During the 1980s, there also continued to be a great deal of research on women's role in agriculture, on women's informal sector employment, and increasingly, on women's entrepreneurship. Researchers in different regions

pointed to the handicaps faced by women in attempting to obtain credit, reconciling productive with reproductive responsibilities, and in coping witʰ the immediate micro-impact of the global economic crisis. There also was a growing awareness amongst feminist researchers of the need to influence national policymakers to improve the working conditions of women.

iv. *Social Participation*

The social and cultural position of women continued to be of interest to feminist researchers during the 1980s. The specific focus varied from one region to another but in virtualy all cases, feminist researchers were exploring the basis of women's subordinate cultural position and examining women's efforts to improve their own status. In Latin America, there was interest in the changing power relations between men and women which emerged as a result of increased urbanization and the greater absorption of women into formal labour markets.

Women's participation in industrial employment has grown substantially throughout the 1970s and '80s, especially in countries like Brazil, where well-entrenched industrial sectors exist (Cunningham 1987). Research revealed that Latin American women were entering formal sector labour markets, both to contribute to family incomes and survival and to improve family quality of life through the acquisition of consumer goods.

An IDRC project in Argentina examined the impact of women's greater economic participation on their roles in the family. The researchers explored the extent to which a growing gender awareness and consciousness has given working class women confidence and verbal skills to renegotiate the sexual division of labour and responsibility and ultimately to win greater respect and recognition within the family. Interestingly, preliminary evidence revealed that the young adult children of working mothers had markedly different attitudes towards «female» roles and towards the traditional sexual division of labour in the household.

A project in Chile has examined the portrayal of women in the media and is measuring the extent to which women's self-images are influenced by the standard stereotypes in popular soap operas. Considerable emphasis is being placed on the conflicts between women's societal roles, the official ideology of the state with respect to women and gender roles, and the systematic devaluing of women's self-image through an essentially negative or patronizing media portrayal.

In Asia, cultural and religious definitions of gender roles remained of compelling concern. Changes in gender roles over time also have been analysed. Indian scholars have shown that historically there existed a strong matriarchal tradition which has eroded with the emergence of powerful economic interests that adopted patriarchal ideologies to protect the interests of elite groups (Mazumdar and Sharma 1990). In the Philippines, research in the 1980s focussed on gender inequality, class domination and the predominance of foreign over national interests (Torres 1989). Other social participation issues

\tion in Asia in the 1980s include decision-making and 'he household, the conceptualization of the value of work)cial relations among women (Karim 1986). In some ...s also been a growing commitment to the study of prostitu-...ie commoditization of women.

In the Caribbean, research in the 1980s focussed more on women's economic integration than on social participation issues. Peggy Antrobus noted that various Caribbean countries established women's bureaus of government ministries in the 1970s with a mandate to focus on social participation issues, among others. However, they have had relatively little impact in improving the social image of Caribbean women (Antrobus 1988). She argued that by the end of the 1980s it still remained important to restructure "gender hierarchies and power relationships as expressed in the family, community and society at large" (:47). Nonetheless, during the decade, Caribbean researchers did focus on health issues, especially on women's own definition of health and well-being. Caribbean researchers have made efforts to move beyond the tendency to see women's health primarily in reproductive terms. In this context, an IDRC project in Trinidad and Tobago has examined the high susceptibility of Caribbean women to hypertension and attempted to determine the socio-economic and other conditions which may lead to such high female susceptibility.

An IDRC project in Jamaica is examining the role of the Caribbean man in the family, recognizing that an extremely high proportion of Caribbean households are female-headed but assuming that this does not necessarily mean that men have no relationship with their offspring. The researchers are moving towards a new conceptualization of family interaction, outside the traditional western norm of the two-parent nuclear family. Given the frequency of marital breakdown in the North, it is possible that the findings generated by such research also can have important implications for a better understanding of family relationships outside the Caribbean.

Research on social participation issues, and indeed on gender, has been less frequent in the Middle East. In general, Middle Eastern women have been given little opportunity or encouragement to integrate fully into the national economies of their countries, although there are important exceptions like Egypt. Women in the Middle East and North Africa often are employed in menial and poorly-paid jobs, usually in the agricultural sector. High fertility rates, segregation of women, and low female literacy rates all have added to the isolation of women from participation in development programmes and initiatives. High-income countries tend to be more conservative and to enforce female segregation to a greater extent.

In view of this situation, it is not surprising that research on and by Arab women in the 1980s has been less prominent than in other regions. It is clear that cultural and religious attitudes towards women have impeded both the possibility for Arab women to examine their own condition and the growth of a strong regional feminist consciousness. This is not to suggest, however, that some level of consciousness does not exist. Egyptian researchers, for example,

have produced a growing body of work on the situation of women in their country and important contributions to feminist research have come from individual researchers in various other countries in the region. However, in general, the level of documentation of the specific conditions of Middle Eastern women seems to be somewhat lower than for other regions of the world. Moreover, because of the seriousness of the problem, there has been a tendency for pathbreaking Arab feminists like Nawal el Saadawi to focus on particularly sensitive, much publicized issues such as female infibulation or cliterodectomy. While such issues are of obvious importance, they have drawn attention away from a more basic analysis of the social relations of gender in the Middle East.

In Africa, there has been relatively little concentration on social participation issues. For the most part, attention has remained fixed on economic and access issues. Much of the research done by African feminists in the 1980s has focussed on basic data gathering to influence local and national policymakers. There has been a strong interest in the study of agricultural production, in the sexual division of labour in agriculture, and in women's access to technological inputs, to credit and to extension services.

v. *Environment*

It became increasingly evident during the decade, that men and women have different attitudes towards the environment and natural resource utilization with respect to expectations, needs and motivations. Although this has been recognized by various researchers and by environmental activist groups, there has been little systematic information-gathering on how women interact with environment and natural resources.

Analysis of the relationship between gender and environment and of the notion that women's interaction with natural resource bases may differ from that of men is still at a fairly embryonic stage. Nonetheless, in Africa there has emerged a growing concern with environmental degradation and with the necessity to regain control of rapidly eroding natural resources. African feminists have drawn attention to the close relationship of African women with natural resources, to their utilization patterns and to the immediacy of the impact of desertification and deforestation on women's work and livelihood (Muntemba 1989; Haile 1989).

Several current IDRC projects address these issues. WEDNET, the Women, Environment and Development Network, was established in January 1989 to support research on the identification and legitimization of grass-roots African women's knowledge about the environment. The conceptual starting point for WEDNET is the recognition that the current environmental crisis in Africa and the enduring poverty of African women are not distinct phenomena. They represent the simultaneous result of global and regional policies that force African women to transfer their own poverty onto Africa's natural resource base. The crucial conceptual shift in the network projects is an emphasis on women as problem-solvers whose success at sustainable resource use is largely dependent upon their own opportunities for constructive decision-making. The WEDNET projects currently underway in anglophone

and francophone Africa focus on indigenous women's knowledge concerning management of water, forestry, and crop systems. They attempt to examine and legitimize the knowledge already held by African women and avoid the more usual tendency to dismiss traditional knowledge systems.

The relationship between gender and environment also has emerged as a concern in some Asian contexts. For example, an on-going IDRC project in India is examining the impact of environmentally damaging strip mining operations on women's farming practices in a remote mountainous region. Researchers have found marked differences in the attitudes of men and women towards the development of mining operations. Women tend to take a longer-term view, measuring the cost of environmental destruction and loss of agricultural lands against the short-term benefits of male employment.

vi. *Technology*

As already noted in the discussion of employment issues, the question of women's use of and access to technology in the formal industrial sector received increased research attention during the 1980s. However, women's access to agricultural technologies also continued to be a major research concern in different regions. In Asia, an important focus was on the displacement of female agricultural labour through the technological developments of the Green Revolution. The general rule has been that as labour processes have become increasingly mechanized, men have been trained to operate machines and female labour has been displaced. For example, in India, with the adoption of tubewell irrigation in Uttar Pradesh, women were eased out of work associated with manual irrigation. The introduction of rice and flour mills removed an important source of income from millions of rural Indian women as the new mills were operated by men (Kishwar and Vanida 1984).

In this context, the work of the International Institute for Rice Research (IRRI), in analysing women's role in rice farming in Southeast Asis has been of particular importance. Between 1985-90, IRRI supported more than 26 different projects aimed at integrating women into all aspects of rice production, marketing and consumption. Further attention has been given to the development of technologies aimed at reducing the work burdens of women without displacing their income-earning capacity (Poats 1990). However, despite this important beginning, there continues to be urgent need for more in-depth knowledge of the impact of agricultural mechanization on women in the region (Jiggins 1989).

African researchers also gave attention to the access of women farmers to new technologies and inputs including fertilizers, pesticides and new varieties. There also was growing recognition of the tendency for technologies to be directed exclusively or primarily at men and at male-dominated cash crops. The role of women in subsistence farming began to be widely recognized in the context of research on food security in the 1980s, however this did not lead to a reorganization of most African agricultural research and extension systems.

vii. *Research Methodologies*

As a group, Latin American feminist scholars and researchers have demonstrated a strong interest in theory. Given the important theoretical contributions made by the Latin American dependency theorists in the 1970s and '80s, this is not surprising. There is a long research tradition in Latin America, and a strong tendency to base research in theory. However, this theoretical predilection has been integrated into a Latin American feminist critique only recently. Marysa Navarro argued in the late 1970s that most Latin American scholarship on women was not feminist, that it often specifically declared itself to be anti-feminist, and that there did not exist a strong women's movement in Latin America (Navarro 1979). This certainly does not appear to be true in 1990 and one can conclude that there has been substantial change both at the level of feminist scholarship and of feminist activism in Latin America during the 1980s. This coincided with a general movement towards democratization, especially during the latter years of the '80s, and with the evolution of many strong gender-based social movements. The Community Kitchens of Peru and the Madres de la Plaza de Mayo in Argentina are important examples of strategies undertaken by women's groups to deal with pressing economic and political problems.

Helen Safa observes that in the 1980s, women's social movements have become prominent in Latin America (Safa 1989). She argues that the women's movement in Latin America is based on gender rather than class and that confrontations between women and the state have been of central importance. Some of the issues given attention by Latin American feminist researchers in the 1980s included the linkages and contradictions of class and gender, relationships between capital formation and gender, gender-based confrontations with the state, and political ideology and gender. There also continued to be many basic data-gathering projects, aimed at generating information about different aspects of women's productive and reproductive roles and exploring the objective sources of their oppression and subordination.

Caribbean researchers have been particularly active in the development and utilization of participatory research methodologies which have attempted to break down and eliminate the traditional divisions between researchers and the subjects of research. The Rose Hall project in St. Vincent was an early attempt to systematically involve research subjects in the definition and examination of research questions and problems. Organized by the Women and Development Unit (WAND) of the University of the West Indies in Cave Hill, Barbados, the project sought to integrate women into rural development strategies by i) developing and testing a participatory methodology; ii) developing self-esteem and self-confidence in village women and in their ability to accept leadership roles in their community; and iii) providing information on women's needs and perceptions for policymakers in the region (Ellis 1986). The project trained community people to do research on their own situation in order to bring about change and improvement.

Action research has also become more prominent during the 1980s. Fre-

quently such research has been undertaken by NGOs or women's groups with little or limited research experience. In essence such groups have "learned by doing" and in the process have developed new insights into women's life experiences and perceptions pertaining not only to their subjects but also to the researchers/activists themselves. Their research efforts usually have not been undertaken within traditional social sciences frameworks and they have seldom used conventional scholarly conceptual frameworks and categories. They have focussed on the achievement of specific goals rather than on the attainment of theoretical understandings. In the process, however, they sometimes have developed important insights.

A good example is found in the work of SPARC, an Indian NGO based in Bombay. SPARC began by attempting to improve the living and working conditions of pavement dwellers. It soon became evident, however, that in order to influence municipal authorities, it would be desirable to have an accurate count of the numbers of pavement dwellers. This led to the undertaking of a census and to the collection of specific social data about pavement dwellers. This information in turn was used to identify, in consultation with pavement dwellers, programs and projects which better met their needs. There are many such examples of research by NGOs in developing countries and it can be argued that in undertaking research which includes a central action component that is identified by the objects of research themselves, women's groups are moving towards the destruction of barriers between the researcher and the researched.

Third World Action and Grass-Roots Groups

In the 1980s, a significant proportion of "women in development" research was being carried out by Third World women themselves rather than by visiting researchers from the North who tended to dominate development studies in the past. But while the growth in knowledge production by Third World feminist researchers has been immense, it has been matched with an even greater growth of women's activism. Women's activist groups and NGOs have emerged everywhere and as already suggested, many are trying to bridge the gap between research and action by designing programs based on research findings or by undertaking research themselves, usually in an action-research or participatory mode.

There is a strong argument to be made for close linkages between action and research. It must be recognized, however, that NGOs are not universally excellent and impartial in their activities. A U.N.-supported evaluation of the role of NGOs in Asia and the Pacific in 1989 revealed that NGOs often ignore women's productive role in the economy and their equal entitlement rights in the household and in society (UN 1989). NGO programs often reflect the intersts of a small vocal group but do not necessarily meet the actual needs of all concerned women. This in itself provides a good illustration of why action should be grounded in research. While no attempt will be made here to provide

an exhaustive list of the activities of NGO and grass-roots groups, it may be useful to review the activities of a few typical examples.

In Latin America, numerous women's groups combine action with research. The work of Flora Tristan of Peru provides one good example. Flora Tristan has gathered information about the conditions of Peruvian women which at the same time devising specific activities aimed at empowering them. CIPAF (Centro Investigacion para le Accion Femenina) in Dominican Republic provides another. CIPAF was established in 1980 to undertake research, popular education and information dissemination about the status of women in the Dominican Republic. In the past decade, the group has undertaken many important studies, most with a strong action component. They have worked on issues of trade union representation for women, political participation, prostitution, legal rights, and sex-role stereotyping. In 1983, CIPAF established a course in methods for doing research on women. Using such varied means, CIPAF has tried to compile information data bases, to provide training and popular education for poor women, enabling them to improve their own situation, and to provide research skills for women working in various sectors allowing them to better analyse their own situation. Their work epitomizes a feminist approach with researchers and experienced activists sharing knowledge and skills with other women to give them the analytical tools to better understand and ultimately to improve their own situation.

In the Caribbean, groups like CAFRA (Caribbean Association for Research and Action) and the Sistren Theatre Collective in Jamaica are playing important roles in politicizing women and in legitimizing alternative views of economic and social development during a period of severe economic strain. Sistren, which began in 1977 as a theatre group composed of working class women, concentrates on the empowerment of women by providing skills and knowledge through the dramatization of their condition. The group now undertakes a variety of activities, including popular theatre performances, educational workshops for women and men on issues of gender in the Caribbean, distribution of a quarterly magazine (which serves as a forum for women in the region), production of screen-printed textiles, research on Jamaican women's issues, and publication of books and audio-visual teaching materials. CAFRA, which includes more women with academic training, also is trying to help Caribbean women find their own voice both at the level of national and regional action and research. Again, the emphasis is on sharing information, knowledge and skills.

In India, the work of the Chipko movement has become well-known in its opposition to the destruction of sources of fuel. The dramatic action taken by women, of encircling trees to save them from destruction, caught world attention. Similarly, SEWA, the Self-Employed Women's Association, has gained international attention in its efforts to ensure that home-based workers receive adequate compensation. SEWA has been active in the development of training programs to imporove the knowledge bases of association members and it has made effective use of new communications technologies by teaching poor and illiterate women to make videos which help them better to analyse their own

condition. In the Philippines,GABRIELA, an umbrella organization of various women's groups has worked towards the recognition of women's rights and potentials in all spheres of life.

In Africa there are hundreds of thousands of indigenous women's groups working on local issues in virtually every country. In Kenya alone, it was estimated in 1984 that there were 16,232 active women's groups working on development issues (Mbeo 1989). Most African women's groups are income-generation or welfare-oriented and do not place primary emphasis on reserach. However, AAWORD, the Association of African Women for Research and Development, with a roster of more than 400 African women members, has become an active and vocal proponent of African women's views. it publishes a regular newsletter and has consistently championed the cause of African feminism.

Towards a new Vision of the Future

In the 1980s feminist researchers collected voluminous information about the conditions, perceptions and needs of women. They began to organize this information into specific understandings about the social relations of gender in different parts of the world. Women organized themselves more effectively than ever before and their voices were heard in social movements around the globe. The NGO Forum at the End-of-the-U.N. Decade for Women at Nairobi in 1985 was a celebration of women's growing strength and solidarity. In the 1980s women moved closer towards their own empowerment and towards the articulation of a feminist perspective.

But at the same time, at a more general level, it can be argued that feminism lost ground during the decade. As a result of the global debt crisis, Third World policymakers have less control over their own economies today than they had in the past. Third World populations are becoming more impoverished and women's concerns are being heard even less readily in the context of general decline in standards of living. Moreover, Third World development has become a less central concern in a world that is focusing on the so-called "failure" of development in many countries. International interests and investments are continuing to shift towards Eastern Europe and the NICs (newly-industrialized countries) of Southeast Asia and away from the poorer countries of Africa and Latin America. "Donor fatigue" and growing disenchantment with the slow pace of development processes is frequently cited as explanation for decreasing interest in the less-developed countries. At the same time, "women in development" has become a less popular theme among international agencies; it has been replaced by a new focus on environment. In these shifts, the voices and causes of women are receiving less attention than even five years ago.

Despite the difficulties imposed by this somewhat negative climate, it is essential that feminist researchers and activists not lose the ground that has been won during the past decade. A feminist vision for the end of the 20th century must be based on a coherent articulation and integration of what has been

learned through research and action since the early 1970s. The task for feminists during the 90s, must be to bring women's experience, knowledge and values into the mainstream of global decision-making. We must be both researchers and activists and we must point in the direction of a more equitable sharing of the world's dwindling resources.

REFERENCES

ANTROBUS, Peggy
1988 "Woman in Development Programmes: the Caribbean Experience (1977-1985)." In Patricia Mohammed and Catherine Shepherd, eds. *Gender in Caribbean Development*. Mona, Jamaica: University of the West Indies, Women and Development Studies Project, pp. 32-52.
BRYDON, Lynne and Sylvia CHANT
1989 *Women in the Third World. Gender Issues in Rural and Urban Areas*. New Brunswick, NJ: Rutgers University Press.
CALLAWAY, Barbara and Enid SHILDKROUT
1986 "Law, Education and Social Change: Implications for Hausa Muslim Women in Nigeria." In Lynne B. Igilitzin and Ruth Ross, eds. *Women in the World 1975-1985. The Women's Decade*. Santa Barbara, Ca: ABC-Clio Inc., pp. 181-205.
Commonwealth Secretariat
1990 Engendering Adjustment for the 1990s. Report of a *Commonwealth Expert Group on Women and Structural Adjustment*. London: Commonwealth Secretariat.
COOMARASWAMY
1982 "A Third World view of Human Rights," UNESCO Courier 49. Quoted in Cook, Rebecca J. 1990. "Women's Legal Issues and Status in the Developing World." Paper presented to the Association for Population/Family Planning Librarians and Information Centres, Toronto, May 1.
CUNNINGHAM, Susan
1987 "Gender and Industrialization in Brazil." In Janet Henshall Momsen and Janet Townsend, eds. *Geography of Gender in the Third World*. Albany, NY.: State University of New York Press, pp. 294-308.
ELLIS, Pat
1986 "Methodologies for Doing Research on Women and Development." In *Women in Development*. Perspectives from the Nairobi Conference. Manuscript Report 137e. Ottawa: International Development Research Centre, pp. 136-65.
HAILE, Fekerte
1989 "Women Fuelwood Carriers and the Supply of Household Energy in Addis Ababa," *Canadian Journal of African Studies* 23, no. 3: 442-51.
JACQUETTE, Jane
1986 "Female Political Participation in Latin America: Raising Feminist Issues." In Lynne B. Iglitzin and Ruth Ross, eds. *Women in the World 1975-1985. The Women's Decade*. Santa Barbara, Ca: ABC-Clio, pp. 243-69.
JIGGINS, Janice
1989 "Agricultural Technology: Impact, Issues and Action." In Rita S. Gallin, Marilyn Aronoff and Anne Ferguson, eds, *The Women and International Development Annual, Volume 1*. Boulder, Co: Westview Press, pp. 26-55.
KARIM, Wazir-jahan
1986 *Women's Work and Family Strategies in South and Southeast Asia*. Proceedings of Workshop and Meeting held in Penang, Malaysia, 20-25 April 1986. Penang: Universiti Sains Malaysia.
KISHWAR, M. and R. VANITA
1984 Eds. *In Search of Answers: Indian Women's Voices from Manushi*. London: Zed Press.
KUDAT, Ayse and Helen ABADZI
1989 "Women's Presence in Arab Higher Education: Linking School, Labour Markets

and Social Roles. "Paper presented at Seminar on the Determinants and Conse-
quences of Women's Education, World Bank, Washington, 8-9 June.

Lim, Linda
 1980 "Women in the Redeployment of Manufacturing Industry to Developing Coun-
 tries." UNIDO *Working Papers on Structural Changes*, 18.

MacKenzie, Fiona
 1989 "Research Note: Women, Land and Legal Systems." In Eva M. Rathgeber, ed.
 Women's Role in Natural Resource Management in Africa. Manuscript Report 238e.
 Ottawa: IDRC, pp. 52-57.

Manuh, Takyiwaa
 1989 "Women, the Law and Land Tenure in Africa." In Eva M. Rathgeber, ed.
 Women's Role in Natural Resource Management in Africa. Manuscript Report 238e.
 Orrawa: IDRC, pp. 26-40.

Massiah, Joycelin
 1990 "Defining Women's Work in the Commonwealth Caribbean." In Irene Tinker,
 ed. *Persistent Inequalities. Women and World Development*. New York: Oxford University
 Press, pp. 223-38.

Mazumdar, Vina and Kumud Sharma
 1990 "Sexual Division of Labour and the Subordination of Women: A Reappraisal from
 India." In Irene Tinker, ed. *Persistent Inequalities. Women and World Development*. New
 York: Oxford University Press, pp. 185-97.

Mbeo, Mary Adhiambo
 1989 "Organizing and Mobilizing Women's Groups in Kenya." In Mary Adhiambo
 Mbeo and Oki Ooko-Ombaka, eds. *Women and Law in Kenya. Perspectives and Emerg-
 ing Issues*. Nairobi: Public Law Institute, pp. 123-28.

Mbugua, Wariara
 1989 "Women's Employment Patterns: Emerging Aspects of Economic Marginaliza-
 tion." In Mary Adhiambo Mbeo and Oki Ooko-Ombaka, eds. *Women and Law in
 Kenya. Perspectives and Emerging Issues*. Nairobi: Public Law Institute, pp. 97-112.

Momsen, Janet Henshall and Janet G. Townsend, eds.
 1987 *Geography of Gender in the Third World*. Albany, NY: State University of New York
 Press.

Muntemba, Shimwaayi
 1989 "Women and Environment in Africa: Towards a Conceptualization." In Eva M.
 Rathgeber, ed. *Women's role in Natural Resource Management in Africa*. Manuscript
 Report 238e. Ottawa: IDRC, pp. 1-5.

Navarro, Marysa
 1979 "Review Essay: Research on Latin American Women." *Signs*, 5, no. 1 (Autumn):
 111-20.

Poats, Susan V.
 1990 "Gender Issues in the CGIAR System: Lessons and Strategies from Within."
 Paper presented at the CGIAR Mid-Term Meeting, The Hague, 21-25 May.

Safa, Helen I.
 1990 "Women and Industrialisation in the Caribbean." In Sharon Stichter and Jane L.
 Parpart, eds. *Women, Employment and the Family in the International Division of Labour*.
 London: MacMillan, pp. 72-97.
 1989 "Towards a Theory of Women's Collective Action in Latin America." Paper
 presented at a Workshop on "Redefining the Position of Women and the Family
 in the Reconstruction of Social Life: Perspectives from North and South," Univer-
 sity of Notre Dame, Notre Dame, Indiana, 30 November-1 December.

Tibaijuka, Anna K.
 1988 "The Impact of Structural Adjustment Programmes on Women: the Case of Tan-
 zania's Economic Recovery Programme." Report prepared for the Canadian Inter-
 national Development Agency, Dar es Salaam.

Torres, Amaryllis T.
 1989 "The Filipina Looks at Herslef. A Review of Women's Studies in the Philippines."

Paper presented at KANITA/UNESCO Workshop on Research Methodologies, Perspectives and Directions for Policy in Women's Studies in Southeast Asia, Penang, Malaysia, 11-15 December. Also appears in A.T. Torres. *The Filipino Woman in Focus: A Book of Readings*. Bangkok: UNESCO, 1989.

United Nations. Economic and Social Commission for Asia and the Pacific.
1989 *Co-operation Between Goverment Agencies and Non-Governmental Organizations in the Delivery of Social Services for Woman. A Study on Measures to Enhance the Contribution of Non-Governmental Organizations to Social Development*. New York: U.N.

Afghanistan:
Women, Society and Development

NANCY HATCH DUPREE*

ABSTRACT

This study views Afghan women at the close of twelve years of war as their country starts to rebuild. If they are to share in their country's redevelopment, their voices must be heard. Over one-quarter of Afghan refugees are women and children; despite hardships, the women have been respected. In pre-war Afghanistan, women gradually began to participate in national development. Now, religious conservatives try to legitimize their leadership by associating pro-feminist views with social chaos.

DEVELOPMENT IN THE CONTEXT of this discussion is meant to describe an enhancement of being, an increased sense of identity and self-esteem. While making use of the mechanics of modernization—technology, improved services, the management of skills and the allocation of human resources—true development must necessarily emphasize the quality of life. Too often frenzied modernization submerges individual dignity leaving women, particularly, diminished.

This emphasis on the distinction between development and modernization has particular relevance for Afghan women today as the nation of Afghanistan, shattered by twelve years of war, stands on the threshold of peace, ready to rebuild. The challenges are monumental. Reconstruction of the extensive physical damage requires determined efforts, but these are relatively manageable; the reconstitution of the political structure is more vexing, but solutions are currently in the forefront of national and international investigation; the rebonding of social institutions, however, remains fraught with deep emotional contentions with the result that in the many fora debating Afghanistan's future, women's voices are scarcely heard. If Afghan women are to share in Afghanistan's development, assessments of this exclusion warrant careful consideration.

* ARIC Secretariat, 2 Rahman Baba Road, University Town, Peshawar, University P.O. Box 1084, Pakistan
(ARIC is the ACBAR Resource and Information Centre established by mandate of the ACBAR General Assembly in Peshawar, Pakistan in April 1989. ACBAR, the Agency Coordinating Body for Afghan Relief, is a consortium of 63 non-governmental organizations providing assistance to Afghan refugees in Pakistan and cross-border inside Afghanistan in areas outside the control of the central government. ARIC collects and disseminates documents generated by all assistance organizations, members, non-members, bilateral and multinational, and maintains a reading room in Peshawar.)

With this in mind, the following comments seek to explore three primary themes: first, the effects of war on Afghan women; secondly, the place of women in pre-war society; and lastly, the prospects for women in national reconstruction.

Women and War

Exodus. Over one-third of Afghanistan's pre-war population of 15 million now live in exile: over three million in Pakistan; almost three million in Iran. Another two million displaced inside Afghanistan live in equally unfamiliar surroundings. Of these millions upwards of 2.5 million individuals living in Pakistan are women over the age of 15 and their foremost responsibilities, children.

This tragic situation began after a leftist-oriented leadership seized power in Kabul, the capital city, in April 1978; a Soviet invasion followed in December 1979 (Bradsher 1985). To provide equal rights for women was an early priority heralded by the new Kabul regime and to this end an ineffective decree was issued (Beattie and Tapper 1984), a literacy campaign targeting women launched and attempts to mobilize women initiated (N. Dupree 1984). The heavy-handedness of these and other reforms exhibited a total disdain for Afghan cultural values giving rise to mounting dissent which erupted into open revolt put down by indiscriminate bombings of villages and civilian populations (Giradet 1985). Women shared more than equally in these events; often only women with their children occupied the mud-brick housing flattened by air and ground fire. With continued ideological assaults on their value system, with their houses in ruins and with the agricultural infrastructure inoperative, the population saw no option but exile.

Two cultural patterns supported women from the moment they left, a decision typically taken jointly within extended families. Rural families usually moved out in kin-related groups and family solidarity is well-illustrated by the fact that contrary to many other refugee situations, rape did not figure among the hardships women suffered during the exodus (N. Dupree 1988a). There were many widows, many single girls, who suddenly found themselves bereft of close male kinsmen but the obligation to protect women which is incumbent upon all males, no matter how distant their membership in the extended family may be, was meticulously observed.

Secondly, the innate respect for women characteristic of Afghan culture is not only articulated but practiced. As one example, urban women who often moved out alone with their children were little taken advantage of by the *mujahidin* (resistance fighters) contracted to escort them. Avarice, of course, infects all societies and tales of outrageous swindles abound, but dishonorable behavior toward women does not figure in these accounts.

Exile. Once arrived in Pakistan, women were forced to contend with a multitude of appalling physical hardships such as unaccustomed tent-living under climatic extremes with inadequate water and fuel and no sanitation (Christensen 1983). More difficult for the women were the crowded conditions

which afforded them none of the privacy in protected work and social spaces their traditional village architecture provided.

In addition, women in Afghanistan enjoyed considerable freedom of movement throughout their mostly kin-related villages. Visiting and gossiping were important components in their women's networks which provided individuals support and strengthened community cohesiveness (Doubleday 1988; Shalinsky 1989). The huge refugee settlements in Pakistan, on the other hand, contain mixed populations of up to 150,000 crowded into five square miles. Although most are divided into sections representing single villages, these sectors are so closely jammed together that women dare not move about and, in many cases, they are expressly forbidden to venture beyond the perimeters of their own dwellings (N. Dupree 1987). Many Afghan men regard all spaces beyond the immediate vicinity of their homes as hostile worlds where women become intolerably vulnerable. As a result, many women are more tightly confined than they ever were in Afghanistan.

About the only accepted outing is a visit to a health center, and some are even denied this break in the day's monotony. Health care is basic, but it has prevented the outbreak of epidemics, a remarkable accomplishment considering the fact that the Afghans in Pakistan represent the single largest refugee concentration in the world. It must also be noted that rural refugee women in Pakistan generally have better access to health facilities than they had in prewar Afghanistan.

Nevertheless, as the years wear on, an alarmingly high incidence of malnutrition and anaemia is notable among women of child-bearing ages. The refugee diet is deficient in many ways, but more germane to the subject of nutrition is the pervasive attitude that women's main contribution to the war effort can best be realized by producing as many children as possible so as to replace an estimated one million individuals who have fallen on the battlefield or perished during the hostilities. The birth rate is therefore alarmingly high. Anxious to do their part, women no longer space their pregnancies and with no hope of obtaining the supplementary foods pregnant and nursing mothers require, the health of mothers continues to worsen and premature, underweight children present grave problems for the future. Urban families are equally anxious to add to their families. Often parents of children with offspring of their own start new generations.

Added to deteriorating health is the psychological distress occasioned by a sense of marginalization; some women even express a diminishing sense of self. Mutual respect and self-esteem among rural women living in Afghanistan were generated by closely interrelated male-female economic roles, but since the refugees are not permitted to engage in agriculture, these activities have been totally suspended, leaving rural women little to do beyond child care (N. Dupree 1988b).

For urban refugee women, particularly those from Kabul, great concern rises from current restrictive attitudes toward education and employment. Any threatened culture tends to impose stricter behavioral codes on women and this is particularly evident in the resurgence of social conservatism among the

Afghans. To protect honor and the values for which the war had been fought, women's activities, including education, have been curtailed and restrictive customs, including the application of *purdah* (seclusion) and the veil, have been intensified (Boesen 1988).

Honor is of such paramount importance in the culture that Afghan males are characteristically prepared to die in its defence. Since this honor depends to a large degree on the propriety of female family members, it is not surprising that the concept of male control dominates all male-female relationships. Women also often rigidly uphold these rights for they derive both status and mental tranquility from conforming to the rules (Tapper 1980).

The concept of physical protection extends to the ideological as illustrated by attitudes repudiating education, the vehicle by which godless communism was introduced. To preserve honor and society, therefore, conservatives insist that women's place is in the home, their role exclusively dedicated to child-rearing.

Despite these attitudes, girls and women among the refugees are taking advantage of a variety of educational opportunities offered them in Pakistan. In fact, applicants for both formal and technical courses, including English, public administration, specialized health courses, tailoring and other income-generation classes, far exceed placement capacities. The waiting list at the employment bureau is also long. What this means for the future is discussed later.

Women and Society

Urban Women. Current conservative attitudes represent a reversal of an evolutionary women's movement which began early in the 20th century and continued steadily until 1978, with only two major interruptions. In 1925 and 1929 conservative tribal and religious leaders, objecting to westernized reforms, succeeded in overthrowing the government and expunging all vestiges of the incipient women's movement. The girls' schools were closed, *purdah* and the veil were strictly enforced, and western dress and hair styles expressly prohibited (Stewart 1973).

For the next 30 years—that is, until 1959—women remained secluded and behind the veil. Nevertheless, the concept that women should participate fully in national development became a national policy. Women in growing numbers attended separate schools and were employed, principally by the government, in professions considered appropriate, predominantly as teachers, medical professionals, and administrators in these female institutions.

Then, in 1959, the government dramatically announced the voluntary removal of the veil (L. Dupree 1959) thus paving the way for the entry of women into a full range of employment opportunities (Rahimi 1986). No career was closed to them except menial public manual labor which was considered dishonorable by men and women alike. Undercurrents of dissent led by conservative religious groups occasionally surfaced, but these demonstra-

tions were effectively suppressed by the government which challenged the religious leaders to provide conclusive evidence that Islam denies women education and the means to contribute to community and nation (L. Dupree 1971:17).

The conservatives failed to meet the challenge and gradually the urban society became reconciled to women's full participation in the public sector. Education came to be taken for granted even among many in the lower strata of urban societies. The ideology advocating broader participatory roles for women was, however, almost exclusively promoted by western-oriented men who, despite their encouragement of broader roles for women, continued to insist on patriarchal control as an ideal. A girl sought education or prepared for a career only with the consensus of male family members. Furthermore, although they were encouraged to pursue careers, working women were expected to socialize within the family and were allowed few social interactions with their colleagues. Major lifecrises decisions, such as the choice of marriage partners, were determined by the family.

Women were automatically enfranchised by the 1964 Constitution. A Penal Code (1976) and Civil Law (1977) addressed rights concerning child marriage, forced marriage, inheritance and abandonment, but because the government insisted on the voluntary introduction of change, family attitudes, not government guarantees, prevailed. In addition, few women had the knowledge or the recourse to demand their rights and few mechanisms facilitating an approach to judicial institutions were availabe to the ordinary woman in spite of the establishment (1975) of a Special Court for Family Affairs in which female judges participated. Furthermore, family prerogatives were seen as the provenance of Islam and, therefore, beyond the competence of secular law (Knabe 1977:340).

Nevertheless, as they became increasingly aware of their considerable contribution to the nation, women began to articulate goals which conflicted with the male-oriented ideology of control. In the workplace where they had been given decision-making responsibilities, they sought to be included in policy-making; at home they longed to be released from family strictures so as to be able to make decisions as individuals. But in truth, women could not exist outside the family.

Although such undercurrents of frustration fostered rebellious sentiments, only a minute minority spoke out on their own behalf; few women engaged in politics or were willing to take a public militant stance. As a result women were unable to forge even a modicum of solidarity and no cohesive leadership emerged to force the guarantees pledged to them in the legal statutes.

The rhetoric following the leftist coup in 1978 promised to amend the situation by instituting full equality for women (N. Dupree 1984). Women moved freely in public and filled government offices and higher educational institutions leading members of the western media to write glowingly about women clad in blue jeans and the fact that women students outnumbered males at Kabul University. This ethnocentric emphasis on the significance of western clothing, which was, in any case, standard for urban women before

the war, also fails to account for the fact that all males outside privileged Party members had been conscripted or fled into exile.

Deeper investigation reveals that although women were more visible in Kabul, they were for the most part enmeshed with the political fortunes of individual leaders and no promised cataclysmic changes in male-female relationships materialized. In fact, no qualitative changes in decision-making and power-sharing between men and women occurred. Rather, by allowing themselves to be manipulated as tools of party politics, the militant Party activists subordinated the women's movement to male domination, adding a sinister dimension to the patriarchal attitudes their rhetoric condemned.

Rural Women. While urban women exposed to western-oriented concepts of emancipation—a scant 2% mainly among upper elites—chafed in frustration over the constraints of patriarchal family control, the majority of Afghan women, 95% of whom lived in the rural areas, derived a sense of security, accomplishment and self-esteem within the family. The absence of nation-wide government institutions and facilities in the rural areas necessarily required individuals to look to the family for their socio-economic and political rights and obligations, from birth through old-age (L. Dupree 1980:81).

Family orientation and spatial segregation in no way excluded these women from exerting considerable individual influence, however. Women's networks maintained family solidarity, arranged marriages, mediated personal and familial difficulties and disputes, supplied moral and economic support during crises, organized religious gatherings and provided communication links. Individual women gained status and respect in accordance with the expertise with which they carried out household management services, processed food and raw materials, manufactured crafts, and much more, in addition to their recognized domestic chores. Often trivialized and seldom represented in national production statistics, it is this multiplicity of personally meaningful activities that created a sense of identity that manifestly contributed to the quality of women's lives even in their limited surroundings.

Women and Development

Initial responses to questions concerning future roles for women in Afghanistan almost inevitably reflect current uncertainties, the "wait and see" attitude characteristic of unsettled times of transition. The composition and style of future leadership will affect women's roles, depending on whether ultra-conservative or moderate Islamic beliefs prevail. But no one knows what that leadership will be.

Regardless, women's issues are at this moment highly politicized. Refugee communities team with zealous conservatives who seek to legitimize their leadership by evoking the purity of their teachings so as to delegitimize the opposing moderate voices. The manipulation of women and Islam reached particularly worrisome heights during the summer of 1990 when a series of ugly incidents centered on women attending educational institutions and employed by mostly foreign-funded relief agencies.

Anonymous, surreptitiously circulated leaflets aggressively predicted the imminent dissolution of Muslim morals and gave warnings of dire consequences to not only the women who persisted in engaging in these activities but to their male protectors as well. One *fatwa* (religious opinion) issued over the signature of 83 persons using religious titles quoted selectively from the *Qur'an* (which addresses both women and men) and the Sunnah (sayings and practices of the Prophet Mohammed), the two pillars of Islamic law. It called for the maintenance of social order through the strict observance of *purdah* and veiling, proper deportment, Islamic dress codes, restricted movement and forbade mixed associations outside immediate family members. It was especially vociferous in its denunciation of female education, going so far as to expressly forbid it. A final Declaration called upon the Afghan Interim Government, headed by the leaders of seven religious political parties, to close all the schools and the fledgling Afghan Muslim Women's University.

Their call went unheeded, but this sudden spate of conservative pronouncements comes at a time of extreme political uncertainty when the religiously-oriented leadership outside Afghanistan jockeys for power in their attempts to claim legitimacy for their bids to succeed the secular regime still ensconced in Kabul. The Charters of the major political parties led by these men range from explicit denials of the vote to women and insistence on strict seclusion to generalized statements in support of women's participation in reconstruction, including higher education and employment in separate institutions (*Afghan Jihad* 1988: N. Dupree 1989a:3-5).

Moderates within the society pragmatically predict that these hardliners will crumble once the refugees return and some semblance of normalcy is reestablished. In fact, noting that the *fatwa* reads more like the thinking of the Pakistani clergy, they speculate as to whether Pakistan, having failed militarily and diplomatically to establish influence in Afghanistan, is now attempting a new strategy through the medium of the Afghan clergy, many of whom were trained at Pakistani religious centers. Certainly Pakistan's most prominent conservative political religious party has had close association, at times officially promoted, with the refugees since their arrival. In addition, Arab missionaries, most notably Saudi Wahhabi purists, are making concerted efforts and expending extravagant sums to win the minds and souls of the Afghans. All these groups are excessively obsessed with women's morality which serves to intensify ultra-conservative practices, but it is the blatant exploitation of women in the political arena that is the greatest cause for concern.

Although viewing the current anti-feminist campaign in measured perspective, the moderates express their belief that these attitudes are inimical to Afghan traditions and that by making a mockery of Islam by perverting the Islamic prescriptions for a respected place for women in society, the conservatives represent the greatest constraint to women's future development. They propose a more conciliatory synthesis based on the Qur'anic concept of *ijtihad* or interpretation based on analogy of the Qur'an.

These moderates, however, have yet to establish effective communication

channels to the conservative decision-makers. So, for the time being, they permit the conservatives to speak for them, fearing that to do otherwise would compromise the reputations of their families. In the event, a few who have spoken out have been assassinated.

Below the leadership level, the distributors of the anonymous leaflets are generally believed to be young, one-time *mujahidin* (resistance fighters) who have grown to maturity on the battlefield. The war against the foreign invader has been won, but the struggle for the protection of cultural ideals, remains in focus. Visible religiousness characterizes many of these young men, but the lackluster political leadership has largely lost its credibility and provides no direction, no outlets for the pent-up youthful zeal. Having largely eschewed formal education in opting for the more manly exploits of war, they are now knowledgeably ill-prepared and emotionally incapable of engaging in routine productive activities. Instead they have transferred their energies to an aggressive defence of women's morality.

At the same time, it may also be that the growing numbers of girls and women engaged in educational pursuits and gainful employment are disturbing these young men faced with job insecurity. Whatever the source of their discontent, perceptive women have for some years now voiced concerns about the post-war reactions of these war-hardened youth. They wonder if perhaps women will become the objects of aggression once the enemy of battle is removed.

Certainly these attitudes will have long-term effects for it is well-established that the staunchest conservatives are oftentimes to be found among the young. The women who are preparing now for active roles in the future are aware of this, but their determination is undaunted. Where men proceed with the greatest of caution, the women leaders push ahead with courage.

Here perhaps is the most meaningful signal for the future. Unlike the women of the past who took the advantages given to them for granted, the active refugee women perceive that they must speak out if they are to realize self-fulfillment. This awareness may well herald the beginning of the politicization of Afghan women.

They face a daunting task not only because the needs are great but because qualified implementors are distressingly few (Connor 1989). In addition, support, both moral and financial, is so minimal. The dynamism evidenced by the activists and their new-found determination helps to offset these negatives. However, it is a difficult, often discouraging task to need constantly to inspire pessimistic detractors among the assistance community as well as women in their own groups who, under the pressure to conform, continue their characteristic natural passivity.

Education and technical training, therefore, are uppermost on the list of priorities. Here the women need tread with caution on two accounts. Most training is provided by or supported by foreigners from western countries. The belief that western motives plot the destruction of Islamic societies is widely articulated along with the suspicion that seemingly innocuous aid programs provide the weapons in the grand design. The failure of past Afghan govern-

ments led by the secularized westernized elites who are held responsible for the current tragic situation strengthens these views. These polemics seeking to establish an Islamic identity add fuel to the exhaustive tirades against secular reformers which have raged for decades in the area, the main purport of which is that permissive moral values diffused through western education result in sexual and moral anarchy (Maududi 1986).

Women program directors among the refugees are, therefore, scrupulous in maintaining blemish-free, upright moral reputations. Not all, but growing numbers, wear the *hejab*, a distinctive type of veil which is being widely adopted throughout the Muslim world as a unifying symbol among women. Among many young Afghan women the *hejab* symbolizes propriety (*Bashir-ul-Momenat* 1990).

While acknowledging that the *hejab* has its positive uses in facilitating women's activities, some find its adoption a cause for worry, another assault on Afghan culture. They find it an abhorrent innovation which will eventually legitimize and institutionalize inequality.

This question is one that must ultimately be decided by the society as a whole once peace is established and repatriation accomplished. Separate institutions for women nevertheless would seem to be a certainty for some time to come. This poses no real break with past attitudes toward co-education which were always decidedly ambivalent. From co-educational primary schools pupils moved on to separate secondary schools only to be brought together once again at Kabul University. Maturity, it was reasoned, would ensure proper social behavior, but in reality considerable uneasiness was manifest. But "separate" need not signify inequality if planning, financing, equipping and monitoring are assiduously promoted. Neither need separate necessarily equate with inferior, if vigilance is institutionalized.

Current dilemmas are even more readily discernible in the field of income-generation and employment. Rural women anticipate resuming the closely interrelated economic roles which fostered mutual respect and self-esteem. There will, nevertheless, be considerable need to ensure that the unaccustomed number of single women, particularly widows and their children, are provided a dignified place in society. Afghan culture with its emphasis on the rights and obligations of the extended family will protect single women from destitution but unless they can be accorded the means to contribute economically to the households that give them shelter, they may find their lot little better than that of indentured servants.

The task here is to educate male programmers to the fact that women are as capable, if not more so, of implementing programs involving agriculture, horticulture, poultry and animal husbandry with their accompanying extension training schemes. Food processing and storage have always been the responsibility of women. The introduction of improved appropriate technology and production of surplus beyond domestic needs is another important component. The same may be said of crafts where women also traditionally dominated. Access to innovative small credit schemes for women is an extremely important dimension if the benefits of introduced improvements are not to fall solely to men. (N. Dupree 1989b).

Beyond this, the mobilization of women in health, sanitation and potable water schemes should not be overlooked. Despite restrictions in the refugee milieu, women's awareness and expectations concerning health care have been considerably raised. It will be a very long time before a centralized service infrastructure can be put in place and the community health projects already functioning among refugee populations have proven conclusively that grassroots community-focused approaches are the most likely to have positive results (Forman 1989).

Within urban populations there are two segments to be considered. Middle-class women did not have a tradition of working outside the home. In fact, extradomestic pursuits for women were thought to bring shame on both the women engaging in them and their male family providers. Many refugee women from these groups, however, have taken advantage of employment opportunities either because of economic necessity or in response to the belief that helping the less fortunate, widows and orphans especially, contributes to the overall efforts of the war. Working refugee women, therefore, have gained respect through involvement in activities of perceived social value.

These women from mainly educated, mid-income, urban families are candidly pragmatic when they speak of the future. Here their work is respected because it is an important part of the war effort. But many members of their families remain in Afghanistan and have no concept of the refugee mentality. Will these members be reconciled to the idea of women producing items for sale or attending workplaces outside the home? Or will they still consider it shameful for women to extend the traditional boundaries of the woman's domain? Social pressures will figure prominently in determining what these women may or may not do on their return.

The second segment within the urban milieu consists of the progressive technocrats, professionals and elites, many of whom are in the forefront of the nascent women's movement. Their progress is still only measurable in terms of individuals rather than the collective female population and, as indicated, their paths are uncertain and filled with obstacles.

These women are well aware of the problems and their involvement in program planning is an imperative priority. They have articulated their concerns at various fora in which the expected attention to training, health, education, management and income-generation plus financial and logistical support figure prominently. Of special interest are their pragmatic pleas for enhanced security, cultural tolerance toward the *hejab*, and support for Islamic education focused on women's rights within Islam (IRC 1990). Almost all women's groups emphasize their firm conviction that the study of women's place in Islam will strengthen women's awareness of the justice and equity guaranteed them and thus increase the power of their voices at home and within the community.

These last points highlight the need to place more women in decision-making positions. Not only will this improve programming, but if women are to take a lead in their own development after repatriation new attitudes toward responsibility and commitment need to be inculcated. Because in the past

women played so little part in policy-making, planning, or even simple decision-making, there were few incentives to develop commitments towards their work or interest in long-term development. Family always came before work.

Whether influenced by conservative or modernist attitudes, working women seeking sources of personal satisfaction must struggle to achieve a balance between family obligations and a career. Some of the more psychologically traumatic personal conflicts rise from attempts to combine modern careers with the institution of the family which will remain the single most important social institution in the society.

For many the conflict will not arise. Many do not question the existing order; some actively oppose change for the traditional protected roles provide many rewards while independent roles seem fraught with insecurity. While preparing women for development-oriented roles, programmers should not neglect to note that for a majority of both rural and urban women motherhood will remain the primary option. This raises the need for community services, much neglected in the past, in association with programs targeting mother-child development.

Yet to be adequately addressed in current programming are the wide range of needs regarding legal procedures guaranteeing women rights and justice. Here Qur'anic and customary law, secular practices, and a plethora of divergent interpretations cloud thinking and present obstacles few are capable—and willing—to confront. Present sensitivities toward women and their relationships to the rest of society are emotional and highly volatile. The idea of a safe enclosure for one is captivity for another; security, seen from another angle, is unbearable restriction. For an equitable solution, women's issues need to be debated by the society as a whole rather than depend on the dictates of vested-interest groups or the aberrations expressed by any one segment of the society.

Any movement of change causes reactions. A legal system should guarantee that these reactions remain true to the values of the society which, for Afghanistan, will mean that they must rest on the equity which forms the essence of Islam. History has shown that merely conceptualizing precepts of equality is far from sufficient. Provisions must be made for the implementation of their intent so that the guarantees can be translated into policy measures leading to tangible programs benefiting women. To accomplish this, women should sit on legislative bodies so they may guide in formulating the guarantees.

To conclude, women's voices should be heard in all fora. The conventional wisdom now expressed in the corridors of the policy-makers in Geneva, Washington, Paris, Bonn and Canberra is that "Afghan women are technically incapable and psychologically unwilling" to participate in reconstruction so there is "no point in planning anything for women especially since the next generation of men will not allow them to participate." Sentiments in Riyadh, Tehran and Islamabad would probably concur.

To the contrary. Afghanistan can scarcely rebuild without the assistance

of half of its population. Afghan women are already dynamically involved, albeit in limited numbers, and they seek to expand their numbers and the variety of their contributions while simultaneously preserving the essence of the Afghan culture. This is where they will find their identities and self-esteem in the future if given the opportunity to be heard.

REFERENCES

Afghan Jihad
 1988 Islamabad, vol. 1, no. 3, pp. 55, 59, 71, 75; no. 4, pp. 22, 48, 61, 63.
Bashir-ul-Momenat
 1990 Peshawar, vol. 1, no. 5, p. 2.
BEATTIE, Hugh
 1984 "Effects of the Saur Revolution in the Nahrin Area of Northern Afghanistan", in *Revolutions and Rebellions in Afghanistan: 1978-1981*, eds. N. Shahrani and R. Canfield, Berkeley: University of California Press.
BOESEN, Inger W.
 1988 "What Happens to Honor in Exile?", in *The Tragedy of Afghanistan*, eds. B. Huldt and E. Jansson, London: Croom Helm.
BRADSHER, Henry S.
 1985 *Afghanistan and the Soviet Union*, Durham: Duke University Press.
CHRISTENSEN, Hanne
 1983 *Sustaining Afghan Refugees in Pakistan*, Geneva: United Nations Research Institute for Social Development.
CONNOR, Kerry M.
 1989 *Development Potential for Aid Projects Targeting Afghan Women*, Peshawar: Swedish Committee for Afghanistan.
DOUBLEDAY, Veronica
 1988 *Three Women of Herat*, London: Jonathan Cape.
DUPREE, Louis
 1959 "The Burqa Comes Off", *American Universities Field Staff Reports*, III, No. 2.
 1971 "A Note on Afghanistan: 1971", *American Universities Field Staff Reports*, vol. 15, no. 2.
 1980 *Afghanistan*, Princeton: Princeton University Press.
DUPREE, Nancy Hatch
 1984 "Revolutionary Rhetoric and Afghan Women", in *Revolutions and Rebellions in Afghanistan: 1978-1981*, eds. N. Sharani and R. Canfield, Berkeley: University of California Press.
 1987 "The Demography of Afghan Refugees in Pakistan", in *Soviet-American Relations with Pakistan, Iran and Afghanistan*, ed. H. Malik, New York: St. Martin's Press.
 1988a "The Afghan Refugee Family Abroad", *Afghanistan Studies Journal*, vol. I, no. 1, pp. 29-47.
 1988b "Afghan Refugee Women in Pakistan: The Psychocultural Dimension", *WUFA* (Writers Union of Free Afghanistan), Peshawar, vol. 3, no. 1, pp. 34-45.
 1989a *Seclusion or Service: Will Women Have a Role in the Future of Afghanistan*, Occasional Paper No. 29, New York: The Afghanistan Forum.
 1989b *Women in Afghanistan: A Preliminary Needs Assessment*, Occasional Paper No. 9, New York: United Nations Development Fund for Women.
FORMAN, Sophy and Catherine LIDWILL
 1989 *The Training of Female Health Workers in Afghan Refugee Villages in N.W.F.P., Pakistan*, Peshawar: Save-the-Children Fund (U.K.).
GIRADET, Edward
 1985 *Afghanistan: The Soviet War*, London: Croom Helm.

International Rescue Committee
 1990 *IRC Women's Program Workshop*, Peshawar: mss. report.
KNABE, Erika
 1977 "Women in the Social Stratification of Afghanistan", in *Commoners, Climbers and Notables*, ed. C.A.O. von Niewenhuijze, Leiden: E.J. Brill.
MAUDUDI, Abdul A'La
 1986 *Purdah and the Status of Women in Islam*, 1st. ed. 1972, Lahore: Islamic Publications.
RAHIMI, Fahima
 1986 *Women in Afghanistan*, Liestal: Stiftung Bibliotheca Afghanica.
SHALINSKY, Audrey
 1989 "Women's Relationships in Traditional Northern Afghanistan", *Central Asian Survey*, vol. 8, no. 1.
STEWART, Rhea Talley
 1973 *Fire in Afghanistan*, New York: Doubleday.
TAPPER, Nancy
 1980 "Matrons and Mistresses: Women and Boundaries in Two Middle Eastern Tribal Societies", *European Journal of Society*, vol. 21, pp. 59-78.
 1984 "Causes and Consequences of the Abolition of Brideprice in Afghanistan", in *Revolutions and Rebellions in Afghanistan: 1978-1981*, eds. N. Shahrani and R. Canfield, Berkeley: University of California.

Palestinian Women in View of Gender and Development

ABSTRACT

Can women's involvement in a national struggle lead to a transformation in gender rela-
tions? This study examines women's role in the Intifada to answer this question. Even before
the establishment of Israel, Palestinian women were active in organizing against Zionism.
Today their role begins increasingly to challenge their traditional place in society.

Introduction

DURING THE 1980s, awareness about women's role in development,
particularly in Third World countries, has increased significantly. A new
feminist analysis has emerged taking into consideration women's conditions in
a Third World context, whereby class and sex oppression intermingle and
shape women's daily life. A new emphasis is put on gender relations and the
necessity to empower women so they can become full agents in the process of
development within their own society, along with men. Little understanding
and support, however, has developed so far around women living under cir-
cumstances of war, foreign occupation, and repression by military forces.

What do development and empowerment mean in the context of national
struggle and fighting against repressive regimes? Can a feminist analysis apply
to these realities? How does women's involvement in a national struggle lead
to a transformation in gender relations? In the case of Palestinian women, to
what extent do they participate in the development of their society? What is
the weight of traditions facing them? Will Palestinian women benefit in the
long run from the new role that the recent Uprising in the Occupied Ter-
ritories has urged them to play? These are some of the questions we would like
to address in this short essay.

Cultural Bias

It is rather astounding to realise the amount of misconceptions surround-
ing Arab societies and Arab women in particular, in the eyes of many Western
intellectuals. Edward Said,[1] a well-known Palestinian author, has revealed

* 135 Rue Prieur West, Montreal, Quebec, Canada H3L 1R3

with great art the powerful misconception and cultural stereotyping that permeates the view that Western scholars have taken for centuries on Arab and Islamic societies, a concept he refers to as «Orientalism», which is intimately linked to political imperialism.

The political, economic and ideological support given by the West to the creation and then the reinforcement of the State of Israel on the land of Palestine has long acted like a wall in hiding the Palestinian reality from the rest of the world. Luckily, like the Berlin wall, it is beginning to crumble stone after stone at the hands of the Intifada, unveiling to Western consciousness the great injustices and suffering imposed for decades by the occupation forces, thus drawing increased sympathy towards the Palestinians.

Cultural bias, however, is not limited to Arabs and it is necessary to remember that if we have a genuine interest in understanding any different reality, we ought to be ready to challenge our own criteria of analysis. To illustrate this basic assertion, let's take the female participation rate in the work force, which is often considered as a good indication of the degree of women's emancipation in a given society. In fact, we can be greatly misled if we uncritically apply this criterion to traditional or weakly industrialized societies where the majority of people, and particularly women, work in the informal sector often ignored by official statistics. This is but one example and one can find many others.

Women's Historical Political Participation

Even if we are mainly concerned with the present and the future, taking a glimpse at history allows us to better evaluate the distance covered when looking at women's role in any society. It is necessary to remember that women have always taken an essential part in political struggles, in spite of the limitations imposed on them by their cultures and traditions. Palestinian women are no exception. In fact, they have often resorted to astute strategies in order to get around the social obstacles standing in their way. Historians having largely neglected to register women's role; we are often left with mere fragments hinting at the whole truth.

If the current Uprising, which sparked off in December 1987 and continues until now in the Occupied Territories, sheds new light on the feminization of the Palestinian struggle and the new role undertaken by women, it is safe to assert that the history of their involvement in the national struggle is as old as the Palestinian struggle itself.

Women's spontaneous participation in the national struggle

Starting in 1917 with the Balfour Declaration, by which the British rulers agreed to the creation of a Jewish Homeland in Palestine to the detriment of the Palestinian population, the majority of whom were poor and uneducated peasants, women appeared as a part of the Palestinian national movement. Braving social stigma which traditionally considered it inappropriate for women to invade the public sphere, Palestinian women nevertheless took an

active part in public demonstrations, sit-ins, and even participated in official delegations meeting the British High Commissioner, and later in delegations meeting with international bodies, in order to express their plea concerning the threat of massive immigration of European Jews to their country coupled with the eviction of Palestinian peasants from their land.

Later on, Palestinian women also took part in the general popular uprisings of 1929 and 1936, which flared up in the whole region, and were brutally crushed by the British rulers. In May 1936, 600 Palestinian female school students had gathered in Jerusalem in order to support the popular demands and decided on a general students' strike which was followed in every city and village of Palestine. Women could be seen everywhere giving public speeches in order to incite support for the popular demands. It was, for example, Palestinian women who initiated a popular boycott of British products, which successfully led to the bankruptcy of several British trades.

Thus many examples indicate that women actively participated in the popular movements of the time which led them to face repression at the hands of the occupation forces. In fact Palestinians had to face repression from two sources: on the one hand, British forces directed to the repression of popular uprisings and, on the other hand, increasing violent acts led by armed Zionist groups carrying out vast massacres of unarmed peasant populations comprising women and children.[2] Numerous terrorist attacks were conducted by these underground gangs against Palestinians, destroying their houses, burning their fields and crops and successfully turning hundreds of Palestinian villages into rubble in order to clear the space for Jewish kibbutzim. Palestinian women made a substantial contribution to the national struggle.

Although women's direct participation in the armed struggle was rather limited because of tradition, they achieved numerous courageous acts, hiding combatants and supplying them with arms and ammunition, using astute tricks to overcome checkpoints such as pretending to attend weddings or funerals. Often during curfews imposed on Palestinian villages, women from their balconies would pour boiling water or oil over the heads of British patrols. They also learned to deny their deepest grief when faced with the dead body of their activist husband or son, pretending not to recognize them in order to protect their community from retaliation by the British soldiers.

Another form of resistance in which women typically continue to play an important role is the maintenance of cultural traditions transmitted to the youngest generations through stories, songs, and customary festivities. Although considered more traditional, this takes on significant importance for Palestinians in light of the constant negation of their political and cultural identity. Finally, women's role in maintaining a resistance spirit within their family and the whole community, healing more than physical wounds imposed by the occupation forces, cannot be minimized.

Women organize around charitable work

In light of this dramatic situation, it is often forgotten that women's workload in all strata of society increases tenfold in the middle of social and

political unrest which tremendously complicate the organization of daily life. It is little surprise that during these difficult times, women display various organizational skills in order to replace the formal networks of support which are breaking down. It is interesting to recall the stories of some Palestinian women belonging to rich rural families, recounting this dramatic period whereby they woke up one day to find on their land hundreds upon hundreds of women, children and elderly who had escaped from the ruins of their houses in neighbouring villages and were exhausted from days of walking, for whom they spontaneously organized food and sleeping arrangements, offering first aid and comfort as well.

As in many Western societies, it was mainly women from the educated urban elite who started organizing collectively. They began to systematically organize humanitarian support for families of prisoners and combatants killed, distributing food and clothing, looking after the orphans, visiting prisoners' families and providing moral support and encouragement. Gradually Women Associations began to sprout everywhere in cities and villages. The funding of these voluntary associations came through fundraising among the population itself, during marriages, anniversaries and other festivities, but soon a new popular source of funding was introduced linked to popular education, whereby money was collected during presentations of small theatre plays with a historical and educational content.

In 1921, the Arab Palestinian Women's Union was founded in Jerusalem, with the purpose of unifying the scattered efforts of social and political struggles. It was quite an achievement when, in 1929, the Women's Union held its first congress in Jerusalem, gathering 300 delegates from all over the country. On the agenda were items concerning social work and support for the national struggle.

The declaration of the State of Israel in 1948 created thousands of homeless Palestinian refugees, thus further tearing apart the social fabric of Palestinian society. Palestinians expelled by force and terror from their homeland, in what became the pre-1967 border of Israel, created the phenomenon of camp dwellers. Thousands of homeless Palestinians fled to the West Bank and Gaza (presently the Occupied Territories), while thousands of others found refuge in adjacent countries such as Jordan, Lebanon, Syria and Egypt. Subsequent attacks, and particularly the 1967 war, created new waves of refugees, sometimes for the second or third time in their life, and hence increasing the number of camp dwellers. Stories of Palestinian women peasants who were driven out of their country highlight the trauma of changing overnight from a status of proud and independent peasant, to that of a homeless refugee in a hostile world where one is considered threatening or undesirable.

Social work is political under the circumstances

It is then understandable that in the middle of the Palestinian tragedy, women began to get involved mainly in social charitable work meant to

alleviate human sufferings. In response to new and pressing needs, many Women's Associations at the time focused their efforts on the camp dwellers. Sixty-eight charitable Women's Associations were created between 1948 and 1967, in order to respond to the population's needs mainly centered around health, education, security and work. Their activities ranged from the setting up of nurseries, schools and literacy classes for women, opening clinics and hospitals, dispensing informal education about health, nutrition, first aid and child care, to providing technical training to develop working skills, teaching Palestinian embroidery as part of preserving their cultural heritage, and also managing security problems and crises due to the regular Israeli bombing on the camps, as well as running orphanages for the numerous war victims who happened to be children.

Although geared around social and charitable work, it is often forgotten that these Womens's Associations set an example of self-help. In fact, they represented a genuine effort by the population to organize around community work, thus contributing to providing Palestinians with some sense of autonomy instead of remaining totally dependent on international charitable organizations. As mentioned by many women activists, even social work is political under the circumstances.

The creation of the Palestinian Liberation Organization (1965) and the National Council, which became the equivalent of a government in exile, greatly contributed to the enhancement of the sense of autonomy and pride among Palestinians. The General Union of Palestinian Women (GUPW) was founded by women activists living in exile, as part of the PLO structure. The GUPW gathered all charitable associations working in exile, pursuing the charitable work but adding a new emphasis on raising political awareness among women in support of the national struggle. Military training was extended to young girls as well as boys, essentially to defend the security of camp dwellers.

Diversification of women's political and social action

Since 1967, it can be said that Palestinian women both inside and in exile began to play a much more visible political role, getting involved in a wider span of popular organizations which emerged everywhere. Many women became very active within the students' movement, the workers' unions, the teacher's union, the artist's union, while many others mobilised within the Arab nationalist movement and the political parties.

It must be remembered that involvement in these popular organizations meant facing repression. In the Occupied Territories, the Israeli military authorities systematically used repression and harassment against voluntary workers in Women's Associations as well as other popular organizations, the majority of whom were often women, regularly closing down their offices, smashing their equipment and files, confiscating books and publications, forbidding them from receiving any funds from neighboring countries, imprisoning their leaders, threatening and intimidating their families. Today, we can

observe a new generation of Palestinian women who fill up Israeli prisons because of their active involvement in the popular Uprising.

Women's Present Role in Development

When talking about development, one normally thinks in terms of programs pertaining to education, health, agriculture, and trade, all meant to respond to the population's needs through a democratic process enhancing autonomy. If this is already a difficult process in a Third World context of poverty, it becomes a tenfold greater challenge in a situation like the one facing the Palestinians, in the absence of political autonomy and in the face of gross violations of their human rights. Israeli policy is admittedly aimed at hindering any development favoring the Palestinians, in order to push them toward leaving their own country. Needless to say this is precisely the situation which paved the way to the recent popular Uprising in the Occupied Territories.

Emergence of the Popular Movement

During the decade preceding the Intifada, a large number of grassroots popular committees bloomed in the Occupied Territories, parallel to the more traditional institution-type organizations. These are referred to as the popular movement, which is characterized by a much wider base and a decentralized functioning at the village level. This movement stemmed from the deep desire of the younger generation to take their destiny into their hands and have a greater share in the development of their society, in spite of the hostile political contingency. It has effectively succeeded in establishing a link between the educated youth and the rest of the population. Although not the initiators of the Uprising, they have clearly succeeded in gaining increased importance as a mobilizing force. Since the Intifada, neighborhood committees have been created in addition to the previous popular committees, in order to respond to the special needs of the Uprising.

Trained by the student movement which has been politically very active within Palestinian universities, young professionals, both men and women, founded grassroots committttees in every city and village in order to respond to the needs of the population. Health professionals founded grassroots health committees, which were badly needed since the population's needs in this area were far from being adequately met by the existing institutions due to budget restrictions and permit limitations imposed by the Israeli authorities. Other youth formed grassroots agricultural committees in order to support and encourage Palestinian food production which had been jeopardized by Israeli policies of land expropriation and limitations on the use of water, as well as the numerous restrictions imposed on Palestinian exports.

Young educated and politicised women formed new women's committees which began by focusing on improving work conditions for women working in factories. Their program soon included literacy classes, health education, kindergartens and small scale production training, which spread to every town

and village gaining wide popularity among the poor and working classes. Women's committees also began to raise issues concerning women's status in society calling for more active participation of women at all levels.

Women's committees and other popular committees soon crystallized along the four main political streams present within the Palestinian society. One year after the beginning of the Intifada, in December 1988, the Higher Women's Council was set up to ensure better coordination among the Four Women's committees.

Transformations in women's position

As underlined by some authors,[3] the Uprising has brought about a kind of gender and generation revolution, in which traditional hierarchies (such as authority of the older over the young, and men over women) are being challenged by new hierarchies. This naturally generates certain tensions, so women came to realize that their greater involvement in development work outside the family could not be achieved without collective efforts aimed at overcoming internal resistance to change. Women's committees reportedly have started to play an active role in encouraging mentality changes concerning the acceptance of women's involvement at all levels.[4] The social pressing needs, coupled with the examples set by highly respected women activists, have certainly acted as a leverage to overcome traditional objections, so that today many families tend to be proud of their daughters' political activism.

Even among the poor rural population, where traditions normally have a stronger hold, women's role has been extended to encompass their community not just their family. Their activities now include confronting the army entering a village, defending the youths in the street against beatings and arrests by Israeli soldiers, visiting families and attending funerals of victims of repression which has clearly connotations of popular demonstrations, and smuggling food into camps and quarters under curfew. For those who realize the weight of tradition in rural areas, these new activities represent quite an achievement.

Another social implication of the Uprising in which women have played an important role has been the creation of alternative teaching courses, in order to overcome the serious drawbacks imposed by the closing of schools and universities by the military authorities for long periods of time. This implied small group teaching in houses as well as the creation of specially adapted curriculum and pedagogical tools.

Consciousness about the necessity to develop Palestinian autonomy in relation to the Israeli economy has deepened since the Uprising. Hence, in accordance with the strategy adopted by the Unified National Leadership of the Intifada,[5] the Women's Committees have initiated and supported a number of economic projects involving small-scale, local food production (such as community gardening, food storage, and preparing jams and pickles) while at the same time strongly promoting the consumption of Palestinian products among the population, in order to reinforce self-sufficiency. These local initiatives have gained wide popular support and women who have been

encouraged to start food cooperatives find it an encouraging way of supporting their own family. Many of them have gained a new feeling of pride and self-affirmation through this simple experience.

The general confidence women have gained due to their greater social implication in the last few years is also translated by the fact that they more readily step in to replace men leaders, who are imprisoned in large numbers since the Intifada, thus chairing meetings, making important decisions, and even guarding the neighborhood at night.

Women's Empowerment

The Intifada's psychological effect of empowerment on the Palestinians and on women in particular can best be understood if we recall Frantz Fanon's notion of violence, whereby in writing about the Algerian revolution, he proposes that "the act of violence against the source of oppression should be measured not by the degree of damage inflicted upon the oppressor, but by the degree to which this act empowers the victim of oppression."[6]

Resistance facing repression

To any outside observer the degree of fearlessness and bold resistance manifested, particularly since the Intifada, by Palestinian women young and old, in the face of brutal beatings, arrests and harrassments by the Israeli military forces is astonishing. This is probably best captured in a photograph taken by a journalist during the first weeks of the Intifada, wherein a 50-year-old Palestinian woman is courageously voicing her anger and raising her umbrella, albeit in an illusory act of defense, in front of a young Israeli soldier threatening her with his sophisticated rifle.

Many stories give accounts of the tenacious resistance by women who commonly use kicking, biting, cursing and shouting against Israeli soldiers, in order to protect their family members from arrest and beatings. As reported by Sahar Khalifeh's portrait of Umm Samih, a 42-year-old mother, "Women can take it better than men, she tells her husband, before explaining why she can better confront the soldiers who will beat her while she orders him to the kitchen."[7]

New responsibilities and leadership roles

When we try to analyse the changes which have occurred in gender relations within Palestinian society during recent history, it is interesting to note that unlike in the West, they did not stem from a direct confrontation with patriarchy, yet the challenges to old sex roles and models are numerous and imposed daily by the reality of military repression and the national struggle. For instance, we find little direct questioning of the male's authority as family head and protector, yet the reality of arbitrary detentions, imprisonments, deportations and killings which affects a large number of males actually drives

more and more women into stepping in to take the leadership within their family and community in general.

Numerous examples[8] can be found today of well-educated women political activists who are often the first ones among the members of their families and their communities to mobilize and contact lawyers, media or human rights organizations in response to the dynamiting of houses, the imprisonment of family members, or to denounce the forced deportation of community members. Their initiatives and resourcefulness make them indispensable in times of crisis, thus giving them considerable power within their own communities and gradually forcing admiration and acceptance for non-traditional roles for women.

Division of labour

As women assume new responsibilities and leadership roles at the community level, there no doubt is an effect on the division of labour in the domestic sphere. As one older Palestinian woman activist once said, "I tell my husband and sons, yes, it is your right to have a clean shirt and a warm meal, but I cannot be responsible for everything in this house; more urgent responsibilities await me in the community." In fact, this topic has not been investigated, but many young men are seen taking on new domestic responsibilities although admittedly this is not yet very common. It is clear that the urgency of the national struggle imposes new behaviors in gender relations; whether or not these will last beyond this critical period remains to be seen.

Increased freedom of movement

Similarly, there is no observable confrontation around sexual freedom, or the need to control one's own body in terms of contraception, abortion and health in general, such as we have witnessed in the West. Yet challenges to the traditional limitations on women's movement deriving from the concept of "family honor", familiar to all Arab societies, are not uncommon and women's committees are increasingly paying attention to health education and the improvement of health services badly needed by women

In fact, the concept of "honor" itself is being challenged in the Palestinian society, due to the use of this concept against Palestinians by the occupying forces through the use of rape and sexual harassment against women in order to obtain forceful confessions from family members, or attempts to discredit women activists by spreading false rumors concerning their sexual morals, all purposefully meant to bring shame on the family, break resistance spirit and discourage women's increasing participation in the struggle. Women's committees often address this sensitive issue while visiting families of women prisoners and begin breaking the taboos surrounding sexual aggression.

The controversial battle of demography

Even challenges concerning the popular belief that a large number of children is preferable in order to reinforce the national struggle are being voiced. This however is a controversial subject in the context. First, there are cultural traditions according to which motherhood is sanctified and; mothers are deeply valued by society and children are considered a source of pride and protection. On the other hand, with the reality of violence and repression imposed by the authorities which cause a large number of deaths and casualties the feeling that large families are preferable is reinforced. For example, even mothers of numerous children often find themselves with only one or no child beside them as a source of protection in their old age. It is then understandable that the issue of family planning does not gain wide popularity, particularly when Israeli sources tend to consider high fertility rates within the Palestinian population as a danger to their plans. Nevertheless, contraceptives are made available and are used by many young Palestinian women. Statistics, however, are not available to indicate whether or not women's increased activism has caused a decline in fertility.

Increased chances of education

On another ground, education proves to be an important tool for empowerment; this is why Palestinians put a large emphasis on education for both sexes, which has greatly benefitted girls and women. It is generally admitted that Palestinians have the highest proportion of university graduates compared to other Arab countries. Women's Unions have managed to make sure that women are not forgotten when scholarships are offered to allow young Palestinian camp dwellers to complete their studies abroad. Hence, today it is rather common to find highly articulate and educated Palestinian women, often stemming from a modest background, rising to the status of community leaders. The increasing number of women artists, authors and poets participating in the cultural development of their society also accounts for this change.

Economic participation

As far as emancipation through economic work is concerned, we find that Palestinian women (and men) become increasingly reluctant to take on salaried jobs within Israeli enterprises, such as construction work, factory work, services and other low paid jobs available to them. The employment rate for both sexes has declined since the Intifada and unemployment has become a serious problem. Since few Palestinian enterprises have been allowed to grow, many women have been encouraged to remain in the informal sector or contribute to support small family enterprises. Given this context, salaried work has hardly been considered as a source of emancipation for them. As was mentioned earlier, since the emergence of the popular movement, women have been successfully mobilized in small production projects in order to enhance

Palestinian autonomy from the Israeli economy. So, as we can see, in this context, women's participation rate in the work force would not be very relevant as an index of emancipation.

Future Prospects for Gender Liberation

Looking back at the significant transformations in society and in women's role in particular, we can better realise how Palestinian women have successfully come a long way since the beginning of the century, largely contradicting the stereotyped image of Arab women as obedient and submissive mothers and wives, shut out of any visible social and political activity.

Many of the recent transformations occurring in Palestinian society could be described as "feminist". The fact that these changes do not proceed through typical Western models should not come as a surprise. One has to recognize that it is harder for a society to challenge directly deep aspects of its tradition when it is put on the defensive because of brutal and powerful threats to its own identity.

Finally, as we can see from the preceding description concerning the evolution of Palestinian women's political and social involvement over time, we can distinguish three stages which in fact overlap and can be seen as cumulative steps:

First, we see that women trespass their traditional role when they mobilize in support of the national struggle, spontaneously joining in popular demonstrations and undertaking various resistance actions and courageously facing repression. At a second stage, we find women starting to organize around charitable work in response to new and urgent needs generated by repression and cruel negation of their rights as a people. This is generally seen as a mere extension of their traditional role, from nurturing the family to nurturing the community. However, a new leadership role is undertaken at this stage by some women who must assume their responsibility at organizational levels. At a third stage, we notice deepened political consciousness among women, coupled with an increased educational level, and their participation in large numbers within the popular movement. At this stage, they have effectively diversified their social involvement at the organizational level, while at the same time increasingly assuming leadership roles in all domains, including many non-traditional ones.

In fact, women's empowerment can be found at every one of these stages, although it is significantly greater at the third stage. It is worth clarifying that the concept of "empowerment" here does not necessarily refer to the improvement of women's living conditions, which can in fact be worsened by the increased repression facing them at the hands of the occupation forces, due to their greater involvement in the national struggle.

If we try to evaluate the degree of empowerment Palestinian women have achieved, we realize that it cannot be measured by some criteria. For instance, it cannot solely be measured by the number of women who have risen to positions of leadership, whether in traditional or non-traditional domains, nor by

the degree of acceptance of these new roles by men. The empowerment of Palestinian women comes from their ability to seize every opportunity to gain a greater *freedom to act* in order to change the conditions of their oppression and to develop their *ability to overcome obstacles* still standing in their way.

However, if we think in terms of durability, we can ask what are the chances of maintaining in the future the present trend, whereby women would succesfully continue to push back the limits to their full and equal participation in the development of their society? Although it appears that the national struggle has created the conditions for women to achieve fuller participation in social and political life, Palestinian women themselves have repeatedly stressed the fact that they must fight oppression at three levels: sex oppression, class oppression and national oppression. The three are inseparable just as development, political autonomy and democracy are.

The end of the road to national and gender liberation for Palestinian women is far from certain. In fact strong contradictions remain, as can be seen most clearly in the Gaza Strip where, particularly since the Uprising, the Islamic movement which had a stronger hold in this area has unfortunately succeeded in making political gains by appealing to the reinforcement of "traditions" as a form of resistance and imposing new limitations on women's freedom.[9] Although it is generally admitted that in transitional periods it is normal to observe the most contradictory co-existence of old models side by side with new ones, a conscious political promotion of new trends is needed to impart firmly a general motion towards more liberating models.

Based on other experiences in the region, one can argue that religious obscurantism, which will represent a drawback to women and a threat to democratic forces, will probably have a much greater hold on people if economic development in the area continues to be hindered. However, in the Palestinian context, political autonomy clearly appears as a prerequisite to any economic development favoring the Palestinians. Moreover, the reinforcement of democratic social models within Palestinian society, which would be more likely under promising economic conditions for the majority, is the only way to guarantee women's rights in the future. In fact, we must realize that women's condition, wherever they are, is ultimately political and determined by domination and power relations prevalent in their society. The political outcome for Palestinian society remains rather uncertain at the moment.

Today, it is the feeling of many prominent Palestinian women that the need for a feminist agenda explicitly addressing women's status in society (legally, economically, politically and socially) is imperative and should not be postponed until independence. A serious discussion is needed within the various political groups on how to improve women's status in a future independent state. A place should be made to openly challenge certain behaviors and make constructive self-criticism.

Progressive forces within Palestinian society should actively contribute to this process, instead of shying away and considering the issue as menial or unworthy of discussion in the heat of tha national struggle. In fact, as some people fear, the very existence of the most progressive groups within a future

independent Palestinian state might well be at stake, since the issue of women's freedom in society is ultimately linked to democracy, freedom of speech, respect for independent thinking and the acceptance of positive innovations in development which will break away from old patriarchal models.

NOTES

1 Edward Said, *Orientalism*. Vintage Books Edition, 1979.
2 It would be too long to recount all the massacres against Palestinians since the beginning of the struggle. As an example, one can mention the Deir Yassin massacre in April 1948, during which all the inhabitants of this village were cold-bloodedly killed (a total of 252 Palestinians, of whom 137 were women) by an underground terrorist gang named the Irgun, led by Menachem Begin who later became Prime Minister of the State of Israel.
3 Rita Giacaman and Penny Johnson, "Building Barricades and Breaking Barriers: Palestinian Women in Politics in the Occupied Territories". In *Intifada: The Palestinian Uprising Against Israeli Occupation*, ed. Zachary Lockman and Joel Beinin. Boston: South End Press, 1989. Pp. 155-169. December 1988.
4 Joost R. Hilterman, "Sustaining Movement, Creating Space: Trade Unions and Women's Committees". In *Middle East Report (MERIP)*, Nos. 164-165, May-August, 1990. Pp. 32-60.
5 The Unified National Leadership of the Intifada includes the main political streams present in the Palestinian society; it has been set up since the Uprising in order to unify popular actions (strikes, boycotts, and demonstrations).
6 As underlined by Suha Sabbagh, in her article: "Palestinian Women Writers and the Intifida". In *Social Text: Theory/Culture, Ideology*, No. 22, 1989.
7 Sahar Khalifeh, "Our Fate, Our House". In *Middle East Report (MERIP)*, Nos. 164-165, May-August 1990. Pp. 30-31.
8 Rita Giacaman and Penny Johnson, *op. cit.*
9 Rema Hammami, "Women, the Hijab and the Intifada". In *MERIP, op. cit.* Pp. 24-28.

The Politics of Gender and Development in the Islamic Republic of Iran

ELIZ SANASARIAN *

ABSTRACT

The present study asks what role the state has played in maintaining or transforming gender relations in revolutionary Iran. State officials have granted men more power over women while increasing their own power over men; state policies have tried to promote particular roles for women; and the state has directed discourse so as to define women as inferior. Some Iranian women activists have turned the arguments against them into arguments for equality.

In AN HISTORICAL IRONY, a portion of the United Nations Decade for Women (1975-1985) coincided with the Iranian Revolution and the founding of the Islamic Republic (1979). The revolutionary regime immediately abrogated the Pahlavi government's commitment to host the 1980 UN World Conference on Women in Tehran; the conference was subsequently held in Copenhagen. In contrast to its predecessor which pretended reverence to the international community, the Islamic regime, consumed with a defiant spirit, could not care less about its political image. Women and development issues, similar to other polity spheres, succumbed to an overall agenda of Islamization.

As a consequence, while the UN Decade stimulated research on women throughout the Third and Fourth World countries, Iran suffered a grave void. The intelligence network of Mohammad Reza Shah's regime had closely watched over every subject of research, including research on women. Therefore, in terms of volume as well as quality, published studies which involved women, both inside and outside the country, were scarce. The immediate effect of the revolution, minor still compared to other Middle Eastern and North African countries, was a handful of publications in the West.[1] Those studies that addressed the condition of women under the new regime were colored by two tendencies. Western cultural anthropologists who had conducted limited case studies based on a small village or an urban lower class locality represented one tendency. They embraced what they saw to be the cause of the oppressed lower

* Department of Political Science, University of Southern California, Los Angeles, CA 90089-0044, U.S.A.

classes as opposed to the Westernized upper classes. This group felt compelled to defend the revolutionary regime against the Western media accounts of female oppression. To them, the new regime represented the downtrodden men and women in Iranian society; the lines between class and culture were blurred. They confused the rhetoric of the revolutionary elite with the actual act of abusing women. They simplified a complex discourse by adopting a problematic tier along Western/Non-Western analogy.[2]

The second tendency originated from those women who were active in the Iranian left movement. Disenchanted with the male left positions on women's rights after the revolution, this group directed its attacks on the left for its chauvinism, the Islamists for their fanaticism, and on the West for its imperialism.[3] Frustration, anger, and abandonment were the natural baggage inherited by this group. They represented, however, a more genuine nativistic expression of the course of events, itself worthy of future investigation.

All the above contributed to a slow pace of growth in scholarship on women and development. In assessing women and development in over ten years of the Islamic Republican Government, this investigation adopts a statist orientation. This perspective views the state as a powerful and significant force in shaping women's lives. It also perceives development and state as inseparable units of analysis with respect to women. Despite a wealth of literature on the state in social sciences, the genesis for the present study is a unique volume on women and development edited by three political scientists.[4] This collection avoids a reductionist approach where politics is solely explained by economic or social factors. Instead, the authors demonstrate that the dynamics of state-gender relations remain extremely complex. Utilizing diverse countries and regions—India, the Soviet Union, Europe, Africa, Latin America—the editors propose a conceptual scheme for understanding the relationship between states and women. State impact on gender relations is the product of three interrelated levels of activity: state officials and their strategies, state policies and institutions, and state definition of policies. State "imposition" and "expansion" at every level of interaction may evoke a multitude of responses from women.

> State leaders opportunistically draw upn existing patterns of gender inequality found in most societies, but in some cases the degree of female subordination interferes with state development goals and is ameliorated by state leaders... Thus public policies may reflect both of these contradictory tendencies—a major tendency promoting gender inequality and a minor tendency promoting gender equality. Policies may also have unintended consequences affecting gender relations.[5]

The unique features of this conceptual scheme are: (1) attempting a merger of state, feminist, and development theories, (2) allowing for flexibility as well as fluidity in policy and ideology, and (3) permitting a myriad of responses from women without locking them structurally and conceptually into the borders of a women's rights movement.

In applying this scheme to the Islamic Republic of Iran, one point of contention remains, namely the revolutionary nature of the new regime. More comparative studies are needed to show how such regimes deal with women

as opposed to non-revolutionary established regimes. In the latter, the processes of public policy and bureaucratic functions are already routnized. The editors of the above-mentioned volume suspect that such regimes are no different in their subordination of women's interests to other state goals.[6]

The present study asks, what role has the state played in maintaining or transforming gender relations in Iran? How have women responded to the "imposition" and/or "expansion" of the state? And, where possible, what have been the consequences of women's response to the state?

State Elites and Their Strategies

The political elite in Iran have gone through several transformations since the revolution. By 1982, most of the earlier group were replaced by individuals who still dominate the political scene. Individuals such as Prime Minister Mehdi Bazargan and President Bani Sadr, despite being termed as politically liberal or moderate, were neither when it came to gender policy. In fact, most of the restrictive measures against women were launched during the first three years. They included profound changes in family laws to the clear disadvantage of women, forced hejab, and restrictions on women's choices of work.[7]

Why did the new elite, despite severe conflicts and power struggle, express such unanimity on issues involving gender relations? How could men of varied educational and political persuasions from Marxist to right-wing religious fundamentalist agree on this? Charlton, Everett, and Staudt, using empirical studies of Europe and colonial Africa, conclude:

> State elites have discovered that promoting male domination contributes to the maintenance of social order in a period of state formation...A common solution involves offering a bargain to (some) men: in return for ceding control over political power and social resources to the state, they gain increased control over their families. Not only does this solution promote male domination, but it also establishes or strengthens a distinction between public and private spheres, and subordinates the private sphere to the public.[8]

It is important here to note that loss of control is not confined to the objective reality of a situation but simply to one's own perception of that reality. Therefore, the publicness of women throughout the 1960s and 1970s was perceived as tantamount to the powerlessness of the male gender although, objectively, the patriarchal nature of the policy and polity had remained unchanged.

At the top of the elite was Ayatollah Ruhollah Khomeini whose hands-off style of leadership provided ample ground for growth of various centers of power. He often stepped in, sometimes at the height of a crisis, to set straight the course of public policy. A case in point was his strong endorsement of women's voluntary military service, which halted public criticism in some quarters. The timing of the decree, March 2, 1986, had both symbolic and practical significance. It was Islamic women's day in Iran (the birthday of Fatemeh, the daughter of Prophet Muhammad) and the birthday of Ayatollah Khomeini. It was a very troubled time in the Iran-Iraq War and there was a desperate need for assistance at the front. Women were asked to prepare for

collective mobilization, to go to the war front, and to serve behind the lines. Women were already serving in the Basij (the Mobilization Army); after receiving ideological, political, and military training they were dispatched to serve in an internal security capacity in banks and various ministries. However, Khomeini's public endorsement prompted acceleration of training and by the end of the year 2000 women were reportedly dispatched to the war front.[9] It also gave the women's press a forum in which to criticize the officials. They wrote that despite Muslim women's readiness and willingness, their rightful place at the war front was denied, and they demanded more extensive female participation.[10] The issue also received attention in a lengthy speech by a female deputy in the Islamic Assembly.[11]

The basic premise of the top elite has been that childbearing is the main duty of women bestowed upon them by nature and endorsed in Islam. This approach is in line with the word and spirit of the 1979 Constitution where women were seen in the context of family.[12] It is on the type and the extent of women's economic and social activities that the top elite have voiced conflicting messages. Several reasons may have contributed to contrasting signals. The Islamic elite have always differed amongst themselves on the nature of female domesticity and the extent of their public participation. In addition, the conflict was partly prompted by need. The genesis of this need was apparent from the start. Although Ayatollah Khomeini had opposed women's suffrage in the 1960s, in 1979 women's suffrage was strongly endorsed by him. The female supporters provided a large pool of voters for the pro-Islamic forces. Also, throughout the operations of the Islamic Assembly, there have always been a small minority of male deputies who have spoken in defense of some aspect of women's legal rights. Some top male elites, often through marriage to women who had embraced the women's cause were sensitized to gender issues. Mir Hossein Mussavi, the ex-prime minister and the husband of activist Zahra Rahanvard, is an example of the latter group. In an interview with the most visible and vocal women's magazine, he asserted: "If women return to the kitchen, the revolution has been defeated."[13]

Interestingly, some conflicting messages may have been prompted by an unexpected source, women themselves. Individual female officials, the women's press, women's groups, and some female professionals have placed the top elite, whenever possible, on the defensive by employing men's own logic and Islamic religion. Female reporters have conducted unusually aggressive interviews with state leaders and the female audience in prayer meetings has asked the most pointed question on gender differences. For instance, Ayatollah Khamanehi (the ex-president who later replaced Khomeini) in one such interview urged women not to abandon their social responsibilities only because they are mothers and wives.[14] In one of his many comments, President Rafsanjani (ex-Speaker of the House) let it slip that there is no problem in a lifestyle where the female is the professional worker and the male is the househusband.[15]

With the exception of one, in spite of their low number, the female deputies have been unusually vocal on the floor of the Islamic Assembly and

in the national and women's press. During the first Islamic Assembly out of over 200 deputies, four were women. All were from Tehran and three were members of the Islamic Republic Party. The most outspoken of the four and the only one who did not run on the party slate was Azam Taleqani. She enjoyed widespread support partly due to her highly respected father, Ayatollah Taleqani who died shortly after the revolution, and partly because of her own determined and feisty character. Her lengthy and forceful speeches in the Islamic Assembly distinguished her from others. Her tireless rendering of interviews to the Iranian press, especially women's publications, had an immeasurable effect on raising women's consciousness. She opposed forced hejab, discriminatory divorce laws, and literally all legislation that negatively affected women.

During the second Islamic Assembly elections, Taleqani was not reelected; her replacement was a member of the Islamic Republic Party. Nevertheless, she continued her activism and criticism outside the government. She became the head of the Islamic Institute of Women and in an interview shortly before the tenth anniversary of the revolution, Taleqani criticized governmental officials, the Islamic Assembly, and the ulama (clerical leaders) for ignoring the human rights of women. The position of women "instead of moving forward has regressed." She cited cases of maltreatment of blue collar and white collar female workers and condemned polygamy as a practice facilitating the disintegration of the family.[16]

During the second Majlis, four female deputies were again present. Although none were as vocal as Taleqani, three of them took stands favoring some aspect of policies affecting women. For instance, the Majlis added a supplement to the revised legislation on sending students abroad for education; it prohibited females with a Bachelor's or higher degree from leaving the country unless they were married and were accompanied by their husbands. Two female deputies fiercely attacked the supplement on the grounds that it blatantly discriminated against women. One deputy argued that the underlying premise for this supplement is that females sent abroad alone will become corrupted; she asked: "...if boys go abroad, don't they become corrupted?"[17] Despite these protests the measure was approved and submitted to the Council of Guardians for final consideration.

During the third Majlis elections in 1988, the same four women were nominated and three were elected during the first round, this despite the fact that more than 30 women were candidates in the election. Eighteen months later, a recount of the by-elections elevated the fourth female deputy to a seat in the legislature. In 1988, a few months before the elections for the third Majlis were held, one female deputy, with unusual frankness expressed her views about elected office for women: "As long as some male deputies believe that woman must be in the kitchen and be a housewife, it is impossible to raise women's rights issues in the Majlis...We often are asked what women do in the Majlis. I respond by asking what have the men done that the women have not?"[18] Despite their small numbers, the female deputies have encouraged women to take unified action and function as a constituency by sending letters of protest to the Majlis and making demands.[19]

State Policies and Institutions

Comparative studies show that state policies contribute to female subordination. There are, however, some unintended consequences which arise out of the implementation of state policies.

The policy sphere of the Islamic Republic from early on was to impart an Islamic identity for women. This was unilaterally perceived as the first and the most important step in departing from the Westernization and moral corruption of the previous regime. Issues which involved gender relations, such as family laws and sexuality were the primary targets. The parameters of this identity were defined by the new regime through the family, the workforce, the educational system, and a symbolic manufacturing of an ideal Islamic female.[20]

The prolonged war with Iraq (1980-1988) had a crucial impact on every aspect of domestic politics. Iran was not only a revolutionary regime but a country involved in bloody warfare with a neighbor with astounding economic losses and human casualties. Whether one addresses women's role in the family or the workplace, the war impinged upon all spheres of public policy.

Marriage was relentlessly advocated by the state. Various measures were employed. The official marriage age was reduced to 13 for girls and 15 for boys; in practice, girls were married off at an earlier age. Polygamous marriages were encouraged through the media and by the lifting of bureaucratic and legal restrictions on husbands. Sigheh (temporary) marriages were also encouraged.[21] Women's rights to divorce were limited to extreme cases such as a husband's withdrawal of financial support or his disappearance for four years. Custody of children was primarily a male bastion.

There were, at least, two possible goals corresponding to state needs; procreation and reducing the number of unmarried females. As each goal materialzed, it generated unexpected results for the state.

Motherhood was revered and perceived as the natural and main responsibility of women. Similar to nationalist sentiments on procreation in Fascist Italy and Nazi Germany, procreation of Muslims was deemed essential. Higher numbers exuberated strength for Islam. Measures such as a higher share of food coupons, during the war, to families with children encouraged higher birth rates. Birth control opportunities became extremely limited and family planning programs became practically inoperable. Despite the absence of an Islamic stand on birth control, similar to that of the Catholic Church, several of the ulama declared abortion and most forms of birth control unIslamic.

The problems inherent in high birth rates hit the state apparatus in the late 1980s. The Iranian population grew from around 36 million in the 1970s to about 50 million in the 1980s. With an annual population growth rate of 3.7 percent, Iran ranked the highest in the world. The effects of the war, dwindling resources, and a high inflation rate forced the government to reverse its position on population control. The year 1368 (March 1989-March 1990) was declared "the Birth Control Year". The United Nations Fund for Population

Activities (UNFPA) was asked to assist Iran on its birth control projects, and large quantities of birth control devices were purchased. To offset some clerical opposition, the Ministry of Health announced that Ayatollah Khomeini before his death had approved birth control with a few exceptions.[22] Again, the ultimate arbiter, this time *in absentia*, was drawn upon to legitimize the course of policy.

The positive outcome of population control policy will be women's access to birth control; there are, however, some probable drawbacks. Considering the unethical practices of pharmaceutical industries in the Third World, bombarding women with old contraceptive devices is an alarming possibility. The lack of supervision and safety of the purchased products were a problem never seriously tackled under the previous regime. There is evidence that women who used the pill, especially in rural and tribal areas, suffered from varying ailments to the disinterest of doctors and health practitioners.[23]

The high male casualty rate on the war front had left hundreds of thousands of widows, most of them young women, many with children in need of support. These women either had to be employed or to be provided for by relatives or the government. Remarriage was seen as a simple solution to the widows' problem where the burden of financial support was transferred to the husband. However, the underlying socio-psychological reason for marrying off these women was entirely different. It had to do with what a young widow—as opposed to an unmarried girl—represented. Having lost her virginity and experienced some form of sexual contact with a man, the widow was perceived as a sexually awakened woman. This awareness implied sexual availability; availability signified search for sexual partners; the search connoted a lead to prostitution. Uncontrolled female sexuality would cause chaos to the social order of the Islamic polity.[24] The Islamic Republic has a disturbing record on arrest, imprisonment, and execution of prostitutes although there have been some reports of attempts to rehabilitate them.[25]

In urging remarriage, the Islamic officials were prepared to go to any length, including contradicting age-old socio-cultural practices. For instance, in 1984, during one of his Friday prayer meetings, President Rafsanjani criticized young men for their desire to marry virgins despite the availability of hundreds of thousands of young widows. Their practice, he said, was neither Islamic nor logical.[26]

While a national birth control policy was the consequence of stressing motherhood, the high divorce rates were the result of an emphasis on marriage. The 1986 census revealed that 10 percent of marriages were ending up in divorce. Although the data were revealed in the late 1980s, issues of divorce and custody had been debated for years. The target of attack was the government organ responsible for implementing legislation on divorce, the Special Civil Courts. The institution was severely criticized on a number of grounds including expediting a man's request for divorce regardless of the wife's welfare (in one reported case a man had been able to divorce two wives in one day) and on giving the custody of children to the husband regardless of his character and ability for parenthood. Various women's groups, most female

deputies in the Majlis, and the women's press were united on this matter. Two female deputies were so blunt in their attacks against the inefficient and highly biased operations of these courts that the head of the Special Civil Courts was forced to defend his institution in public and in the press.[27]

Years before the census was taken, the women's press had already identified some of the reasons for divorce: sizeable age differences between the spouses, moral corruption and drug addiction of men, male machismo, the meddling of relatives in a couple's life, and polygamy.[28] The issue was deemed so urgent that in 1986 one women's magazine set up a special roundtable and invited professional women and a female deputy to discuss the issue. They prepared a list of suggestions, including the founding of new family courts with female legal and family counselors.[29]

Women not only experienced deficient services by government organs, but they also witnessed the conflict among these institutions in interpreting gender-related legislation. A case in point was the enduring dispute between the Special Civil Courts and the Council of Guardians over polygamy. In 1989, President Rafsanjani, despite his previous stands favoring polygamy, reversed himself. Having more than one wife, he said, was not to the advantage of the husband.[30]

Women and work was another arena affected by the contradictory gender policy of the Islamic regime. One study has shown that compared to the previous regime, the change in the pattern of female employment has been minimal. In 1976, the total employed urban females was 11.2% of the total urban employed population; this number was unchanged in 1983. The largest percentage of employed women was between the ages of 25 and 29 and there was an increase in the educational level of employed women. This was accompanied by an expansion of women in the category of professional, technical, and scientific fields in the public sector. The author of this study outlined some of the important reasons why women were maintained in the modern sector of the economy: the regime's need to continue economic development, the economic needs of women, especially those with prior work experience, the Iran-Iraq war, and the conflicting stands of the political elite.[31]

There is little doubt that on the issue of work, mutual need necessitated a meeting juncture between the state and women. The economic problems and the war forced couples to seek work. Also, by most accounts, there was a substantial increase in single female heads of households compared to 1980 when they stood at 15%.[32] This is of extreme importance since it shows how the burden of objective conditions may have contributed not only to women's thrust into the workforce but also to the voicing of their grievances. The workforce arena has not been free of conflict. Both blue and white collar female workers have complained about forced hejab, the arbitrary application of behavior codes, restrictions on the type of jobs they were allowed to do, and whimsical rules based on the personal preferences of supervisors.[33]

No studies have been conducted on women and employment during the mid-to-late 1980s. It remains to be seen how the end of the war will affect female employment in urban areas. There is a high probability that the blue

collar female workers will be more harmed by the return of soldiers than the skilled white collar female workers.

Education has been another arena of conflict in state-gender relations. Initially, educational opportunities for women were tremendously reduced. Many girls' schools were closed down and a lack of female teachers and resources were cited as reasons for keeping them closed. This problem has been especially acute in ethnic provincial and rural sections of the country.[34] At the university level, female students were not allowed to study fields considered unsuitable to their nature, such as agriculture or geology. Instead, they were encouraged to major in midwifery, nursing, and laboratory sciences which were regarded as better suited to the female nature. Note the presence of public private dichotomy in field selection. While agriculture required exposure to the outside/public arena, laboratory sciences was confining to the inside/private arena of work. Nursing or midwifery placed women in the segregated all female sphere and maintained them in the private arena. Also, note the contradictory essence of policies: women served in the military but were constrained in higher education.

The barrage of criticism from women's groups and the visible female elite has been non-stop throughout the mid-to-late 1980s. As Azam Taleqani once pointedly stated: "Two-thirds of the women of this country live in the rural areas; they perform much of the agricultural labor yet women cannot study the field of agriculture."[35] Such protests might have been the reason why women have been allowed to major in agriculture in the 1990s. The fact remains, however, that at the present time, the regime has a dire need for female instructors in girls' schools and the universities.

State-Defined Political Discourse

Charlton, Everett, and Staudt consider this level of interaction between the state and women to be the most complex and ironically the most crucial. Here the state through its institutions and ideology defines the content of politics. Therefore, "the collectivity of norms, laws, ideologies, and patterns of action...shape the meaning of politics and the nature of political discourse."[36] The ideas behind certain measures have already been discussed; here the focus is the combined effect of the overall meaning of state-gender political discourse.

Through an ideology, defined as Islamization, the state imposed a sharply segregated system. Segregation was concomitant with the private/public division which was simply the extension of biological differences between women and men. Gender distinctions were reiterated with rigor and meticulous detail, including public discussion of the physical and psychological characteristics such as the size of the brain and mood differences between women and men.[37]

The 1979 Islamic Constitution had placed the female gender in the domestic sphere of family. But it had also guaranteed the protection of mothers, special insurance for widowed, aged and destitute women, and in some cases even the custody of children. By the mid-1980s it was clear that

government institutions had failed in protecting the women's role in the family. Meanwhile, in an unexpected twist, the segregated political discourse impinged upon female state officials, women's groups, and woman-run presses to address women's problems. They were apt to observe, experience, and question the state.

If motherhood, domesticity, and family were of prime importance in Islam, then why were women treated unfairly in the courts? Why were men given carte blanche in family matters of marriage, divorce, custody, and polygamy? There was no doubt that not only the rights of wives and mothers were not being protected by the state but worse, the Islamic rights of women were being openly violated. In addressing the plight of a mother who unhappy with her life had attempted murder of her children and suicide, an editorial entitled, ''Condemn yourselves, not that mother'' attacked the legal and social system in defense of motherhood. Her attempt to kill her daughters, the article maintained, was an act of benevolence to free the girls from the pains that awaited them in an oppressive structure.[38]

Political discourse in the Islamic Republic, while emphasizing the private/public distinction, encouraged women to perform tasks which by content and definition required crossing over to the public domain albeit with restraint. The Islamic Constitution had guaranteed the equality of women and men in political, economic, social, and cultural arenas. The state elite pontificated on this issue of equality consistently in order to utilize and mobilize women's activism. But in retrospect, having allowed women's activism—though in a sex segregated milieu—they were placed by the same women in a position to back up their claims to equality.

The case of forced hejab is a good example. The issue was predominantly directed at women, symbolizing segregation of women through coverage and non-exposure. However, some women's groups, including the right-wing Hezbollah women, protested against lax dress codes for men. Using the issue of equality they argued that men, too, must have some form of cover (though most admitted a head-to-toe cover might not be possible). Male officials were forced to admit that men must observe modest dress codes and behavior; the matter was even put to practice.[39]

The following speech was delivered by President Khamanehi in the inauguration of the first International Congress on Women and the World Islamic Revolution held in Tehran in February 1988:

> Islam urges women to strive and reach perfection which has no limits nor does it stop at any point and therefore has granted her a right to serve society as a scholar, inventor, philosopher, teacher, physician or even an active politician...[40]

Similar comments have been made by other male elites throughout the years. What these officials did not realize was the probable long-term impact of their comments. Every time they compared Muslim women to Western women and argued that women have been oppressed in the West but not in Islam, they raised awareness. Every time they reasserted female equality and praised women's abilities, they raised expectations. Every time they admitted

that oppression of women is ongoing in Iranian society, they raised demands. Every time they met with women's groups, they gave them recognition. The state officials unwittingly entangled themselves in gender discourse.

In an overwhelming majority of cases, equality was nowhere to be seen. Therefore, women raised fundamental questions: Where is this equality? It is not in education? It is not in family laws? It is not in the workplace? And, it is not in the numbers of female elected officials? There has been no protection in the private sphere but also no visible presence in the public sphere; this regime has failed to fulfill the Islamic principles on women and has worsened their situation.

The failure of state institutions further undermined state ideology. For instance, the head of the Commission on Work in the Islamic Assembly admitted that many divorced women have approached government organs for employment. But because of inefficient planning there has been no mechanism to absorb these women.[41] The failure of the bureaucracy undermined the rhetoric that unmarried women are a temptation and will succumb to prostitution. "Many destitute and downtrodden women because of poverty and misfortune, for the sake of providing food for their unprotected children have fallen into the environs of corruption and prostitution."[42] This comment made by a female deputy is a judgement on the performance of the state.

Conclusion

At all three levels of contact between the state and women—state officials, state policies and institutions, and state-defined political discourse—gender issues have been politicized. State penetration and control of the private sphere and attempts to make it subservient to the public sphere have been problematic. On the one hand, state officials have contradicted themselves, some policies have been reversed, and state institutions have proven to be in conflict and inept. On the other hand, the highly decentralized nature of the Islamic state has allowed for independent and variant female activism. Consistent state failure to meet even the most elementary needs has increasingly radicalized women's responses. Contradictions in the political discourse were used to ask for change. On women and higher education, for example, segregation was a mechanism to prompt asking for female physicians; the equality argument was utilized to demand female geologists and agriculturalists. Women who entered the public arena, such as female deputies to the Majlis, not only were viewed as the representatives of the female half of the population but were themselves exposed to discrimination.

The Iranian state is in the process of war reconstruction and restructuring of its economy. Issues such as health, food, housing, and work are of crucial importance to women but equally important are family and education. "Engendering"[43] women's issues during the past decade has prompted women's demand to be included in state development. If these women succeed, they have made history in turning a classic gender-distinct state around.

NOTES

1 See, A. Fathi, ed. *Women and the Family in Iran* (Leiden, the Netherlands: E.J. Brill, 1985); Guity Nashat, ed. *Women and Revolution in Iran* (Boulder, Colorado: Westview Press, 1983); Azar Tabari and Nahid Yeganeh, comps. *In the Shadow of Islam: The Women's Movement in Iran* (London: Zed Press, 1982).

2 For an article endorsing this perspective see, Patricia J. Higgins, "Women in the Islamic Republic of Iran: Legal, Social, and Ideological Changes", *Signs* 10 (Spring 1985): 477-94. For a rebuttal and discussion see, *Signs* 12 (Spring 1987): 606-8.

3 Some published a bilingual magazine entitled, "Woman and Struggle in Iran" in the United States for a few years. Others wrote various articles under pseudonyms. Also, see, Azar Tabari, "The Women's Movement in Iran: A Hopeful Prognosis," *Feminist Studies* 12 (Summer 1986): 342-60. For a unique and profound analysis of the conflict between progessive male intellectuals and feminist thought, see, Nayereh Tohidi, "Mas'le-ye Zan va Roshanfekran Teye Tahavolat-i Dahehaye Akhir," [Woman's Question and the Intellectuals During the Changes of the Recent Decades] *Nimeye Digar*, no. 10 (Winter 1368): 51-95.

4 Sue Ellen M. Charlton, Jana Everett, and Kathleen Staudt, eds. *Women, the State, and Development* (Albany: State University of New York, 1989). The author wishes to thank Kathleen Staudt for taking the time to read this manuscript.

5 *Ibid.*, p. 180.

6 *Ibid.*, p. 11.

7 For an account of these changes until the end of 1981 see, Eliz Sanasarian, *The Women's Rights Movement in Iran: Mutiny, Appeasement and Repression from 1900 to Khomeini* (New York: Praeger, 1982), pp. 136-40.

8 *Women, State, and Development*, p. 180.

9 For Khomeini's declaration see, *Iran Times* (IT), March 7, 1986, p. 1; for women's military training before his declaration see, December 28, 1984, p. 5; for post-announcement changes see, March 28, 1986, p. 2; April 25, 1986, p. 6; and August 28, 1987, p. 1. Also, see, *Zan-i Ruz*, 23 Farvardin 1365, pp. 6-7.

10 *Zan-i Ruz*, 8 Azar 1365, pp. 4-5.

11 Proceedings of the Discussions in the Islamic Assembly (Majlis), 25 Day, 1365, meeting #363. The comment is made by deputy Mariam Behroozi.

12 For a detailed analysis of articles pertaining to women see, Sanasarian, *Women's Rights*, pp. 131-33. For an interpretation of these articles by the major women's magazine, see, *Zan-i Ruz*, 19 Bahman 1364, p. 4.

13 IT, March 21, 1986, p. 5.

14 *Zan-i Ruz*, 18 Isfand 1363, pp. 6-7.

15 IT, April 18, 1986, p. 5. This comment was reportedly made during the Friday prayer meeting in Tehran.

16 This comment was made to *Zan-i Ruz* magazine, IT, January 27, 1989, p. 5.

17 IT, May 10, 1985, pp. 5 & 14. The excerpts are taken from *Zan-i Ruz* magazine's special feature story on the legislation. See, *Zan-i Ruz*, 31 Farvardin 1364, p. 6.

18 The comment is made by Marzieh Hadidchi Dabagh, reported in IT, April 15, 1988, p. 5.

19 See, Dastgheib's instructions in *Zan-i Ruz*, 25 Isfand 1363, pp. 10-11.

20 For a detailed analysis of each category see, Eliz Sanasarian, "Islamic Identiry and Political Activism," in Ruth Ross and Lynne Iglitzin, eds. *The Women's Decade: 1975-1985* (Santa Barbara: ABC Clio Press, 1986), 210-13.

21 Sigheh is the popular term for the practice of mut'a or temporary marriage in Iran. For an analysis of the Shi'i view of this form of marriage see, Shahla Haeri, *Law of Desire: Temporary Marriage in Shi'i Iran* (Syracuse: Syracuse University Press, 1989). See an editorial response to Rafsanjani's comments on sigheh during Friday prayer, *Zan-i Ruz*, 30 Azar 1364, p. 3.

22 On the development of the birth control policy see IT, January 6, 1989, pp. 1, 11, 16, and January 13, 1989, p. 1; four conditions, allegedly declared by Ayatollah Khomeini are: prohibition of abortion, consent of spouse for birth control, absence of medical conse-

quences or side effects, and the threat of permanent infertility of women see, IT, July 14, 1989, p. 2.

23 Sohaila Shahshahani, *Chahar Fasl-i Aftab* [Four Seasons of the Sun] (Tehran: Tus Publishers, 1366), pp. 224-26.

24 Although several scholars have pointed out this sentiment, it has been philosophically explored in only one work, Fatna A. Sabbah, *Women in the Muslim Unconscious* (New York: Pergamon Press, 1984).

25 IT, July 3, 1987, p. 1; August 4, 1989, p. 1.

26 IT, October 12, 1984, p. 13.

27 On the issue of divorce see, IT, December 14, 1984, p. 2; January 11, 1985, p. 13; December 19, 1986, p. 5; February 26, 1988, p. 5; May 12, 1989, p. 1.

28 *Zan-i Ruz*, 4 Isfand 1363, p. 56.

29 *Zan-i Ruz*, 18 Isfand 1363, pp. 8-9. A female physician is quoted as saying: "On child custody cases in these courts, the value of a heroin addict father is higher than the mother who works to pay for his addiction."

30 On institutional conflict see, IT, October 26, 1984, p. 2. For Rafsanjani's comment see, March 17, 1989, p. 19.

31 Val Moghadam, "Women, Work, and Ideology in the Islamic Republic," *International Journal of Middle East Studies* 20 (May 1988): 229, 233-34, 238.

32 *Ibid.*, p. 236. The percentage is taken from ICRW/AID 1980, p. 92.

33 For a critical feature story on this topic see, *Zan-i Ruz*, 31 Mordad 1366, pp. 6-7.

34 See commentary by the deputy from the Mamasani region on acute lack of girls' schools in his district, Proceedings of the Discussions in the Islamic Assembly, 19 Azar 1364, meeting #204. Also, see, *Zan-i Ruz*, 19 Mordad 1364, p. 48 & 17 Aban 1365, pp. 4-5.

35 IT, January 27, 1989, p. 5. Also see, July 24, 1987, p. 13 and August 11, 1989, pp. 5 & 14 for comments by Zahra Rahnavard, the head of the Committee on Higher Education & International Affairs of Women's Cultural & Social Council.

36 *Women, State, and Development*, p. 12.

37 Refer to a long speech by President Rafsanjani reported in IT, June 27, 1986, p. 5.

38 *Zan-i Ruz*, 1 Azar 1365, p. 3.

39 See, IT, August 17, 1984, p. 2; April 21, 1989, p. 6; April 28, 1989, p. 1.

40 FBIS, 8 February 1988.

41 *Zan-i Ruz*, 13 Khordad 1368, pp. 10-13. For two earlier accounts of the problems faced by widows and the elderly women, see, *Zan-i Ruz*, 14 Ordibehesht 1364, p. 10, and 4 Khordad 1364, p. 6.

42 Comment by Mariam Behroozi quoted in IT, February 26, 1988, p. 5.

43 For further exploration of state penetration engendering the political see, Sonia E. Alvarez, "Politicizing Gender and Engendering Democracy," in Alfred Stepan, ed. *Democratizing Brazil* (New York: Oxford University Press, 1989), pp. 205-51. Also, see, the comparative discussion of this in *Women, State, and Development*, pp. 182-83.

The Rise of Algerian Women: Cultural Dualism and Multi-Party Politics

R. TLEMCANI *

ABSTRACT

During the Algerian struggle for national liberation (1954-1962), nationalist leaders proud-ly proclaimed that women to equal as men would occupy key positions in the modern state building process in Algeria's post-independence period. This original commitment to share political power at all levels has been expressly emphasized since Algeria gained independence. Almost three decades after independence, women's enjoyment of political rights has been insignificant and progress for women has been largely minimal. The rise of the Islamic move-ment in the 1980s and the crisis of rentier state caused by the fall of oil prices have added pressure to maintain the traditional position of women in the home. This article will focus on the problems of women as women and will analyze some of the factors which have inhibited women's emancipation in Algeria.

I. Algerian Women and the Armed Struggle for Independence

ACCORDING TO STATISTICS from the Ministry of Former Moud-jahidines (war veterans), some 11,000 women were active in the war for independence.[1] The number of moudjahidates (women militants) is in fact small when compared with the total feminine population of the country. But the number of moudjahidines (men militants) is also small when compared with the total male population of Algeria. Less than 4% of all persons repor-ting involvement in revolutionary activities during the armed struggle were the most wretched of the earth, *i.e.*, women. Approximately 20% of these women were involved in clandestine activities in the cities while around 80% were involved in rural areas.

According to statistics, less than 4,000 women played a direct role in the revolution. The roles exercised by women in civilian activities were chiefly in supporting roles to the male militants, *e.g.*, liaison agents with the guerrillas, nurses, secretaries, seamstresses, and above all, providers of food and shelter. Except for the few women involved in terrorist acts in the cities, most moud-jahidates provided support services to the moudjahidines. The roles of women in the armed struggle for independence paralleled their activities prior to the revolution, *i.e.*, they were feminine types of roles. The male leadership of the nationalist movement did not at all attempt to unfold political education to

* Institute of Political Science and International Relations, Algiers.

ultimately emancipate women. This issue was not on the agenda of the leadership during the war. Even the best known moudjahidates such as the troika, Djamila Boupacha, Djamila Bouhired and Djamila Bouazza, who attracted international support when imprisoned by the French, were not involved in the decision-making structures of the national movement. Furthermore, no woman became a member of the Provisional Government of the Algerian Republic (GPRA) and no woman assisted in writing the first historical document of the Algerian state, *i.e.*, the Charter of Tripoli in 1962. In all state documents, from the first one to the new constitution adopted by referendum on February 23, 1989, women's full participation in the state institutions has been seen as a necessity in the process of social change. As we will see, this goal was more rhetorical than attainable because the Algerian political leadership is moulded by a military-bureaucratic spirit and is fundamentally conservative when it comes to the issue of women's rights and status. The very few women appointed to positions of power so far received their appointments on the basis of power they wielded through family relationships. When Madame Z'hor Ounissi was appointed the Minister for Social Protection in the 1980s, people who were not familiar with her work as a writer thought that the first minister in Algeria's political history would make a significant contribution to social progress for Algerian women. Contrary to these expectations, she undertook conservative and regressive measures on social security matters.

II. Women in Official Documents

The Algerian bureaucracy has been very prolific in writing documents and bills in the post-independence period. In all major state texts, the Algerian women were to share rights as citizens equally with men. The 1976 Constitution, the most radical political text ever written in the post-independence era, has a number of articles that explicitly refer to women's rights and status in the process of political participation in Algeria. Article 42, for instance, notes that "all the political, economic, social and cultural rights of Algerian women are guaranteed by the Constitution." This idea is reinforced in Articles 44 and 59 which clearly guarantee success in work and equal pay. All these articles and others written in the National Charter speak in one way or another of a woman's role in a modern society in which she could not return by any means to her couscous (a national dish). The thrust of the argument is that discriminatory gender distinctions that shape social relations born at home and in the work place are not the outcome of Islamic traditions. According to this dominant line of reasoning, even among secular people, Islam had historically liberated women from manipulation and exploitation. In this respect, Madame Banhamza Saadia, the President of a newly-created women's association in Oran (the western part of the country), said most recently:

"The Day of March 8th symbolizes for me the emancipation of Occidental women because the Moslem women gained her rights and emancipation, with the advent of Islam, 14 centuries ago." [2]

In addition to the religious element in the state ideology, both the nationalist and socialist elements are also key factors in the state discourse.[3] That is the reason why the state discourse, when it is translated in the media, highly valued women's participation during the war for liberation. Moreover, in a similar fashion to the "socialist" Constitution (1976), the "liberal" Constitution adopted after the October, 1988, events,[4] guarantees fundamental liberties and the rights of women as citizens. So does the Family Code that was finally approved by the National Assembly and promulgated on June 9, 1984. Because of widespread opposition in 1981, the government decided to postpone sending the draft of the Code for ratification to Parliament.

The government's attitude toward this code oscillated for 22 years. From the time of independence until the promulgation of the family law and personal status law, there were several attempts to reform the law, but the project aborted. Conflict between *Laïques* (secular) and religious or liberal and conservative tendencies within the state apparatuses has delayed its promulgation. One should not, however, over-stress this type of tension and conflict because both tendencies contain no fundamental disagreements and subsequently unfold no different conceptions of women's rights and status.

The few modifications to Maleki law introduced by the colonial power were reconfirmed and a few new laws have been passed in the post-independence period. But for more than two decades the Algerian people lived without a comprehensive family law and personal status code. Legislation consisted of a perplexing mismatch of Koranic law and secular codes.

In the approved version, earlier explicit references to adult women as minors have been eliminated from the final draft. However, a careful reading of the Code will clearly disclose that the "body of domestic laws", considers adult women as minor persons. The Code plainly places the Algerian woman in an obedient position to the husband and remains, in this respect, faithful to Maleki legal principles.[5] For instance, like other schools of Islamic law, maleki law gives the husband the privilege of breaking the marital bond at will, called "repudiation", while it restricts the circumstances to be considered legitimate grounds on which a woman may be granted a divorce. The repudiation must occur in court, but the husband's will to terminate the marriage is still a sufficient and legitimate reason for divorce.[6]

In the case of divorce, the wife has custody of the children, girls until they reach the legal age to be married (18 years old), and boys until the age of 16. The principle of matrimonial guardian is thus reconfirmed. If the father dies, the mother automatically becomes the children's guardian. But, if the mother dies, the father cannot have custody of his own children. The wife's parents become the children's guardians. The assumption is that man is not suited in any circumstances for raising his children. Here again, the distinction between men and women follows the traditional line in the sense that the father is regarded as the head of the family

In Algeria, adoption is, in contradistinction to Tunisia, *de jure* forbidden in the Family Code as it is in Koranic law. Nevertheless, relatives and others can assume the guardianship of children not their own. If the child has reached

the age of reason, he/she can elect to return or not to the parents. Because of popular dissatisfaction with this provision, the government was about to pass a bill that would reverse it. With the rise of the Islamic movement as a dominant political force, this bill was put aside for the time being.

In the section on inheritance, the Family Code preserves the rights of all parties to family goods and property. These parties include sisters, daughters, mothers and wives. This means that a woman receives half as much as would a man in a similar situation. Here again the Code follows the traditional law.

One of the main assumptions on which the Code is based is that the conjugal unit may be short-lived, whereas the ties with male kin may be enduring. Overall, the Code, written within the Maleki law framework, defines the agnatic kin group rather than the nuclear family unit as the pivotal point of solidarity. The state commitment to feminine equality has only been an ideological theme which badly disguises the conservative political culture that shapes the Algerian bureaucratic bourgeoisie. As further evidence of this argument, it is worth noting the bill of elections passed on August 9, 1989. In it, Article 53 clearly states that a woman does not have to go to the poll; her husband is legally allowed to do it for her. This provision, in fact, reinforces the status of a minor or of an adult minor as depicted in the Code. A more disgraceful piece of electoral legislation was passed on the eve of the first democratic elections in the post-independence period. In it, Article 54 plainly states that the husband is allowed to take up to three procurations. In other words, an adult man is legally allowed to vote in place of three adult women. As an immediate consequence, the Islamic Salvation Front (FIS) won majorities in 55% of the 1541 communal assemblies and 32% of the wilayas (provinces) on June 12, 1990. Its victory, which did not take political scientists by surprise, bolstered its demand for the dissolution of the FLN-controlled National Assembly. It is interesting to point out that the so-called democratic parties and groups as well as the feminist associations did not attempt to press hard the political leadership to amend the electoral law?[7]

The Family Code is divided into three main topics: marriage and its dissolution; legal representation; and inheritance. Free consent to the marriage by both parties is required. A marriage guardian which can be the father, a relative or the judge if there is no one else, is still required for the woman. But the function of the guardian remains only formal; it is restricted to representing the bride in the marriage. The mahr[8] is also required; its value rests on the consent of both parties. As women belong to social classes, the mahr sets back family capital. It remains, for the overwhelming majority of young women, a must in that it provides some financial security to the woman on the one hand; it helps to keep the husband from marrying many wives or divorcing rapidly, on the other hand.

According to the Algerian Code, the mahr belongs totally to the wife once the marriage has been consummated. The absence of community property between husband and wife implies that the patrimony of each may remain untouched by marriage.

Among the rising class of professionals, the mahr has started to disappear

from the marriage contract. By and large, the two parties to the marriage can include in the marriage contract virtually anything not noted by the Family Code. A women may elect to have as part of the contract that she have the right to hold a job after marriage or to sent a portion of her income to her parents. In other cases, she may elect to keep her income only for herself in accordance with Article 37 of the Code. This article clearly stipulates that the husband is required to provide for the full support of his wife and family; it has caused conflicts and divorces in some cases, and in fact, it does not work in favor of women's emancipation; it is not even questioned by feminists that I interviewed for this study. For them, the working woman is exploited at two levels, at home and at work; thus, she is entitled to keep her income for herself.

According to the Family Code, a man has the right to marry up to four wives "if the reason for this is justifiable." The main reasons often cited for electing to marry as many as four wives are the inability of a wife to have children or her incurable illness. Marrying more than one woman can only be done, according to the Code, after the husband informs his wife and fiancée of his intentions. In this event, the Code which is grounded in religious traditions, provides that legal support and care must be given to all wives. If the wife does not consent to the proposal, she is entitled to ask for a divorce.

In recent years, the number of polygamous marriages has been very small in Algeria. To the best of my knowledge, I do not recall any polygamous marriage case in my extended family and among my friends. In the future, polygamous marriage, I presume, will be *de facto* dissolved completely in this country. The argument for choosing many wives is no longer valid today because of the great development of health care; moreover, in most cases, sterility can be treated in hospitals throughout the world.

III. Hidden Curriculum and Cultural Dualism

The first books that an Algerian girl can read in the event that she gets the opportunity to be enrolled at school remain the textbooks. These present not only skills for reading and writing but also ideological themes. Elementary as well as secondary schools contain a "hidden curriculum" to prepare girls primarily for marriage. The Algerian woman depicted in these books is the traditional housewife, her role being essentially working, cleaning and child rearing. In a textbook for the first grade, the first sentence, for instance, goes as follows: "Mum has cooked a delicious cake for dessert." Furthermore, the working woman is presented as a hairdresser, teacher or nurse.

From a social structure perspective, the Algerian woman is analyzed in these textbooks as if women in Algeria belong only to a "modernist middle class." The Algerian family is depicted as being basically urban with two or three children and the father is formally educated and well-off. Every family owns a spacious apartment or house which is well-equipped with all material facilities (telephone, color TV and washing machine). This ideal image is far removed from the real situation in which the Algerian family is crowded into a two-bedroom apartment in dormitory-cities. To further illustrate the

mechanisms working in favor of cultural alienation, it is worth citing television programming. Algerian television conveys two clashing themes: the traditional theme in the Arabic films imported from Egypt and Lebanon, and the modernist theme in the Western films from the USA and Europe.

In the first type of film, the woman is depicted either as a submissive wife or as looking forward to marriage. In Egyptian soap operas, which are scheduled at seven p.m. every day, a woman spends a great deal of her time in quarrels and love affairs, so as to seduce ultimately the "charming prince." Directed in a Hollywood-like setting, there is no struggle in these melodramas between a man and a woman, and the questions of women's rights and status is never raised in these films. This image is further conveyed in a few movies made by Algerian directors. Egyptian melodramas have become most popular for women in Algeria. For the past decade, they have attracted a great number of women, rural as well as urban. The infatuation is such that some women forget to cook dinner for the family. It seems that they are destined for the traditional housewife whereas the American action films are destined for the professional and modernist woman. These types of movies, in a subtle way more misogynous than the Arabic ones, have a very negative effect on the Algerian young woman's mentality and subsequently her behavior.

The misogynous discourse is further carried on in French magazines such as *Femme d'aujourd' hui, Elle,* and *Femme Pratique* which have become the most readable literature for the young and intellectual woman in Algeria. The woman depicted in these magazines remains an object for sexual desire. It is interesting to point out that the activists of the growing women's movement in Algeria gladly read this type of literature. On the other hand, El-Djazaria, the only feminine magazine edited by the FLN controlled women's union, the UNFA, is scarcely read by women. According to some women, this magazine is "too much" politicized and subsequently does not tackle the real problems encountered by the Algerian woman at large.

The cultural dualism between traditionalism/secularism or between religion/laïcité has widened in the mid-1980s because of the rise of the Islamist movement on the one hand and of the impact of the French media in Algeria on the other. An ever-mushrooming number of parabolic antennas, which pick up French television channels, has attracted the attention of everyone visiting this country. As an immediate result of these antennas, according to Islamists, a great number of women are not following the Shari'a (religious law), and do not wear the hidjab (Islamic dress; modern style garments consisting of long dresses with long sleeves accompanied by an ample head covering).

IV. Women and the Work Process

Published in March, 1990, the National Statistics Office (ONS) Bulletin clearly discloses, in contradiction to the state commitment to feminine equality, that the number of working women outside the home has been very low in Algeria. In fact, this number has been decreasing from 1987 onwards. In 1966, about 34,511 women were working outside the home; in 1977 the

number had grown to 138,234 and to 365,094 in 1987. According to these figures, the percentage increase of women having paid employment in the public, private and self-managed sectors grew 3.5% between 1966 and 1977, and 10.2% between 1977 and 1982. This number decreased to 338,400 in 1989. In 1990, women's participation in the labor force was less than 7% and it never reached 10% even at the height of industrialization under Boumedienne (1965-1978).

Both the "industrializing industries" in the 1970s and the new economic policy in the 1980s have in fact confined the Algerian woman to her traditional function, *i.e.*, reproduction. A sectoral examination of ONS's figures will provide further evidence. Women's participation in the health services reached 44.5% and in Education 38% in 1989. Both nursing and teaching, even though they are not related to the traditional role of the mother in the home, still are nonetheless related to the function of social reproduction. The National Charter further restricts, despite its stated claim, women's participation as follows:

> "The integration of Algerian women into the work productive cycle must take account of the limitations placed by their roles as wives and mothers with responsibility for creating and maintaining social cohesion." [9]

The percentage of women working in factories has been very low. In 1986, 14,645 women worked in factories, that is, 14.67% of the total female work force. This percentage decreased to 10.06% in 1977. Since the political leadership, under Chadli, did not undertake any significant industrial projects, I presume the number of industrial women workers has decreased in the 1980s. The high percentage of working women in cleaning and child care can be seen as good evidence for the argument. Despite the fact that the Algerian population is negative towards this type of work, the percentage of this category of women increased in the 1980s, and reached 13.7% of the total female workforce in 1989. These women come from poor social background. Their economic situation is further worsened by the death of a father or his abandonment of the family.

Another important feature of the ONS's figures, is that working women are essentially concentrated in the three largest cities of the country: Constantine, Algiers and Oran. Approximately 25% of these women, for instance, work in the region of Algiers.

State emphasis on industrial development, particularly during Boumedienne's period, could partly explain the exodus of young women from the countryside to the cities to find a job. There are so many more working women in these three cities than in the rest of the country.

One of the most important features of women's participation in work is that Algerian women are highly trained and skilled. The percentage of women cadres (liberal functions, managers and engineers) is relatively high in Algeria; it is equal to 17.7% of the total Algerian cadres. According to government statistics, 85,000 trained women were seeking jobs in 1989; 12,000 of them had been laid off as a consequence of administrative and economic reforms under-

way. In addition, a category of trained women would rather stay at home than work outside the home. Inadequate food supplies, derelict social services, and lack of day care centers de facto prevent women's access to paid employment.[10] Unemployment for skilled women is actually higher than the official figures. But, according to the Islamic discourse, women have taken men's jobs.[11] Unemployment in Algeria, according to this line of reasoning, can be solved by keeping working women at home. The number of working women, as analyzed above, is virtually insignificant. The Islamists' solution to unemployment is not practical, however, as Algerian women are well-trained and skilled.

V. Women and Political Institutions

Considering the 1960 revolutionary environment in Algeria, it was expected that the Algerian woman's participation in the first local assemblies in the post-independence era would be very important. Against all expectations, only 99 out of 10,852 seats were won by women in the communal elections held in 1967.[12] Also, in the provincial elections of 1989, only 26 out of 665 seats were taken by women. The number of women decreased by almost half in the re-election of local assemblies held in 1971. Women's participation did not exceed 0.5% while the female population was over 50% of the total population. This decrease reached a critical juncture in the recent elections held in 1990. It is interesting to stress the point that in the first free elections since independence, voters in the June 12, 1990, local and provincial balloting did not elect a single woman.

At the national level, women's participation in state institutions has also been more symbolic than real. In the current parliament which is controlled by the FLN, only 7 out of 295 seats are held by women. The number of women, that have seats in the National Assembly so far has not exceeded 10, that is to say less than 3%. As a prediction, I highly doubt that a single woman would be elected in the forthcoming legislative elections which will be based on multi-party politics. The question that should be investigated in another study is whether the Algerian state, under the single party system, has been less misogynous than under multi-party politics.

VI. The Rise of the Women's Movement in the 1980s

With the creation of the UNFA (Algerian National Woman's Union) in 1963, there was a hope of seeing the Algerian woman play an active role in the socialist revolution that gripped the momentum for independence. Against all expectations of observers and particularly Arabs, the UNFA, in a manner similar to other mass organizations, has been more of a symbolic institution. A trivial incident in January, 1981, caused the UNFA to come out of its lethargy. The enactment of a regulation prohibiting women from leaving the

country without a husband's authorization sparked off protests in the streets. This discriminatory measure swiftly catalyzed energies around the project of the Family Code that was about to be ratified by parliament. Women then organized their own demonstrations in Algiers and other cities. As an immediate result, the government decided to postpone sending the draft to the National Assembly.

After the October, 1988, events, the feminist groups became active. Within the space of two years, more than 30 feminist associations obtained official authorization to operate outside the ruling party's control. They are principally led by the *Association pour l'egalite devant la loi entre les Femmes et les Hommes* and the *Emancipation de la Femme*. Their tireless campaign was directed at the abrogation of the misogynous Family Code and the end of intolerance against women. These feminist groups have helped politicize the issues of dress, co-education, family size, and female employment in a country where the average number of children for women between the ages of 30 and 35 is five.

It is interesting to point out that political parties in Algeria vie to control feminist groups. Their leaders, influential at one point in their political careers in the FLN, did contribute to the suppressing of women's freedom and their alienation from the public sphere. Moreover, the political parties that strive for democracy in Algeria did not show any form of active opposition to the misogynous bill of elections which regards adult women as minor persons. No wonder that these parties performed poorly in the June 12, 1990, balloting. Furthermore, they did not join the demonstration against the electoral legislation held the day after the balloting in Algiers and organized by the radical feminist group, the Independent Association for the Triumph of Women's Rights. This demonstration did not attract more than a few hundred persons.

So far the feminist groups have not succeeded in gaining active support from the democratic parties and groups and much less from secluded women. They have not yet presented alternatives that would address the problems affecting the overwhelming majority of Algerian women. On the other hand, whenever the Islamic association led by the El Irchad Wal Islah (Orientation and Reform) and the D'awa Islamiah (Islamic Mission) called for protests, they attracted many thousands of women wearing the hidjab in the streets.

To a close observer of women's movements, the Algerian woman is kept hostage to the dichotomy traditionalist versus modernist, or between religion and laïcité (secularism). The conservative group is oriented toward Ryadh (Saudi Arabia) whereas the modernist group is oriented toward Paris (France). The first group should gain autonomy from the FIS, and the second from the democratic political parties. In so doing, the Algerian woman would ultimately become an actor on the political scene rather than a stake in the practice of multi-party politics. It seems that the leaders of the newly-created group, the Independent Association for the Triumph of Women's Rights, are aware of the political parties' hegemony over the women's associations. According to the platform of this association, ''The Algerian women is movement should not be used as an instrument in the power strategies of the political parties.''

VII. Islamisation of Politics and Women

During colonial rule, Islam served as a factor of national cohesion and creative force against foreign rule. In Algeria, Islam's importance is not based on the orthodox observance of the faith. Attendance at the mosque in Algiers before the recent rise of the Islamist movement resembled church attendance in Moscow. This can hardly please the Ulema, the religious reformers in the 1940s, who rejected, for instance, popular superstitions and maraboutism. The rise of Islamist movements in the 1980s signifies that official Islam and state reformism have together failed to incorporate popular Islam and subsequently to modernize Algerian society. The former minister of religious affairs had virtually total authority over religious matters. He administered all religious schools and hired imams, the bureaucrats in cloaks who preached the state's Friday sermons in the 1970s.

Boumedienne subsequently made bold moves that favored a resurgence of Islamic politics. One was a sudden and rowdy campaign to Arabize street and shop signs. He used Islamism to counterbalance Marxist penetration into the state apparatus. In the mid-1970s, a strong popular drive, for instance, was about to radicalize the regime in suppressing private property in Algeria.[13]

The argument was that Islam does negate private ownership of the means of production. This critical juncture in Algerian politics set in motion the development of the Islamist movement. By the mid-1980s, the Islamists became exceedingly active. They obstreperously demanded "purification" measures, e.g., the elimination of co-educational schooling, a ban on the alcoholic beverages in public places, and above all, wearing the hidjab for women.

In the 1990s, the majority of young women in the cities wear the hidjab in contrast to their sisters in other Maghribi countries. The hidjab does not pertain to the Algerian cultural heritage and tradition. In Algeria, women are accustomed to wearing the haik or the meleya that involves the covering of the face. At first, one should not be impressed by the phenomenon of wearing the hidjab per se in Algeria. Women wear the hidjab for different reasons. Some of them, for instance, do not wear it for religious considerations; they wear it to avoid having to buy a western-style wardrobe that they may not be able to afford, or to attract a potential husband in a country where dating is difficult, while, others are clearly compelled by their families. This phenomenon unveils the transformation of Algerian mentality which has become less permissive and more conservative.

Despite the fact that the Islamist movement rose in the Middle East, more particularly in Egypt, modernization in cultural domains has been more tangible in these countries than in Algeria. Furthermore, the most visible manifestation of the challenge to secularization is the growth of street side mosques and prayer rooms in schools, government offices, and factories. Using electronic amplification in these places, imams and FIS's spokesmen loudly preach against infidels and women who do not follow the Shari'a, the Islamic law. The religio-political discourse is often articulated in a blistering critique of both

capitalism and socialism responsible for the loss of values, corruption, and economic mismanagement. Last but not least, circulating cassettes of sermons and political speeches by eastern theologians allow Algerian fundamentalists to follow trends from the other side of the Arab world. This heavy drive forced in some way a debate over co-education for the first time in Algeria's political history at the November, 1989, FLN meeting.

In this context, the FIS, as I mentioned above, won majorities in the communal as well as provincial assemblies in 1990. Despite the fact that the FIS is a recent party, it has overnight become the strongest political force in the sense that it won in every region of the country, particularly with the strong support of the youth. Concerning the 1990 balloting, Ali Belhadj, the leader of a militantly conservative wing in the FIS which steadily calls for the return of women to the home, said during a Friday prayer sermon: "it is not democracy that won, but Islam." More critically, the FIS has succeeded in radically altering the political discourse in Algeria, making Islam versus laïcité the fundamental bipolarity. In a country where all people are Moslems, the FIS came up to dominate the political discourse by putting all other parties (more than 40 parties) on the defensive regarding their fidelity to true Islam and their stand on women's issues.

VIII. Conclusion

In the light of the previous analysis, I have tried to show that there have been qualitative as well as quantitative improvements in the status of women and women's enjoyment of political rights in Algeria. With the recent rise of Islamic movements which has coincided with the new regime under Chadli, the slow but contradictory process of modernization has been gradually interrupted in this country. This interruption refers to a partial withdrawal from secularization based on the misogynous Family Code, the electoral laws, and the question of eliminating co-education.

Against all expectations of observers, the Islamic Salvation Front, the FIS was formally sanctioned even though it contravened the procription against religious political parties in the July, 1989, political party bill. According to the political leadership, Islamic fundamentalism would be unlikely to spread throughout Algeria in the foreseeable future. The Algerian people, according to this line of reasoning do not welcome the "retrograde mysticism" of Saudi Arabia. This interpretation has an element of empirical validity; it does not, however, take into account the inner dynamic that animates a social movement in a context where the rentier state reached the limits of its capacities.

The FIS's victory in the local balloting bolstered its demand for the dissolution of the FLN-controlled National Assembly. Its re-election would be a further turning point for women's status and rights. Taking into consideration the most recent balance of power among the different political parties and forces, I doubt that the FIS will control the future national assembly should elections take place as scheduled in January 1992. The issue of women's emancipation will enable the women's movements to develop independent strategies

for ultimately gaining access to the public sphere. It is worthy of mention that Madame Louisa Hanoun, General Secretary of the PT (Worker's Party), even though she is head of a Trotskist party in a conservative society, succeeded in becoming a great political figure in Algeria. In a word, despite the fact that the "immediate reality" (Hegel) appears to be hopeless for women's emancipation, there is, in the final analysis, a basis for hope for the emancipation of Algerian women.

NOTES

1 The actual number of women militants is higher than the state figures. Because of bureaucratic procedures, many women, particularly rural, had not been able to record their names in the Ministry of War Veterans in order to receive benefit allowances.

2 She is the President of the Association for the Protection and Promotion of Women and Young Women in the province of Oran. El-Moudjahid, March 8, 1990.

3 Khodja Sovad, Les Algériennes du Quotidien, ENL, Algiers, 1985, p. 13.

4 In early October, 1988, the capital of Algiers and all other major cities in Algeria erupted into violence. The authorities declared a state of emergency and imposed martial law in Algiers. The riots, according to state figures, left 159 dead, many more injured and 7,000 arrested, as well as material damage of $20 million. The riots of October, 1988, overnight set in motion the transformation of Algerian socialism into a political democracy. For a concise analysis of the recent economic and political changes that are taking place in Algeria, see R. Tlemcani, *Chadli's Perestroika*, in Middle East Report, March-April 1990, No. 2, 163. For a more rigorous analysis of the process that led to the riots of October, 1988, see R. Tlemcani and W. Hansen, Development and the State in Post Colonial Algeria, in *Bureaucracy and Development in the Arab World*, edited by Joseph G. Jabbra, Leiden, Holland, E.J. Brill, 1989.

5 It, in Article 19, states that "the wife is bound to obey her husband and to grant him consideration as being the head of the family and to respect her husband's parents and his close relatives."

6 According to the Code, it is enough for him to repeat three times "tallaqtuki" (I repudiate you), in order to obtain legal divorce in court, while the wife can only ask for divorce, according to Article 53, in a very specific situation, *e.g.* sexual infirmity and absence of married life.

7 The National Assembly amended this law in October, 1991, expecting to be reelected. However, the husband continues to be allowed to vote on behalf of his wife. I predict that this measure will greatly help the Islamic parties to have the upper hand in future parliaments.

8 *Mahr* in the Shari'a (Islamic law) refers to a transfer of wealth from the groom (and his family) to the bride. Sometimes, despite the law's requirements, the bride's family may appropriate the amount. The amount of the *mahr* is negotiated before the marriage contract is signed: it is higher in wealthier families. Frequently, part of the *mahr* is deferred, to be paid if the husband repudiates his wife.

9 The National Charter, p. 128. In the same vein, the Iman Mohammed al-Ghazali, former President of the Scientific Concil at, the Islamic University of Constantine, and the state spokesperson on religious matters for several years, wrote "women will remain the left hand of mankind and her actions will continue to be more important at home than on the street" (Nouredine Saadi, *La Femme et la loi en Algérie*, Algiers: Bouchène, 1991, page 120). This statement does not, in fact, bring forward a new interpretation of Maleki Law. It is in accordance with the themes developed by the theologians of the Nahda (reawakening) at the turn of the 19th Century. In this respect, Monar Rachid Redha wrote in 1910 that the Koranic Law laid down the division between the married couple: the wife takes care of the home while the husband brings the money to home.

10 Twenty percent of Algerian women give up their employment after marriage as a result of the social constraints.
11 In December, 1989, a Deputy suggested that working women should gain advantageous retirement benefits if they are willing to give up their jobs for men (El-Moudjahid, December 31, 1989).
12 Vandelvel, Helen, *Femmes Algeriennes*, OPU, Slhirtd, 1973, p. 296.
13 Abdeslam Belaid, the former Minister of Industrialization under Boumedienne, in *Entretiens avec Abdeslam Belaid*, edited by M. Bennoune and A. Elkenz, Algiers, 1990, p. 236.

Political Ideology and Women in Iraq: Legislation and Cultural Constraints

AMAL RASSAM *

ABSTRACT

The Arab Ba'ath Socialist Party is committed both to national development and to the liberation of women. However, as in other Arab-Muslim societies, Iraq's people are also concerned to maintain their heritage, the core of which includes personal and family values. The result is that Iraq's leaders have segmented women's status into two parts, the private/familiar and the public/economic, and confine change mainly to the latter.

"THE LIBERATION of the Arab woman and her release from her antiquated economic, social and legal bonds is one of the main aims of the Arab Ba'ath Socialist Party. The party must therefore work tirelessly toward legal equality and the provision of equal opportunities of work. It is the duty of the Party and its organization to fight against the backward concepts which relegate the role of women to a marginal and secondary place. Such concepts conflict with out Arab and Islamic heritage and are in fact alien and harmful. They also conflict with the values and concepts of the Party, the Revolution and the needs of modern times ... The liberation of women can be done through the complete political and economic liberation of society. The Arab Ba'ath Socialist Party has a leading role to play in the liberation of women since it leads the process of social and cultural change."[1]

Leaders of Islamic countries, including the most conservative ones like Saudi Arabia, have all declared their commitment to national development. They may differ on the exact meaning of "development", but they all subscribe to the goals of increased production, higher educational levels, improved health and nutritional standards, and a more equitable distribution of goods and services. Towards that end, the full participation of women in the development process is considered to be necessary, if not crucial. For example, Zia ul Haqq, the late conservative president of Pakistan, called for women to

* Department of Anthropology, CUNY-Queens College, Flushing, NY 11367-0904, U.S.A.

"participate fully" in the affairs of the nation and agreed to a feminist demand for a high level government commission on the status of women. At the same time, President Zia endorsed the conservatives' demand to repeal the Family Laws Ordinance of 1961 and to establish a new segregatred university for women. The 1961 Family Ordinance, which tightened the regulations governing polygyny and divorce, had been hailed by Pakistani women as a virtual "bill of rights."

The ambivalence exhibited by President Zia with regard to the role of women in a Muslim society is neither unique nor surprising; it is shared by the majority of Muslim leaders and may be considered as part of a much larger dilemma. This dilemma consists of what is perceived as the contradictory demands of "modernization" and those of "cultural authenticity": the problem of how to effect basic socioeconomic change while maintaining a sense of pride in native culture and a secure feeling of identity. In Arab-Muslim societies, much of this historical pride and sense of identity is bound up with Islam. Furthermore and significantly, Islamic values and notions of proper and improper behavior still inform the life of the vast majority of the population and regulate the most intimate and immediate domain of personal and familial relations, at whose core lies "the question of women." This general dilemma assumes its clearest and most dissonant expression in the self-styled "secularist" and socialist Muslim regimes such as those of Algeria, Syria, and Iraq.

Socialist countries in general consider development to mean a total restructuring of the society which involves, among other things, a new and different basis for social relations. Moreover, it is believed that this planned and controlled change can be brought about through a political revolution which must assume the character of a total revolution. The Arab Ba'ath Socialist Party, which came to power in 1968 in Iraq, is one such regime committed to total revolution and to the building of a new "future free from the old, obsolete, and exploitative relationships that held the peasant, tribesman and the women prisoner in their own society." But whereas the Ba'ath state-led initiative to transform the position of the peasant and the tribesman has been radical and systematic in nature (sweeping land reform, state-sponsored agricultural cooperatives, state credit, dismantling of tribal leadership structures), no comparable programs were undertaken regarding women. In fact, as will become clear, legal reforms introduced by the Ba'ath are less far-reaching than those of Egypt and Tunisia, two Islamic states that make no claim to state-led radical overhaul of the society. Does this mean that Ba'athi ideology is not much more than mere rhetoric and is to be dismissed as such?

In what follows, I will examine the role assigned to women in the ideology of the Ba'ath as well as some of the actual changes taking place in their position in today's Iraq. The case of Iraq illustrates some of the ironies and contradictions involved in attempts to ochestrate change in the status of Muslim women as well as provides another example of the tenacity of the Arab-Islamic cultural code that circumscribes the private life of women and constrains their personal autonomy.

Iraqi leaders, much like their counterparts in other Muslim countries, seem to perceive women's status as being differentiated into two separate and independent spheres: the private/familial and the public/economic. Thus while granting women full and equal rights in the Labor Codes which regulate their status in the wage labor sector, they have balked at doing the same for their legal status within the family. Given the religious segmentation of Iraq (into Sunni and Shi'a communities) and the presence of a strong tribal component, it may well be the case that the Ba'ath leadership finds it politically prudent not to engage in any overt and direct confrontation with the more conservative religious and tribal elements over the issue of women. I believe, however, that the disjunction reflects a genuine dilemma on the part of Iraqi leadership, caught as it is between the dictates of its Arab-Islamic heritage and the demands of its secretarian and scientific revolution.

Iraq is undergoing an unprecedented period of change under the leadership of the Ba'ath Party, one of whose slogans is "Permanent and Total Revolution." Following its seizure of power in 1968, the Ba'ath has extended and consolidated its hold on society; it has created a well disciplined popular militia force that includes women as well as men, grass roots party organization, and a strong political hierarchy.

The party's slogan of "Unity, Freedom, and Socialism" projects its vision of an independent and united Arab Nation founded on socialist economic principles. This is contrasted with a past characterized by ignorance, backwardness, and exploitation of the many by the few. Viewing itself as the motor for transforming the society and the means to stir the masses from their lethargy, the Ba'ath has placed special emphasis on the role of women in the national struggle.

The opening quote from the political report of 1974 adopted by the eighth regional congress is self-explanatory. It is important, however, to underscore some of the points. First, women's bondage is seen as resulting from antiquated "values and concepts" in the social and legal spheres; second, these backward values and concepts are not only seen as alien and harmful, but also as being in conflict with the Arab-Islamic heritage and the values of the Ba'ath whose duty it is to liberate women; third, the liberation of women will spearhead the total transformation of the social order.

This general statement apart, the most articulate and systematic treatment of women was made in a speech by Dr. Elias Farah, one of the party's top theoreticians. The speech, entitled "The Woman in the Ideology and Struggles of the Arab Ba'ath Socialist Party," was delivered in December 1975 to a conference-workshop held by the General Federation of Iraqi Women (henceforth GFTW). Farah pointed out that the general constitution of the Ba'ath Party, drafted in 1947, granted Arab women full citizenship rights and promised that the party would strive to insure that they fully enjoy these rights. The constitution also stated that the family is the primary cell of the nation, whose obligation is to protect and nurture it. Farah proceeds then to link "the problem of the Arab woman" with the general problem of national development and liberation, arguing that any attempt to improve the status of women

which does not call for a basic transformation of the class structure and its supporting ideology is bound to fail: "The Arab woman is doubly dispossessed, being a woman in a dispossessed society ... The Party is committed to undertake the struggle to liberate the Arab woman in a fundamental and real sense. The Arab Ba'ath believes in the equality of men and women and is committed to support all efforts undertaken by women to ensure their liberation as it (*i.e.*, the Ba'ath) refuses to divide Arab society into free men and enslaved women"

The Arab woman, Farah adds, suffers special liabilities in such areas as education, choice of profession, opportunity for work, salaries and wages, marriage and divorce, and political participation, all of which give a special urgency to the question of women and to their role in safeguarding the revolution. As he puts it, "The success of the Ba'ath revolution depends, to a large extent, on the mobilization of women and on their positive contribution to a new social order. To that end, they must be liberated from all economic, social, and legal constraints."

After a critical review of the role of women in the revolutionary ideologies of Marxists, Maoists, and Vietnamese, Farah maintains that even though the revolutionary struggle of Arab women has taken many forms, it can still be seen as part of one historical movement towards emancipation and self-realization. He identifies certain watershed dates in that history: the year 1922, when women in Egypt defied their society and went out unveiled; 1929, when the first Conference of Arab Women was organized in Palestine; 1932, the year women organized and led demonstrations protesting British support of Zionist activity in Palestine; 1949, when women won the vote in Syria; and 1954, when Algerian women actively joined the FLN in the Aures mountains. While these achievements may have been impressive for their time and place, Farah points out that they failed to generate enough momentum and force to radically alter the condition of women. This, he adds, is largely the result of viewing the "problem of women" as separate and separable from that of the total society. Farah then proceeds to list some of the ways and means which would effectively contribute to women's liberation, including the party's commitment to the development of programs aimed at combating the negative image of women as well as for integrating them in the development process.

The programs initiated by the Ba'ath will be considered in terms of two categories: educational and service programs and legislative reforms.

The GFIW is the party organ charged with and committed to translating party policies regarding women into practical programs. These programs vary in nature and in scope. One of the larger and more important has to do with the sponsorship and management of a number of rural centers where peasant and townswomen are encouraged to come for a few hours a day to learn to read and write. In some of these centers, local teachers (some hired by the GFIW, others university volunteers) offer instruction in sewing and other domestic crafts. But the major emphasis is on literacy. It should be noted here that sewing is an important skill in rural (and urban) Iraq, that women do not "naturally" know how to sew, and that women greatly value leaning the skill as it allows them to sew clothes for their families. It is also one of the few means

available for an illiterate woman to generate income while staying at home.

Not long ago, I visited a number of these rural centers. I was impressed by the dedication and earnestness of the young teachers and by the eagerness of the "students", many of whom had to walk a long way following a hard day of work to reach the center. At that time, absenteeism was a problem, for, as the teachers complained, "their men try to stop them (i.e. the women) from coming, they do not want them to take off the two or thre hours it takes daily to come here, and they claim that the women are needed at home and that at their age (these are adult women) they can do without reading and writing. We suspect, however, that they are worrid about the new ideas we are putting in their women's heads. But the women are thrilled to be learning to read and write and besides it gives them a chance to get away from house chores and to relax. So, it is a continuous battle, and often we have to go out into the villages and settlements and argue with the men to allow the women to come here."

In December 1979, a law was passed in Iraq which makes literacy compulsory for all citizens. Illiterates are required to report to literacy centers: wives, mothers, grandmothers, employees, everyone. The government announced that it hoped to eradicate illiteracy within five years or so. It may well be argued that this goal is not realistic: there are neither enough teachers or centers to carry on the task at this time. Furthermore, it is resisted by the most conservative sectors of the society who balk at sending the women to the literacy centers. However, the significance of the gesture should not be mimimized. A husband who refuses to let his wife go to her literacy class at one of the centers, for example, could be reported to the police and might even be prosecuted.

In addition to the rural centers, the GFIW sponsors a number of radio and television programs aimed at women. One of the more popular and controversial consists of a weekly television show aired usually on Saturday evenings. The hostess and moderator was a well-known woman lawyer and a member of the legal section of the GFIW. Each half-hour program was devoted to explaining some specific problem that had a legal implication, and the majority of the issues related to women and the family. Often a court case was simulated, based on a question sent by the audience; legal points and court procedures were carefully and simply explained by the moderator who alerted women to their rights and advised them on their legal status. Lawyers, judges, and scholars were inivted singly or in panels and interviewed. Similar programs were a regular feature on the radio as well.

The legal section of the GFIW is engaged in more than general consciousness raising. Volunteer lawyers explain and interpret the more obscure statutes, advise women on their legal rights in the office or factory, and write reports and recommendations to the secretary general of the party and to the various ministers. A recommendation that was successfully adopted for a while consisted of assigning special legal aides to the family courts (or more correctly, the Courts of Personal Status). These aides assisted the judge in interviewing women, interpreted for the judge, lawyers and often the plaintiffs, and did

follow-up to selected cases, especially those that involved custody of children. This experiment, which was carried out on a limited scale and only in Baghdad, was abandoned for reasons unclear to me. However, I was told that the law school is planning a special program to train legal aides who will fill the same positions.

One judge told me that the aides performed a very important and necessary function and that he was sorry to see the program stop. A few hours in his court made me see the value of these assistants. The pace of the proceedings and volume of cases are such that any help in court would make a great difference, especially to the women (and a few of the men) who are intimidated and baffled by the court experience.

Perhaps the most crucial area in which the regime has directly and indirectly been effective in altering the traditional role of women is that of labor. As stated in the political report, the regime's goal is to provide women with "equal opportunity for work." Towards that end, education is mandatory for both girls and boys until the age of sixteen and women are encouraged to enroll in the universities and professional schools where admission is strictly in terms of the grades attained in the high schools baccalaureate exams. All education is nationalized in Iraq: there exist no private schools or universities, and the Queen Alia College, a women's college founded under the monarchy, was closed down by the Ba'ath in favor of mixed higher education for everyone.

Men and women graduates of the higher insitutes and colleges are employed by the government and are assigned to their respective sectors.

The Iraqi Bureau of Statistics reported in 1976 that women formed 38.5 percent of those working in the field of education, 31 percent of those in medicine, 25 percent of lab technicians, 15 percent of the accountants, and 15 percent of the government bureaucracy. Salaries, promotions, and benefits are all regulated by the Unified Labor Code which grants equal status to men and women. Women, moreover, have special legal provisions that exempt them from night work and allow them a fully paid one month off before maternity and six weeks after it. Under the same law, women have full and independent access to credit and power to borrow money from the state.

This emphasis on and support of women's equality in the economic domain is consistent with the regime's aim of transforming Iraq into a "modern productive state"; it is also an area where a transformation in women's role is not likely to be challenged by conservative or religious groups. In fact, the general attitude toward women and work has already undergone a profound change in Iraq. Much of this change is a result of the government's redefinition of jobs and of its expansion of the public sector of the economy.

Despite its generally negative image in the foreign press and its virtual isolation within the Arab political scene, the regime has been both active and effective in launching a series of large-scale public projects. Using oil revenues carefully, it has invested in basic long-term undertakings such as a vast desalinization project in the south of Iraq and a huge petrochemical plant, as well as in construction and light industry. As a result, there has developed a

large and lucrative market for wage labor. This expanded market and the shortage of labor in the country (Iraq has a total population of approximately 18 million), along with increasing inflation and dependence on cash, have propelled women to join the labor force, not only as professional but even as unskilled labor. In 1978, for example, I saw women working on construction sites. Whereas this may be a fairly common sight in Egypt, it is an innovation in Iraq, where now, in addition to being clerks and government employees, women are street cleaners, and gas station attendants.

What is of special interest in all of this is that these women (and their male counterparts, for that matter) are all considered to be government employees (*muwazafin*), who receive salaries and are entitled to government pensions and medical insurance. The fact that these women are hired by the government and not by individuals in the private sector is largely responsible for the breakdown of the traditional reluctance to allow women to work for "strangers" outside the home. The government has also encouraged a new attitude toward work in general. For example, as part of their general educational campaign, posters and banners all over the streets proclaim slogans to the effect that "He who does not produce, does not eat" "He who does not work is without honor."

Husbands and fathers do not consider it shameful today to permit their daughters and wives to work since the women now work for the government and as such they are contributing to the "national struggle." Respectable young women are even beginning to join the national dance and acting companies or are employed in television as announcers, singers, or models, all of which would have been unthinkable not long ago. Interestingly enough, nursing seems to remain one of the few careers still stigmatized in Iraq. This is no doubt due to the fact that nurses come in close contact with male strangers and handle unclean matter. Thus while it may still be shameful and humiliating to work as a maid in someone's home, less shame is attached to being a street cleaner when one is classified as a worker with salary from an impersonal employer (i.e. the government).

This shift in attitude regarding women and wage labor raises serious doubts about our perceived notions of traditional Islamic societies and their attitude toward women working outside the home. Nowhere in Iraq did I hear anyone object to women studying medicine, law, or engineering, nor did anyone cast doubt on the reputation of television announcers and store clerks, all considered employees doing their job. I do not mean to minimize here the class differences involved, and it should be obvious that here (as elsewhere) upper class women are not generally the ones who join theatre companies or work in factories. nor does my observation necessarily call into question the general conclusion of Nadia Youssef (1974) to the effect that women in the Middle East are less active in the public work force than their Latin American counterparts for reasons having to do with cultural attitudes and constraints. That probably stillholds as a general observation for the region, but it is also equally true that attitudes and behavior are radically different in Iraq today from what they were in the thirties when women first went to college.

In 1936, a Muslim woman applied to and was accepted in law school in Baghdad. Upon graduation, Sabiha Sheikh Daoud became the first woman lawyer in Iraq, and, shortly after, she was appointed as a judge in juvenile court. In common with the other pioneering Arab women of her day, Mrs, Daoud came from a prominent famiy; her father was a distinguished jurist and the head of a religious order. In a book which she published in 1952, Mrs. Daoud recounts the difficulties she experienced, first as a student and later as a lawyer in Baghdad, describing the repeated efforts made by the conservative city notables to bar women from higher education and public employment.

Since the 1930s, Iraqi women have gone to school and graduated as teachers and then increasingly as doctores, lawyers, and pharmacists. But this was, until recently, essentially a middle- and upper-class phenomenon, one limited in scope and in consequences, as it was underwritten by a bourgeois reformist ideology which called for the need to educate women in order that they become "better mothers for the future citizens of the country." This is not the case of the Ba'ath ideology which calls for the liberation of all women and their full and direct participation in the new social order.

In both their formal and informal statements, party leaders readily acknowledge that women's personal status still lags behind both the role assigned to them in the political ideology of the Ba'ath and the realities of their changing role in the economy. They usually attribute this lag to the tribal heritage, itself perpetuated by British imperialism. It is well known that the British did much to encourage and reinforce tribalism in both its political and cultural forms. For example, in 1918, they instituted the Tribal Legal Code which differentiated between "tribal" and "nontribal" Iraqis. The Revolution of 1958 abolished the Tribal Code and declared all Iraqi citizens to be subject to the same national legal codes.

The lag in women's status, nonetheless, cannot be totally explained by the persistence of tribal customs and practices, unless one is to include among these the patriarchal values and attitudes expressed in the cult of virginity and sexual modesty for women. These values, of course, exist among tribal and nontribal populations alike and are reinforced by islamic notions of women's proper comportment and behavior.

Admitting to the presence of this lag, however, has not led the Ba'ath leadership to enact radical family legislation. In general, the Iraqi experience closely resembles that of Syria and Jordan, where a series of amendments and modifications have been gradually introduced into the law, amendments that deal with the different aspects of personal status.

The present Code of Personal Status was first promulgated on January 30, 1959 under the pre-Ba'ath regime of Qassem. It marked the first time in Iraq that the various laws and statutes concerned with personal and family status were systematized and organized into one coherent legal document. The preamble states that the Code drew part of its rules from the *shari'a*, without being bound by any one specific school of legal thought, and that it was also guided by the modern legislation of certain other Muslim countries such as the Egyptian Code of 1923.

Until the promulgation of the 1959 Code, Iraqi religious judges had based their judgments on either the Hanafi or the Ja'afari legal traditions, depending on the sectarian affiliation of the parties involved: Hanafi law for Sunni Muslims and Ja'afari law for Shi'a Muslims. The unified Code of 1959 applies to all Muslims who are Iraqi citizens; however, judges have the right to refer to Hanafi or Ja'afari laws in cases where they deem the Code to be unclear, inadequate, or inapplicable.

The preamble to the Amended Code of 1978, states that the Code is based on the principles of the *shari'a* but "only those which are suited to the spirit of today and on legal precedents set in the courts of Iraq, especially the High Court and on the principles of justice."[5] The most important new amendments in it follow. The relative conservatism of these stipulations is especially notable

Capacity for Marriage: In the 1959 Code, it was stipulated that only those who were mentally and physically mature could marry. Maturity, however, was not defined. A second clause did specify that these conditions are fulfilled when the parties reach their eighteenth birthday. Left unclear was a well-defined criterion for maturity for those under eighteen, a fact which caused much contention in courts and resulted in contradictory rulings

The new Code resolved this by substituting one clear statement to the effect that the conditions for matrimony are sanity (*l'aql*, or reason) and attainment of the eighteenth birthday. The minimum age for marriage and its conditions were also redefined: whereas previously it was required that both the man and the woman be sixteen and have the consent of fathers or legal guardians, the age was lowered to fifteen and the permission of the *qadi* or judge was added.

The lowering of the age of marriage was intended in part to address the reality of early marriage in Iraq, especially in the rural areas and among the poor. It also responds to traditionalist sentiments. Also important in understanding the intent of the provisions is the clause which states that "in the case where the guardian refuses to allow marriage and where the *qadi* sees no valid reason for this refusal, he, the *qadi*, asks the guardian to reconsider within a set time period; should the guardian still refuse, the *qadi* has the authority to permit the marriage." By vesting the *qadi* with this new authority to grant the young couple permission to marry even against the wishes of the father, the law has in effect posed a direct challenge to the traditional autonomy of the family and the authority of its head. Power, at least in part, is now vested in the state through the judges it employs

Forced Marriage: *Jabr* refers to the act of forcing a young woman to marry a man without taking her wishes into consideration. Among the tribally organized populations of central and southern Iraq, tradition allowed the father and other senior males of the famiy to exercise full control over the marriage of female members of their family. *Jabr* was also manifested in the traditional right of the man to marry his father's brother's daughter or, when he himself did not wish to marry her, his right to forbid her to marry anyone else without his consent. The issue of forced marriage was totally neglected in the 1959 Code.

The 1978 legislators considered forced marriages to be void if they were not already consummated. When consummated, divorce was provided as an option should one or another of the parties so desire. Penalties were also specified for those found guilty of forcing marriage upon a man or women. Of special significance here is that the legislators differentiated between two categories of relatives. Parents could be penalized by imprisonment for a period of no more than three years or the payment of an unspecified fine or both. Relatives other than parents, including brothers, uncles, cousins, and certain other kinsmen, could be imprisoned for a period of not less than three years and not more than ten. The nuclear family thus was clearly separated from the larger extended one, and the traditional authority of kinsmen vis-a-vis women of the group was strongly rejected.

These provisions appear to be consistent with Iraq's strong drive for economic development and modernization. Modernization, among other things, consists in the erosion of encapsulating groups like extended patriarchal kin groups and in the dirct articulation of individuals as citizens into an all-pervasive state apparatis. In fact, it may well be that the success of a modernizing socialist regime is partly contingent on its ability to free individuals, men and women alike, from their familial matrix, one which usually competes with the state for their loyalty.

These measures are also consistent with modern interpretations of the *shari'a* that claim that marriages should only be contracted with the full consent of the parties and that a woman has the full right to refuse whom she does not want as a spouse. Of course, in this case the state, rather than religious personnel, interprets the *shari'a*, a substantial procedural shift.

Polygyny: On the key issue of polygyny, the new Code has little to say directly. A number of new clauses seem to have been designed to discourage it. For example, the 1959 Code decreed that an additional marriage, albeit valid under the *shari'a*, was liable to criminal sanction if it was not first cleared judicially and registered. Yet, penalties for failure to register marriages, were not specified. The new Code of 1978 defines these penalties clearly; for failure to register a marriage, a man is liable to imprisonment for six months to a year or a fine of 300 to 1,000 dinars (approximately $900 to $3000). If the husband already has a wife, rendering the unregistered marriage polygynous, the penalty is stipulated as imprisonment for a period of not less than three years and not more than five. Fines are excluded.

The need to obtain the permission of a judge in order to contract second marriages is an important condition designed to limit polygynous marriages, for in granting or refusing permission, judges take into account such matters as the man's financial status and the reason for the second marriage (e.g., sterility of the wife, her ill health). Furthermore, the new Code added an important clause: a wife could divorce her husband should he take a second wife without the judge's permission. Women are granted the limited and residual right to ask for separation (with alimony) should their husbands acquire another wife without the *qadi*'s consent, a consent which presumably would be granted only for some good reason.

Divorce: The various statutes dealing with the dissolution of marriage are grouped under the heading of *tafriq*, a category that includes the Arabic term usually translated as divorce. *Talaq* is in reality but one form of divorce in Islam and is more accurately translated as repudiation.[6] In the *shari'a* not only *talaq* the unilateral right of the husband, but it may be valid without any legal process and it may even take place in the absence of the wife. This is not to say that arbitraty divorce is not discouraged, nor to deny all of the measures designed to act as restraints on the abuse, such as the *'idda* or waiting period and the *tahlil*, which stipulates that for a husband to take back a thrice repudiated wife, she must first conclude a marriage and divorce with an intermediate party. Second, there is *khul'*, *mukhala'* or renunciation, which is voluntary divorce with the agreement of the two parties, as differentiated from the *talaq*, where the wishes of the woman have no bearing on the husband's rights. The usual pattern here is for a clause to be included in the marriage contract whereby it is stipulated that the wife can obtain a divorce in exchange for an agreed upon sum which she pays to the husband. This sum is presumably to be used by the divorced husband as all or part of a dowery for a new wife. Third, there is *tafriq al-qada'i* or divorce through the actions of the courts.

. Whereas the 1959 Code dealt with the whole matter of divorce in an offhanded and summary fashion, the 1978 Code gives considerable attention to the subject, adding new conditions which allow for the initiation of divorce proceedings by both the husband and wife. In what follows, I shall concentrate on the part in the Code entitled "divorce" and discuss some selected items therein.

Article 40 in the divorce section identifies certain conditions which permit either party to initiate divorce proceedings. One such condition has to do with abuse and the infliction of personal injury. The original 1959 Code required that the qadi appoint arbitrators or referees, one each from the husband's and wife's families, to validate the claim of injury before the case is allowed to proceed. In the 1978 Code, the judge himself can decide on the claim of injury without necessarily involving referees from the families concerned.

Another condition identified in the Cade is that of marital infidelity. Previously, the term employed was *zina* or fornication. The substitution of the term marital infidelity, *khiyana zawjiyya* for fornication or *zina* connotes a real change.

Previously, a husband's adultery was not considered within the fornication category as a valid cause for divorce, unless committed within the conjugal home. A woman's adultery constituted fornication regardless of where it was committed.[7] Moreover, fornication was always associated with the woman, whereas the new phrase is more general and draws attention, as it should, to the betrayal of the marital relationship by either spouse.

Again, the intention of the legislators seems clear: there is a shift in emphasis from family honor, as demonstrated through the sexual behavior of the woman, to the importance of the conjugal unit. The shift is also consistent with the emergence of the nuclear family as the overriding family group and

its increasing independence from the larger, more encompassing extended family unit. Concomitantly, the conjugal bond between husband and wife assumes more significance. Finally, holding the husband responsible for his sexual behavior both within and outside the conjugal home underlines that women's rights are no longer confined to the traditional sphere of the home.

Child custody: Important amendments were also introduced into the laws governing child custory. The aim of the amendments is to safeguard the well-being of the child who is explicitly singled out for consideration and protection. Generally, under the traditional interpretations of *shari'a*, the child is not viewed as having inherent rights, while the mother's rights extend only to the child's first few years. After that time, the child is transferred to the father or his family and kin group. The right of the father and his family to the child after the first years of life is consistent with the whole complex of patrilineality and patriarchy.

The 1959 Code augmented the mother's rights somewhat. She was given custody of the child, male or female until age seven. The 1978 Code increases that age to ten and adds that custody might be extended until age fifteen if a committee of experts so recommends on the basis of the child's welfare. Furthermore, upon reaching fifteen, a child has the right to decide with whom to live among his parents or other relatives.

Moreover, should the mother prove unfit to hold the custody of the child, custody will not automatically be transferred to the father. The court in this case has the right to choose the best guardian. The guardian may be unrelated to the child, and under certain conditions the court can decide to put the child in an appropriate government center. Last but not least important is the new stipulation that when the father of the child dies or is found to be unfit as a guardian, the child remains with the mother, and none of the child's relatives has any right whatsoever to take the child away from the mother, with whom the child must stay until reaching maturity.

The measures discussed above, mild and cautious as they may seem, are nonetheless viewed by some Iraqis as subversive. They are regarded as a preliminary step to planned radical reform that would involve the promulgation of a civil code much in the Turkish manner. Given the ideology of the Ba'ath, they argue, the delay is merely tactical in that the regime does not want to risk any direct provocation to the religious establishment, especially the Shi'a one.

Others criticize the measures on the grounds that "they do more harm than good" since they add to the stress and confusion already felt in the society. As one judge said to me, "These amendments are going to cause new headaches; they are going to make matters worse by making things more complicated. Women are led to believe that they have gained much more power than they actually have, and they will come more to court. But what they have really done (referring to the government) is to make things more difficult by granting women more rights without limiting those of men. They have made it easier for women to divorce, for example, whereas they should have made it more difficult for the man to do so. Tampering with one side and not the

other helps no one. In fact, a group of us practicing *qadis* are preparing a critical memorandum on the subject to send to the ministry of Justice.''

The judge, with his fifteen years of experience in the courts and sensitivity to Iraqi culture, is probably correct in his general prognosis that these measures will not substantially ameliorate the legal status of women but may, in fact, contribute to social tension. At the root of such tension, however, is the larger contradiction between the increasingly independent economic role assumed by women and the legal and cultural constraints that govern their personal lives. This tension between culture and society, which is present in most Islamic contries today and which, I believe, is at the heart of the ambivalance with regard to the proper role of Muslim women becomes most explicit and discordant in those states where the official political ideology proclaims the total liberation of women.

The Iraqi Ba'ath Party has been in power for a period of less than half a generation, and it may well be the case that it is too soon for a true assessment. It does seem clear, that despite its seculatist/modernist ideology and bold economic programs, the Ba'ath has displayed unexpected caution in undertaking reform in the area in which the Muslim ethic is most explicit, namely that of women and the family. The reforms enacted so far are, at best, compromise solutions. By basing the Code of Personal Status on the *shari'a* while choosing eclectically from among the different schools of law, for example, the regime has allowed itself maximum room for legal manœuvering while still remaining within the boundaries of Islamic tradition, which decrees that the individual's personal life be governed by Divine Law.

In general, compromise solutions like this are often the first step towards more radical reform. This appears less likely in view of the general mood in the Middle East today with the resurgence of Islamic fundamentalism and general cultural retrenchment. Iraq may be poised on the verge of a radical takeoff but this is no guarantee that traditional cultural inertia has lost its power.

NOTES

1 Quoted from the political report adopted by the eighth regional congress of the Arab Ba'ath Socialist Party. The report, entitled Revolutionary Iraq: 1968-1973, was published in Baghdad in 1974 and is widely available.

2 Sheikh Daoud, Sabiha, *The Beginning of the Road to Women's Awakening in Iraq*. Baghdad, 1958 (in Arabic).

3 The preamble to the 1959 Code and large sections of it are found in Kubba (1973), which also includes both the Hanafi and Ja'afari variations of some key articles in the Code.

4 The Ja'afari fiqh, which is sometimes referred to in Iraq as the fifthe madhab, represents a compromise Shi'a school of law and has its origins in the attempt made in the eighteenth century under Tahmasp Nadir Shah to effect a rapprochement between the Sunni and the Shi'a. Ja'afari fiqh is based, to a large extent, on the writings of the sixth Imam, Ja'afar al-Sadiq (d. 756).

5 The amended Code 21, 1978 was published in the official government paper on February 20, 1978. My analysis is also based on a special memoir available from the Ministry of Justice and on personal interviews.

6 As is well known, the juridical status of divorce in the *shari'a* is too complex and difficult for the nonexpert to tackle. For a concise and succcinct summary of the subject and of other issues of personal status in the Arabic speaking Middle East, see al-Mahmasani (1962).
7 Article 216 of the Iraqi Criminal Code states that whoever finds his wife committing zina and kills her on the spot may be sentenced to prison for a period of no more than three years. An informal survey indicated that the usual period of sentencing in cases of *zina* varies between three and six months!

REFERENCES

AL-KHOLI, al-Bahi, n.d.
 Islam and the Modern World. Kuwait (in Arabic).
AL-KUBAISI, A.
 1977 *Personal Status Law*. Vols I and II. Baghdad, Iraq (in Arabic).
KUBBA, A.
 1973 *Legal Reform and the Legislative Movements in Iraq*. Baghdad (in Arabic).
AL-MAHMASANI, S.
 1962 *The Status of Legislation in the Arab Countries*. Beirut (in Arabic).
MAHMOUD, T.
 1977 Muslim Personal Law. New Delhi.
WHITE, Elizabeth
 1978 "Legal Reform as an Indicator of Women's Status in Muslim Nations." In N. Keddie & L. Beck (eds), *Women in the Muslim World*. Cambridge: Harvard University Press.
YOUSSEF, Nadia
 1974 *Women and Work in Developing Countries*. Berkeley. Population Monograph. Series No. 15.

Women Development and Employment in Saudi Arabia: the Case of ʿUnayzah

SORAYA ALTORKI *

ABSTRACT

Saudi Arabia has been transformed economically and socially since the rise of oil prices in the mid-1970s. It might be thought that these transformations have resulted in women taking a more visible part in the Saudi economy. In fact, however, a study of the town of ʿUnayzah in central Najd shows that women worked in commerce, agriculture, and crafts long before the oil boom. What has happened is a decline in agricultural work, an increase in modern sector employment, and a continuation of commercial activity.

Introduction

THE DRAMATIC INCREASES in the price of oil in the 1970s have been the object of much attention on the part of theorists of development in the Arabian peninsula. To put it briefly, it is usually maintained that the rapid economic growth rates attendant upon these price increases mark a watershed in social change in Saudi Arabia. Thus, it is argued that prior to the oil boom social processes and structures had remained relatively unchanged over generations, whereas after the mid-1970s dramatic transformations occurred throughout the social and economic systems. This line of argument acknowledges that oil prices declined markedly after 1982 and never again reached the high levels of the late 1970s and early 1980s. Nevertheless, it emphasizes that petroleum prices have remained high relative to their early 1970s levels, a phenomenon that has permitted elites to advance economic and social programs that heretofore would have been unthinkable.

The changing role of women is considered to be part of the social and economic transformations attributable to the oil boom. More specifically, the visibility of women in the Saudi economy is said to be the product of the last decade and a half. Whereas they did not participate in the economy prior to the October War of 1973, it is supposed, they have since that time made their presence felt in a variety of economic sectors.

It is time to discard these assumptions in the light of the available data, much of it new and based on evidence that is increasingly being reported by

* Department of Sociology, Anthropology and Psychology, The American University in Cairo, P.O. Box 2511, Cairo, Egypt.

social scientists who have had the opportunity to do detailed field research. This new evidence allows us to say that the earlier notions, fostered even in academic research and mainly based on intuitive or incomplete assessments, were wrong. In fact, female participation in the economy is not as new as some have indicated, although its visibility may not have been clear to those with inadequate opportunity to observe.

In my own research in the central Najdi town of ʿUnayzah (population 26,990 in 1986) I have been struck by the unreality of the standard interpretation. In this paper I will argue that women have been employed in agriculture, commerce and the crafts for centuries prior to the establishment of the modern state (1932), and that the patterns of their participation in the economy during the last decade and a half do not mark a sudden break with the earlier period. What the oil boom has produced is modifications in female employment patterns in agriculture, the crafts and commerce. It is true, though, that one consequence of the boom has been the creation of new employment opportunities in the service sector—especially education, although even here, it must be noted that women had worked as teachers, for example, long before the 1970s.

In this paper, I will define development as a process that entails improvement in the standard of living of the people—their nutrition, health, housing and education. While I will maintain that improvements in these areas certainly have occurred in ʿUnayzah, it may be concluded that such rewards have been not altogether unequivocal 'for the town's women. That transformations have occurred in their lives may not be doubted, but whether such transformations have indeed been as salutary as the theory of development suggests is open to doubt.

Pre-Oil Boom Female Rural Employment Patterns

The organization of work in pre-state and pre-oil boom Arabia was centered on family and kinship networks. However, those who cultivated crops did not draw their workers exclusively from their own family members and relations. Interviews with the residents of ʿUnayzah show that cultivators also used to hire neighbors to help them farm the land. Specifically in regard to women, they participated in agricultural activities, both in their capacity as members of the family unit and also as hired help on the land of neighbors. This is quite different from the standard view of women as having been confined to their own households and banned from working outside the home because of certain cultural norms that, it is alleged, effectively prohibited such activity.

Consider, for example, the story of Umm Fahd, a woman informant who told me that in the 1940s her husband hired a family to help on their farm in the environs of ʿUnayzah. This family consisted of a man, his mother, his wife, and their children. Among the activities that the mother and wife undertook was the guidance of the camels, which were hitched to an irrigation apparatus and were led to walk back and forth to draw water. Other duties performed by these women included the preparation of food for the camels to eat and

levelling the ground that had been churned from the effects of the camels walking back and forth.

Women's agricultural work in the past was a critical component of daily life. Agriculture in ʿUnayzah in this period typically involved palm trees, wheat and alfalfa. Generally speaking, female agricultural labor in the pre-boom period did not extend to work related to palm trees. Only rarely, when a family's resources were severely limited, did women take part in the planting of these trees, tending to their growth, pruning, fertilizing and harvesting the dates. However, once the dates were gathered, it was women who sorted them arrayed them in boxes or tins with some syrup, and pressed them in their containers.

The other major agricultural crop in the pre-boom era was wheat. Female labor in regard to wheat came somewhat toward the end of the process—harvesting the wheat, piling it in stacks, helping to transport it, winnowing and sifting it (after the men had thrashed it), re-threshing it when necessary, and sacking the grain. In reard to alfalfa—the chief fodder crop—the role of women in its cultivation was similar to that in regard to wheat. However, women's involvement in alfalfa was more intensive than for other crops because this crop grows quickly and requires more frequent cutting—a fact that necessitated working practically every day.

As for vegetables, women shared the process of planting and irrigation with the men, but they alone were responsible for weeding, maintenance and harvesting of the crops.

Non-agricultural rural work for women in the past occasionally included wood gathering. However, this was a task that was quite onerous, and only severe hardship induced men to permit their women to engage in this activity.

In summary, women's employment on the land in the past was significant. Usually, it was in the context of working for the family, although there were times when women were hired with their husbands and other kin to work on the land of another family. Compensation for this latter type of work was in kind, not money. There would also be times when women would help neighbors to harvest their crop—especially wheat. Community norms emphasized the need for neighborly assistance, and those being aided in this way offered meals to their helpers in token of their gratitude.

The literature suggests that female rural employment in the past was twice that of female urban work.[1] Kurayyim estimates that the rate of Saudi Arabian female participation in agriculture in 1970 was as high as 81.5 percent of all rural women.[2] Azzam, however, puts it lower, at 59.8 percent in 1974, the first year of dramatic oil price increases.[3] Either way, these figures alone suggest that women were expected to work and were not confined to their harems by their menfolk.

Trends in Female Employment in Agriculture Since 1974

Let us now examine the situation since the onset of the boom (tufrah) made possible by high petroleum prices. With large revenues at its disposal,

the Saudi government naturally wished to allocate significant amounts for the development of the countryside. But the country has faced significant labor shortages, and this has posed a dilemma for Riyadh. Either the government could encourage growing numbers of the female population to replace the men who increasingly were turning to the urban areas for employment or it could rely on expatriate labor to fill the gap. If it chose the first option, it would risk the possibility of underwriting a much more active role for women in the economy outside the family farm, for—as already noted—pre-state and pre-boom female rural employment was essentially in the context of working on their own family plots. Moving to a new system by replacing men with women for agricultural jobs as a whole would mean that women would be brought into far greater contact with all aspects of the agricultural market. This inevitably would bring them into unprecedented proximity with those men who continued to hold important positions in this market. Were the regime to move in this direction, it would be encouraging breaches in community norms that have so far maintained a stricter segregation of the sexes.

On the other hand, if the regime chose to rely more on expatriate workers to fill the gap by the departure of Saudi Arabian men for urban employment, it could risk the rapid influx of cultural values that to some extent might contradict those of Saudi Arabian society, unless the tightest possible control was placed on the movement of these foreign workers. It is basically the second option that the government has chosen since the mid-1970s, although as oil prices slipped after 1982, many of the expatriate workers—mainly Egyptians and Pakistanis—who had been brought in to replace male agriculturalists were let go and repatriated to their own countries.

What has happened to the family plots in the ʿUnayzah region since the onset of the oil boom? As the men have left the land, female cultivation on these plots has also declined. Not all of these individuals have left the farms altogether, however. Many have remained as managers of lands now worked by expatriates. On the other hand, a number of these women who formerly had worked on their family plots has now entered crafts production and commerce, a topic to be addressed below. Indeed, a few women have even come to own their own enterprises.

Additionally, as we shall later see, as the government has been able to allocate more funds for education, more Saudi Arabian women have received secondary and higher education. This, in turn, has permitted their greater participation in the service sector of the economy, especially teaching, nursing, clerical, and other administrative jobs. The down side of this picture is that the recession that began in 1982 caused unemployment for many of these women.

Women in Crafts and Commerce Before the Oil Boom

As with agricultural work, female employment in crafts in previous years was centered in the family unit, but women also participated in crafts productiona and sales in the traditional market of the town. The 19th century European traveller, Charles Doughty, recalls observing women managing stalls in

the market [suq], although he noted that these stalls were located away from the main shops.⁴ The produce sold by these women included onions, eggs, salt, nails, matches, bread, milk, chickens, and tanned products.

The following are some comments by Abu ʿAlī, an older male informant, regarding the part played by women in old ʿUnayzah:

> There were women who carried sweet water in jars on their heads from one of the four main sweet wells. They worked within the town and carried the water to the houses of many people who did not have sweet water in their houses. These women were paid on a monthly basis and they brought the water to the houses every day without fail.

The water carrying trade was apparently one that was passed on from mother to daughter.

Women also participated in tanning, an activity that was undertaken in the tanners' homes, located in a special section of the town on account of the bad smell associated with this enterprise. According to Abu ʿAlī, some women also used to make products from the leather produced in the tanning process. These products included buckets, milk containers, babies' cradles, belts, sandals, and the like.

Evidence exists, also, that females were employed in the pre-boom period in the production of mud-bricks for housing construction. Other crafts activities in which they engaged, where production occurred in the domestic household, included weaving, sewing, and baking. The latter, as one might expect, represented a major part of female crafts activity.

Although it is difficult to provide a detailed picture of female employment in crafts and commerce for ʿUnayzah's pre-boom period, it is clear that not only did such crafts activity exist, but it was not exclusively confined to the household, either. In short, ample precedent existed for women's participation in market activity outside the home prior to the post-1973 era. As we shall presently see, patterns established in the pre-1973 era shaped the nature of women's market employment in the later period in very significant ways.

Female Employment in Crafts and Commerce in the More Recent Period

The old market, where women had sold products in a special section, was razed in stages, beginning in the late 1970s and fully reconstructed by 1985. During this transitional period, the women's market, as it was called, was apparently moved on four different occasions to a new location. The first move placed these women in an uncovered area, where they not only were subject to the vagaries of the weather but they had to take all their wares home at the close of every day and carry them back at the start of the next day. Later, they were moved to another open space but this time provided with lockers, which served the dual function of protecting their commodities and functioning as a modified "storefront." Their business did well in this new location, according to informants, but their male counterparts who were selling goods in an adjacent area became envious of their success. This eventuated in a third relocation nearby but this time along city street sidewalks. In 1982 town officials provided

these women with a covered market abutting the main storefront, but this site, too, is not considered permanent.

Space for their stalls is provided by the city, and conflicts (for example, over encroachment on allocated spaces) among the women appear to be kept at a tolerable level. These women sell a wider array of commodities than reported for the earlier period. These goods range from spices, pots and pans, silverware, perfumes, soap, dye, biscuits, chocolates, nuts, baked goods, leeks, pumpkins, clothing, shoes and sandals.

Transportation to and from the market for these women is provided by their menfolk, who drop them off. Unlike the main market, the women's market does not close for prayers. They either pray at their stalls or in an adjacent mosque built for them. All market women veil rather strictly, although some will unveil in the absence of men.

One of the most significant social changes involving female merchants in the market is the greater prevalence among them of Bedouin women. Of the 130 women in this market, 15 are Bedouins. According to my informants, some of these Bedouins used to be themselves customers in the women's market. Exactly what accounts for their turning to commerce is not clear, although part of the answer may be that quite a few of their men employ themselves as sellers in the men's market. For reasons that are not altogether clear, women residents of ʿUnayzah (as opposed to Bedouins) who work in the market do not have many male relatives who work in the men's market.

The women sellers are all illiterate, above the age of 40, and are either married, divorced or widows. Community norms rule out unmarried young women selling in the market. They tend to be poor, although I could identify a few who were well-to-do. A government agency, the Real Estate Development Fund, has provided loans to many of these women's families for housing.

Revealingly, one may find among these 130 women representatives of all three of ʿUnayzah's status groups: pure-tribal (qabili), non-tribal (khadici), and slave-descent (ʾabad). Among the non-Bedouin women in this market, quite a few had formerly been agricultural workers who gradually moved into the suq over time. Typically, these female cultivators had additionally sold commodities, such as baked goods, woven straw products, and the like, in the market. The permanent relocation of this market occurred after their children had pased the child-rearing stage. Market activity for a female agriculturalist was all the more likely in the event her family was in need of extra money or she had become too old to continue with the arduous work on the land.

Sometimes, women would move to the market to sell not just products that they were making on the farm but to sell items commissioned by others. In the case of Umm Yusif, a grandmother above 50 years of age, other women, including strangers who had confidence in her honesty because of her reputation, prevailed upon her to sell their gold jewelry on commission. Umm ʿAbd Allah, a 60-year-old woman, sold not gold but cloth on commission before she decided to buy the cloth and sell it directly herself.

Most of the 130 women in ʿUnayzah's market work full time, although about 25 come only in the afternoon. These latter hold down other jobs in the

morning, especially in the town's schools, where they work as attendants and messengers.

The women's market operates very much on the basis of credit extended to them by wholesalers, although there are cases where the latter deal only on the basis of cash. While records are kept of debts, many wholesalers rely on the integrity of the women to repay and do not engage in dunning them, which would appear unseemly. In order to obtain such credit, however, one must first establish trust, something that is not easy to do when the wholesaler is restricted to identifying the woman merely as a voice behind a veil. Women thus establish a record of integrity by initially paying cash for commodities, and then the cash payments are replaced by credit arrangements.

It thus becomes clear that the wholesaler-retailer relationship is markedly informal. The illiteracy of the women means that they rely upon the wholesalers to keep accounts of debts owed. Yet, the latter seldom keep registers, so the entire system appears to rest on memory and trust. It is rare that bitter conflicts occur, since each party needs the other and their mutual interests work to keep the relationship on an even keel.

As for the retailers vis-a-vis their customers, here, too, credit arrangements are maintained, although they apper to be the exception, rather than the rule. When credit is extended in these cases, it is to local townswomen and Bedouins. Occasionally, customers fail to repay after having purchased on credit, but these cases are too infrequent to bring an end to the system.

The reader may have noted that the credit arrangements that have been reviewed thus far involve repayment without interest. Yet, women merchants do borrow from moneylenders (as opposed to wholesale merchants), and my research shows that this borrowing is not simply a product of the most recent period. Umm ʿAbd al-Rahman, over fifty years old when I interviewed her, told me her story of opening her shop in the old market:

> I borrowed 500 riyals from a man who lent money. I used this to buy merchandise and to start buying and selling. I rented a shop for 30 riyals a year. Later on, I had to borrow more money and once again I borrowed 400 riyals from another man. I was careful and was lucky to be able to pay both of them before the year was up.

I discovered a wide variation in profit-making from the sale of commodities by these women. For example, those who were commissioned by townswomen to sell the latters' baked goods typically charge an additional five percent to the price set by the bakers themselves. Compare this to the prices charged by a seller of pots and pans, who purchased a set from a wholesaler for 80 riyals and resold them for 110 riyals, netting a profit of 37.5 percent.

Establishing a price for commodities is usually a product of consultation. In many cases, the merchants consult among one another; but they also may consult with their relatives. The general expectation among these women seems to be that prices will reach a basic level according to the normal operation of supply and demand. There is, of course, a variation across the women's market in the price charged for the same commodity, but the variation only occasionally becomes glaring.

Social etiquette frowns upon rival sellers outbidding each other for a customer. Neither do the women advertise their wares, relying, instead, on knowledge gained by customers from informal networks regarding the quality and integrity of the commodities and their sellers. The merchants establish their own solidarities, which include eating lunch together or sharing coffee; but their cooperation with each other also extends to directing customers to their neighbor merchants when they are out of an item, or minding a neighbor's stall in the latter's absence and even selling that individual's goods to a customer for her—rather than trying to attract the customer for herself.

Women merchants will sometimes be able to save enough money to make investments outside the suq. Their illiteracy makes it difficult for them to acquire the knowledge necessary to reinvest in their modest operation and expand it into a larger store. They stay away from banks in view of the paperwork and other formal arrangements that these institutions require for the handling of money. The normal outlet, then, is real estate. In this way, the activity of the women merchants becomes linked to the wider economy, although in a quite modest way.

Altogether, the pre-boom patterns continue to exert an influence on the new women's market in ʿUnayzah. This market continues to be organized by traditional patterns of buying and selling. The women's businesses continue to be small-scale, and even though they have introduced new products (e.g., children's clothing), and sell better quality products, they have not modernized their operations.

Falling prices in the oil market since the early 1980s have hurt sales in the women's market, since the purchasing power of customers has been adversely affected by the retrenchment. Looking back fondly upon better times, my informants would declare that "the market was hot" and "we sold so well that the men were envious." It remains to be seen whether continued opportunities for education for the daughters of these women will finally lead to the disappearance of ʿUnayzah's women's market. For the time being, though, it seems likely that a place will continue to exist for this market to serve customers with essentially modest wants whose needs can be satisfied by purchasing the products available there.

Women's Employment in the Modern Service Sector

Contrary to commonly held views, female education in Saudi Arabia is not a product of the era of rapid social change. Girls came to be taught in informal schools established by women in their own homes well before the 1950s. Memorization of Qurʾanic verses took place in these schools. A sort of graduation ceremony took place when the student had succeeded in memorizing an entire section of the Qurʾan. But girls who reached this stage had also entered into puberty and hence stopped attending in consequence of their confinement to their own households, a practice mandated by community norms. Those few with the initiative to do so would continue their education on their own by reading books and other materials that were available to them at home.

Parents valued religious education for their daughters, but the wealthier families came to value secular subjects for their girls, as well. When the state began to establish schools for boys in the 1930s, some of their sisters eventually were sent to be tutored by the wives of the boys' teachers. In this way, in the 1950s they came to study arithmetic, grammar and writing in addition to learning the Qur'an.

The government opened the first state school for girls in 1960. 'Unayzah was one of the locations selected for the establishment of the 15 girls schools opened in that year by the regime. Although individual parents may have resisted sending their daughters to the 'Unayzah girl's school, we know from attendance figures that girls education was a popular idea. In 1960, the attendance at this school was 285, but in 1961, it increased to 680.

In 1970, an intermediate school for girls began instruction, and in 1974, a secondary school was established. As a measure of the rapidity with which educational opportunities for females in this town have expanded, we may note that during my field research there in 1987, I counted 29 primary schools, six junior high schools, and two high schools for girls. The combined enrollment of these schools as of 1986 was 5,893 (approximately 22% of the town's population), with 503 teachers. The student to teacher ratio for these institutions was quite favorable, as well, with 12 students for every teacher. In fact, the ratio for girls was better than that for boys.

Eventually, teacher training schools for women came to be established in 'Unayzah in the 1960s. By the time of my field research, these had been absorbed into a new teachers' training college (established in 1980). Two years of instruction at this institution beyond high school results in the certificate for teaching at the primary school level. Those seeking to teach at the junior high and high school levels must earn a university degree.

Rounding out this picture is the existence of a private girl's primary school and five pre-school establishments which are a combination kindergarten and nursery. Three of these five are government-run, while the other two are privately managed.

'Unayzah's experience with expanding enrollments for girl students is generally similar to, although lagging somewhat behind, that of Saudi Arabia as a whole. Statistics for 1964-1965 show that the combined enrollment for girls in all primary schools in Saudi Arabia was 45,143, while the combined primary school, junior high school, and high school female enrollment state-wide in 1979-1980 was 434,412. The percentage increase in 'Unayzah's enrollment from 1960-1986 was 756 percent, whereas statewide, the percentage increase from 1964-65 to 1979-80 was 862 percent).[5]

Since the late 1970s to the early 1980s female education has come to be the norm. Correspondingly, this has meant opportunities for women to gain modern employment. In 'Unayzah, such modern employment for women is manifested mainly in their role as teachers and school administrators. They also have come to be employed in the fields of nursing, office work (where they are mainly typists and secretaries), journalism and banking (where they are cashiers and tellers). Finally, as noted before, some women are employed as attendants (*farrashat*) in schools and offices.

Salaries for teachers can go as high as 13,000 riyals a month for those with long experience (approximately $3500.00 at the current rate of exchange). This is a significant amount, and the expectation of earnings from teaching are sufficient to attract individuals into this profession.

ᶜUnayzah also has a nursing institute, which was established in 1981. After a four-year cycle of studies, the first graduate cohort of 48 women entered the field, almost all of them employed locally or in nearby towns at clinics, hospitals, school hygiene centers and ᶜUnayzah's Social Affairs Center.

Since nurses generally do not work in sex-segregated environments, inducements to attract women into the profession have to be accordingly greater. Thus, scholarship stipends for nursing students are 80 riyals per month higher than for science students and 1000 riyals more than for humanities students. A starting salary of 4,500 riyals per month for nurses working in the governmental civil service (not including fringe benefits) compares favorably with salaries in other professions open to women. Saudi Arabian nurses do not have to serve on night duty, and their contact with males is restricted to doctors and other health professionals.

Social background data for nurses reveal that they are mainly from lower class backgrounds. But individuals from more well-to-do or more established families are also represented among the ᶜUnayzah sample. Female employees in education, by contrast, come from all social backgrounds. Although many enter these two professions out of ecenomic necessity, a fair share commit themselves to work out of a sense of duty and social conscience. One of my informants—Fatmah—clearly exhibited both of these aspects in telling me of her first teaching assignment in 1974 in a village that was two hours (and in bad weather, four hours) ride from ᶜUnayzah. Receiving her first paycheck, she presented it to her astonished father, who wondered what to do with the money. Fatmah, who had insisted upon taking the job so as to be able to contribute to her family's requirements, explained that she also enjoyed teaching and derived great satisfaction from seeing her charges continue their education and so improve their lot.

It might have been expected that daughters of wealthy families would be discouraged from working. But I found instances in which the father was willing to have the daughter become employed, or even to stipulate to her intended spouse that he not object to her working after marriage if she wished to do so. In seeking to find the motive for these fathers' behavior, the common denominator would appear to be their desire to satisfy their children. Although one must not rule out the financial contribution the daughter might make to the household budget as a motive, still the wealth of these individuals would seem to indicate that such supplements as their daughters might be able to contribute to their overall budget would be unnecessary.

It should also be noted that the women have their own motives, beyond the satisfaction felt from a job well done, as expressed by the case of Fatma, or by contributing to the family's fund. For women, employment is a form of liberation from the confines of the household. It provides opportunities for widening one's social horizons. Although the restrictions on single women in

the home are no longer as severe as they used to be (for example, today they may even venture into the market, once strictly taboo), employment means the chance to interact with others and to gain information about community affairs. In this sense, employment becomes the natural extension of the educational process: both are aspects of the overall growing experience.

The above considerations suggest that multiple motives exist for modern education and employment for women. It remains simply to add that these motives appear somewhat removed from the idea that one values work in itself, that human labor is an ennobling experience. Although the people with whom I discussed such matters may have latently harbored such sentiments, they did not express them to me.

Women's Involvement in Voluntary Associations

Voluntary associations are the product of urbanization and other modernization forces. Today, women's participation in such associations is seen partiuclarly in the Committee for the Cleanliness and Beautification of the City of ʿUnayzah [CCBCU]. This Committee has attached to it a subcommittee of 13 prominent townswomen that acts as a liaison for the CCBCU among the schools and other institutions where females are employed, as well as the general female population of the city. Its work is largely informational and fund-raising in nature.

Another community voluntary agency is the Center for Social Services, partly funded by the state and partly by the town of ʿUnayzah and its citizens. Among the projects completed by the Center are the construction of kindergartens, provision of transportation and volunteer summer teaching programs. A special education program for illiterate women is managed by the Center, and other programs offer instruction in sewing, Qurʾan, typing, and a projected course in the use of computers. Other activities managed by the Center and in which women participate are a summer program that teaches home economics, handwork, art and design, and the like. A library for women is administered through the Center, as well, and this library sponsors cultural events and competitions.

Women's Participation in Business and Property Ownership

There are a few examples, in ʿUnayzah, of women owning businesses. One such enterprise is tailoring and embroidery. The government has actually encouraged women to master this trade with the establishment of a special training institute. Women have been provided with a stipend of 400 riyals per month to take a two-year course of training. Although many who take the training courses do not go into business, the state provides attractive loans of up to 200,000 riyals for those who wish to do so. Qualifying for the loan requires collateral, and providing such collateral is often difficult because men object to women going into business for themselves and their cooperation is necessary to secure the loan. Even when men suggest partnerships with

women, things do not always go smoothly, because male tailoring establishments have preceded the women's enterprises by many years and are more efficient in marketing their goods.

Women are also increasingly participating in joint business ventures with male relatives in Saudi Arabia, a pattern reflected to an extent also in ᶜUnayzah. Where such ventures are initiated, records are rarely kept. In one case, a woman became partner with her husband and her brother to open a shop. No documents were drawn to record this arrangement, and the shop, which she was supposed to manage, began to lose money because she was too busy with her duties as a teacher and wife. Her husband and brother thereupon urged her to liquidate the business and keep whatever money was left over for herself.

In another case, a woman whose husband had a second wife decided to put down a substantial amount of money (200,000 riyals) from her savings toward the purchase of the house where they were living. Feeling insecure because of the husband's other family, she suggested that they register the house in both their names. He refused to do so, and she had to be satisfied with a written statement signed before witnesses that half the house was hers.

Mounting Domestic Conflict as a Consequence of Women's Employment

In consequence of the changes that have occurred in the last two decades, ᶜUnayzah may be said to be a predominantly middle class town, now. The townspeople have moved out of agricultural production and into agricultural management positions. We have documented the continued participation of ᶜUnayzah's women in the crafts and commerce, as well as the movement of some of them into salaried positions in the service sector.

Although the fathers and husbands are still considered the providers for the family—responsible for providing food, shelter, clothing, health care and some entertainment—the salaries of some of their women have led to a certain autonomy for them to which these men are unaccustomed. Even women who turn their salaries over to their fathers and husbands to manage for them may be said to have acquired a status not previously encountered.

This has led to an increase in tensions within families which parallel growing conflicts that I have documented elsewhere in studying elite families in the metropolitan city of Jiddah.[6] As we have seen, ᶜUnayzan women with their own sources of income from employment (cf. inheritance or other forms) face a number of options for its disposal. What is unsettling to family relations is that no commonly defined and accepted parameters yet exist for the use to which their employment earnings may be put. This is only natural, given the relative novelty of the situation, but its consequence is that families are basically proceeding on a trial and error basis. One of my informants even told me that

> I suspect that in the future women will be richer than men in ᶜUnayzah. We do not want this, but that is what will happen because women save their income and men spend theirs [on household expenses and maintaining the family].

Even if this prediction proves to be wrong, the fact that it is a held opinion suggests some underlying tension. Thus, the potential for conflict is greater than it was before, although I should hasten to add that when it does occur, it seems to involve wife and husband rather than daughter and father. The norm of filial piety is stronger than that of conjugal piety, and unmarried women continue to respect the claims their parents make on their earnings.

Among married couples relationships are undergoing some dramatic changes. Duties heretofore clearly articulated for each spouse are no longer so clear cut, and the conjugal pair are sharing more time and activities with each other than previously. Although he may find it difficult to get used to it, the husband is increasingly facing the possibility that his wife is contributing to household expenses. While this circumstance does not necessarily create conflicts—indeed, the husband may welcome such contributions—it may breed feelings of insecurity for him. Different role expectations on the part of these spouses have been known to lead to open breaches and even divorce.

In ʿUnayzah, as elsewhere in the country, the tactical mobility provided by independent income from employment is a subject of community discussion and newspaper accounts. Awareness of these issues has reached such a level that marriage contracts increasingly contain specific clauses regarding the right of the bride to work after marriage.

Employment income may be regarded as a supplement to the *mahr* (bridewealth) that the groom has historically provided for the wife. Because of the relative ease with which men can divorce women under Islamic law, and due to the continuing possibility that a man may have more than one wife, women have traditionally felt insecure in their marriages. Income from employment, therefore, is seen as an additional hedge against insecurity.

Yet, this income can itself create its own tensions between man and wife. Furthermore, husbands may insist that all income derived from their wives' employment be surrendered to them. Thus, income from employment is not the panacea that some might feel it to be as far as marital relations are concerned.

Additionally, the traditional cultural norm of sexual segregation has militated against women working alongside men in manufacturing and other non-service related jobs. Thus, no matter how highly trained or educated women may become, they are prevented from taking many positions for which they may be otherwise qualified. Working for the government in relatively high paying positions was always a possibility for them because the government has traditionally had access to massive revenues that have enabled it in effect to duplicate its bureaucracy in many areas. Thus, men and women would be hired to work in these separate bureaucracies. Now, even that is becoming increasingly problematical.

Conclusion: Women and Development

In 1986, a year before my field research in ʿUnayzah, the price of oil nosedived to below $10.00 per barrel, whereas it had reached as high as $34.00

in 1979-1980. As of mid-1990, the price of oil per barrel is hovering at $14.00, still dramatically less than the peak years. Thus, the state's third and fourth development plans inevitably have reflected a scaling back of the more ambitious targets of the plans of the boom years.

The steady decline in the price of oil since the early 1980s has had some adverse repercussions in ʿUnayzah. The government is naturally spending less in the municipality and the region, a fact that has meant either the loss of existing jobs or the absence of new jobs. This has caused distress among the women of ʿUnayzah, whereas the discomfit caused to the male population perhaps is less because men are more mobile and can seek better employment opportunities elsewhere. It is a paradox that at a time when educational opportunities for women have expanded dramatically through all four levels (primary, intermediate, secondary and higher), educated women should be having difficulty finding employment or holding on to their old jobs.

This raises questions about the vulnerability of the economy to changes in the external demand for a single "cash crop"—oil. Saudi Arabia is very much integrated into the world economy, and because it is highly dependent for its economic growth and development upon a favorable market for the sale of its oil, its economy is rather fragile and brittle. The recession has led to the repatriation of many expatriate workers who were brought in to take over agricultural production and industrial labor during the boom. Meanwhile, programs to expand the manufacturing and services sectors have had to be trimmed or shelved.

In conclusion, we have seen that the boom was not the watershed that it is purported to have been, but that instead existing trends were intensified by it. The boom raised people's expectations, and individuals followed a rational calculus to leave lower paying positions in agriculture and crafts production to work for salaries in the state bureaucracy.

The impact of the economic recession brought about by falling oil revenues has not been equal for men and women. Men, being more mobile, can seek more productive employment elsewhere in the face of the retrenchment in the markets. Women, however, cannot easily move to new localities. In addition, it must be remembered that the norms of sexual segregation continue to be powerful in influencing social relations in a society such as ʿUnayzah. It would appear that the prognosis for most women in the town is a reduced ability to work outside the domestic unit. While it is most unlikely that a reversion to the pre-boom period will take place with regard to the employment patterns of women, it seems likely that their role in the modern sectors of the economy will continue to be debated for some time to come.

NOTES

1 Robert Looney, *Saudi Arabia's Developmental Potential* (Lexington, MA: Lexington Books, 1982), p. 123.

2 Karima Kurayyim, "The Arab Woman and the New International Economic Order," *al-Mustaqbal al-ʿArabi*, 39 (1982), p. 69.

3 Henry Azzam, "The Arab Woman and Work," *al-Mustaqbal al-ʿArabi*, 34 (1981), p. 93.
4 Charles M. Doughty, *Travels in Arabia Deserta*, II (New York: Dover Publications, 1979 [1888], p. 429.
5 The percentage increase for state-wide enrollment is based on data in Ismail A. Serageldin, et. al., *Saudis in Transition: The Challenge of a Changing Labor Market* (New York: Oxford University Press, 1984), p. 45.
6 Soraya Altorki, *Women in Saudi Arabia: Ideology and Behavior Among the Elite* (New York: Columbia University Press, 1986).

Impediments to Empowerment: Moroccan Women and the Agencies[1]

SUSAN SCHAEFER DAVIS*

ABSTRACT

Women's participation in development projects in Morocco is limited. It is argued that this is not because of the cultural requirements of seclusion as such, but rather because of the limited viewpoint of the men, both Western and Moroccan, who run development agencies. Morrocan women, in fact, have many strengths that will serve them well once they obtain adequate opportunities to participate in development projects.

Introduction

THIS ARTICLE EXAMINES the ways in which cultural practices encourage or impede Moroccan women's involvement in development activities. The reader may expect an explanation of how the seclusion of Moroccan Muslim women limits their participation in development. In fact, I will argue that this expectation is itself a significant obstacle to those women's participation. In all development work there are at least two sides: the implementors/funders and the target group. They may be different social groups from one cultural background, or, more commonly in development work, come from different cultural groups.[2] In the expectation evoked above, the cultural practices of the target group, Moroccan women, are the focus of attention, as is often the case. I maintain that in this and in many cases, the cultural views and practices of the implementors are at least equally important in facilitating or hindering women's participation in development. I base this view on work as a researcher, implementor, and consultant, trained in anthropology and working with Moroccan women over the last 25 years. During this time I have been impressed by the strength and potential of Moroccan women, and frustrated that they rarely reach the level of productivity or reward which they could and should attain. I will support these assertions with examples of Western-based impediments and of Moroccan women's potentials, and conclude with some possible solutions to the current situation.

* Consultant, 4 College Lane, Haverford, PA 19041, U.S.A.

The Western View: Moroccan Women as "Other"

I am trained as an anthropologist, and anthropology has recently been much concerned about "the Other", i.e. people from a different cultural background, who are our usual focus of research. We disucss questions like "How do we know about 'the Other'? Do we choose people to tell us about their culture based on some bias?" For example, Edwin Ardener (1972) argued that men often present a view of the world that is more readily accessible to Western researchers—often male—than do women, so we more often ask men, and get a particular view. In societies which separate the sexes to a large extent, men's and women's views may differ substantially. Anthropologists also wonder if we project our own needs into our explanations of other cultures. For example, Edward Said has argued in *Orientalism* that European culture used the Orient "...as a sort of surrogate and even underground self (1979:3)." Thus, for example, a Western focus on the erotic harem in Eastern cultures says more about *our* psychic needs and projections than about Eastern realities. We used to claim to be "objective" in anthropology, but we now doubt that pure objectivity is really possible.

The points above may appear esoteric, but in fact development workers should ask similar questions. We too work with "the Other", from a different culture; do our own ideas about them have an effect on our work? Based on my work on women and development in Morocco, I would answer a resounding "yes!", and go on to say that recognition of the impact of our own, in addition to local, cultural views and practices can make our development work more effective.

I feel that Westerners see Moroccan women as "Other" in two ways: as Muslims, and as women. Viewing them as Muslims, Westerners expect them to be secluded in their homes, male-dominated, and unable to act on their own. This is the view I had when I first went to Morocco in the Peace Corps; where did it come from? I had little or no previous knowledge of North Africa; what there was came from seeing "Casablanca" and perhaps the *National Geographic*. Whatever their source, many Americans share these ideas. As I worked teaching home economics skills in a rural women's center, my view rapidly changed: these were lively, intelligent women who liked ribald jokes and sometimes had physical confrontations to defend their assertions, not timid, passive homebodies. But this became clear by working among them, in an all-female setting, an opportunity few development workers have. My doctoral research aimed to deepen this understanding, and focused on the ways these women can control their own lives, and the lives of others, i.e. in what domains they have power. I will elaborate below, in describing the basis for these women's potential, but the point here is that most people do not see this and view being a Muslim woman as a general and perhaps insurmountable impediment to development, and then act—or often do not act—on this basis.

Moroccan women are also seen as "Other" because they are women, and this may be even more limiting for them than being seen as Muslims. While many have the view that Western women are the most liberated and "best off"

in the world (in which there *may* be some aspects of truth), in fact our culture harbors [sometimes] subtle negative views of women, inhibiting their roles both at home and abroad. They are seen as not powerful or not important, or as having a place in the home but not in the wider economy: note the lack of a national daycare policy, despite the fact that 57% of mothers with children under six work outside the home (National NOW Times 1989:12). Moroccan sociologist Fatima Mernissi compares the two cultures' views of women:

> One of the main obstacles Western women have been dealing with is their society's view of women as passive inferior beings...the Muslim social order views the female as a potent aggressive individual whose power can, if not tamed and curbed, corrode the social order. It is very likely that in the long run, such a view will facilitate women's integration into the networks of decision-making and power (1975:108).

The two Western views of Moroccan Muslim women, as submissive and secluded Muslims and as economically unimportant women, often combine to prevent them from having even the opportunity to participate in development projects, except in the domains of mother-child health and nutrition and family planning. Not that these services are unimportant, but Moroccan women deserve access to other areas as well. Thus in my work with Moroccan women over the last 25 years I have seen Western agencies move from no mention of working with or for women beyond mother-child health, to the precence of a part-time WID (women in development) officer who had no budget, to the availability of a little money and an occasional project. While the movement is in the right direction, it is not enough, and in some cases it seems to be reversing. Since the mid-80s I have seen a case where a bilateral agency's proposal to study women's roles in agriculture and livestock production was approved and funded, only to have the funds appropriated by a different project not focused on women; the funded study was never done. Background research showed that the agency's current agricultural programs had little or no data on women; the one with the best sex-disagregated data concerned cows and sheep, not people! These projects were run by Western male agricultural economists, who probably assumed farmers' wives sewed and canned pears, the way they did back in Oklahoma. In another case, research on female factory workers was carried out and recommended the funding of more training for job advancement—but was never acted upon. Generally, work to benefit Moroccan women has had limited or no funding, and lacks full-time staff to monitor and champion it. WID projects are usually taken on by someone with another full institutional job who cannot dedicate the necessary time, no matter how motivated they are: in the cases above, the agency task manager had another, non-WID, full-time job. These conditions are the result of the views that women's roles in development are not really important,[3] and that Muslim women are even less apt to be involved than most others.

It is not only the Western view of Moroccan woman as "Other" that limits her; she is also seen as different by many Moroccan men, especially some of those in government posts who can influence policy on women. One aspect of their view of women is that they are "the weaker sex" and need and

deserve protection from harsh daily life, protection which men from this social class can provide. This view is less common among rural and working class men, whose women do not veil nor remain secluded, but work in the fields or the homes of others. Still, the ego involvement of even these men in being the main providers for their families may help blind them—and even their wives—to the importance of women's work.[4] For example, a recent Moroccan study found that women do two-thirds of the agricultural work near the southern coastal town of El Jadida, yet it was felt that men's work was most important, because they formally begin (plow) and finish (harvest) the agricultural cycle.[5] In another case, the participation of rural women between the ages of 30 and 60 in agricultural labor went up from about 13% to 60% in less than ten years (Royaume du Maroc 1989:100), but not as the result of some innovative development program. Rather, census takers collected time-use data rather than asking (usually a male) if women in the household "worked".

In addition, there is a degree of fear of women's activity outside the home, based either on their innate power (as Mernissi posits above) or on their competition with men in a very tight job market. Both these Moroccan male views of women as "Other" help support the Western view, and limit women's participation.

A few examples illustrate these male viewpoints among Moroccans. At the National Agricultural and Veterinary Institute, a researcher in the late 1980s found NO specific work on women, and a library sampling of general studies found that the Moroccan faculty had not purchased or directed research focusing on this topic. Two of the major Moroccan ministries with specific programs for women (besides Health and Education) are those of Youth and Sports, and of Handicrafts and Social Affairs. Both have large "home economics" style programs, in which the main participants are teenage girls who learn various types of embroidery, a traditional female skill which is poorly paid. Both ministries have initiated more diverse income-generating projects, which have seldom been successful.[6] They have had the general problems which have burdened many women's projects: limited funds (The Ministry of Youth and Sports commits 5% of its already small budget to women's programs) and staff which lack the necessary specific skills. A further limiting factors derives from the past Moroccan tradition of sharing profits with feudal lords. Some vestiges remain, on which it is difficult to set limitations; sometimes superiors lower profits, and along with them, motivation. This latter situation is not unique to women, but they may be less able to resist than are men,[7] although we understandably lack research data on this point.

Moroccan Women's Potential

As a female anthropologist working in Morocco, I do not share the above views of Moroccan women, especially regarding the Arab women of the northern plains where I lived. Of course there is much regional variation in

women's lives, and that should be borne in mind throughout this discussion.[8] Many of the women I know have great potential to be involved in development activities; they are strong-willed, intelligent individuals who would welcome the chance to work to improve their situation. I feel this personal strength grows out of some of their traditional cultural practices. Their culture provides benefits for women, in addition to some often-cited limitations.

I first became aware that the Western stereotype of Muslim women was not true for the women I knew during my Peace Corps service in the mid-1960s. I taught home economics skills in a rural women's center, adding lessons on health and sanitation, and also trying to do community development work. The lively, intelligent, joking women I knew in this all-female environment were not submissive; that was a particular role they sometimes played. They were nearly always very restrained with strange men (who, if researchers, would probably report this as general female behavior), and also at certain times of the life cycle, especially as young brides adjusting to new relatives.

Returning to graduate school, I wrote my dissertation on these women,[9] focusing on the roles in which these traditional Moroccan women do have power over their own lives and the lives of others, even though these roles are often unrecognized. Thus a woman frequently makes her husband do what she wants by making private family information public. For example, a neighbor couple were having dinner with my husband and me, and near the end of the meal the wife (a mother of six) said "I've been asking for birth control pills for five months, and this guy never buys them!" She got them the next week. This was something you do not discuss in public or in mixed company; she had made her point—and he acted because he was probably worried what her next move might be. This is only one example of the many ways in which Moroccan women can and do influence the course of their own and their families' lives.

One lesson gained from my work with these women was that one does not recognize the subtle ways they influence things, or even the extent of their work in different domains, if one is not focusing specifically on these topics. Thus women's projects that are based on superficial or stereotypical views, or that do not allocate funds to understand adequately the actual situation, will not provide women with a chance to be involved in development.

Yet Moroccan women have the potential to do much to promote their country's development. The goal of my current anthropological research is to discover some of the bases of this potential: what is the source of these women's confidence and self-esteem? This interest was stimulated in a faculty seminar with psychologist Carol Gilligan on female adolescent development. Gilligan feels American females are confident until about age twelve, when many "lose their voices" and confidence and become silent and unsure of themselves (1989:324-328). I did not see a parallel course while working in semi-rural Morocco, so feel both that this "silencing" is probably not a universal step in female development, and that we Americans can learn something from our Moroccan sisters.

Some of the sources of Moroccan women's self-confidence, of their readiness to meet challenges to provide a better life for themselves and their families, grow out of traditional cultural practices that others may blame for limiting them. I am thinking specifically of the separate socialization and general segregation of the sexes, and of the related fact of spending much time in female groups with a wide age range.

Separate socialization means that women are raised by, with, and as, females. My premises for suggesting that this has benefits are similar to those that support all-female education in the U.S. In an all-female group, all leaders will be female, while in a patriarchal society, leasers are usually male. If something is to be done, women must rely on themselves to do it, not wait for a male to take charge. Gilligan posits that in the US, much of the course material at high school level is by, for and about males, and that while females can absorb this intellectually, they don't really "connect" and identify with it as relevant to their lives, and feel somewhat alienated. This has not happened to most Moroccan women, partly because most have not reached this level of education. However, I suspect it will not be the same even for those who do, because their education is on the French model of retaining information, not on interpretation and relevance to daily life. In addition, because of the separation of the sexes, Moroccan females have a clear, concrete model of what it is to be female; American females operate in a mixed society in which "human" qualities are often identified with "male" qualities (Gilligan et al 1989:318), and "female" qualities are often devalued ("don't get emotional"). If you told a group of Moroccan females that human nature is identical to male nature, or that female and male nature were identical, they would disagree heatedly; their daily experience clearly denies that. These same females would argue in favor of equal job opportunities and pay for women and men, but they do not feel we must behave identically to reach those goals.

Another cultural practice that benefits Moroccan women is their integration into multi-generational female groups in which they discuss and solve (or hear of solutions to) "women's problems". This is in contrast to middle class American society, where we emphasize peer culture and formal education. The importance of the family in Moroccan culture also supports such cross-generational groups. Every summer Moroccan girls and women visit relatives in different parts of the country and catch up on a year's worth of spouse choices, marital disputes, child-care arrangements, and other important parts of women's lives. They also constantly hear such topics discussed in their own family groups. Thus Moroccan females have a fund of experience to draw on, rather than feeling isolated, having only peer data, or reading how-to books.[10] However, I want to stress that I do not mean that I feel all Moroccan cultural practices are beneficial in this way, or that there are no limitations for these women. The separate socialization of females also has negative aspects, such as the fact that girls do housework and childcare and boys do not; this makes it harder for girls to devote time to schoolwork—although they do, and succeed. Yet a focus on *only* the limiting aspects of the culture blinds us to the great potential for action.

Thus many cultural practices contribute to women's self-confidence, to their willingness to do what is needed to help themselves and their families. We see evidence of this self-confidence in the progress of Moroccan females in the job market and in education; when opportunities are available, women take them. On an anecdotal level, when I first went to a Moroccan village in 1965, almost no women there worked outside the home, and in cities there seemed to be a small number of female teachers, secretaries and government office workers. By the early 1980s there were many village women working as teachers, civil servants, paid agricultural laborers, and as domestics in cities. In the cities, the former jobs continued and one also sees brass nameplates for dentists, doctors and lawyers with female names. In a more official example, the percentage of economically active females between the ages of 40 and 44 rose from 9.7% in 1960 to 43.9% in 1986-87 (Royaume du Maroc 1989:100).

Widespread public education began in Morocco after Independence in 1956. In the 1960 census, 27% of primary school aged girls were enrolled; this percentage rose to 61% in 1982 (UN Statistical Yearbook 1985). The girls not in school are largely in rural areas: in 1982, 78.6% of urban girls between ages 10 and 14 were literate as opposed to 17.2% or rural girls. One clearly sees the progress with time if we look at the previous generation: at those ages, 36% of urban and 2% or rural girls were literate (Royaume du Maroc 1989:49).[11] The town where I work presents a microcosm of this experience. It is now neither urban nor rural; it grew from about 5000 in the mid-60s to 12,000 in 1982, and by 1989 was annexed into a nearby municipality. In 1965 the primary school enrolled about one-third of local girls and two-thirds of local boys, and there were eight male and two female teachers. By 1989, virtually all boys and girls were sent to primary school, and there were 52 teachers, exactly half of whom were female.

Local attitudes to educating females became clear to me back when the women's center opened in 1965. Many families promptly withdrew daughters from school and sent them to our center. As a Westerner, I assumed this was due to cultural attitudes opposed to mixing of the sexes, both among students and with male teachers for girls, and to parents seeing no value in educating a daughter. However, since we did not want our classes filled with 7-9 year olds whom we felt would miss out on education and benefit little from our lessons, we began a campaign to get these girls back to school.

We women's center teachers (a Moroccan and an American) visited the girls families, and in these visits learned about the *real* constraints on them. The main reason girls were sent to us was not to avoid male contacts, or a devaluation of education, but economic. It cost about 3 cents for a needle and thread, as opposed to much more for school books and supplies, a smock and shoes. Almost all families returned their daughters to school with no argument. A few later withdrew them, but again the cause was economic or based on opportunity costs: when a mother couldn't keep up with housework or had a new baby, she would withdraw a girl to help. By 1982, when my husband and I did research on adolescence in this town, only 8% of our sample of over 100 had never attended school, and all but one of those were sixteen or older. We

calcultated that by 1973 parents began sending all children of both sexes to school. We also found that 47% of males and 37% of females aspired to be teachers; the female teacher provides an important role model, for students and parents, of the economic value of educating girls (Davis and Davis 1989). And when the school is convenient, and parents see this value, girls do attend.

Conclusions

Some of Morocco's traditional cultural practices have effects which encourage women's participation in development. Yet projects involving women often do not reach their potential due to limiting *Western* cultural views of them as female and as Muslims, both of which suggest they could or should not participate. How can we surmount these obstacles? There are at least three steps that should help.

First, we need to learn about and deal with the *reality* of Muslim women's lives, not some Western or middle-class Moroccan male stereotype. This requires specific research with close observation, not facile generalizations. Some of this material is already available and should be consulted; specific work on women in anthropology increased greatly after the early 1970s.[12] If we cannot find what we need, research on women in specific domains like agriculture, or credit, must be funded as a prerequisite or initial step in project work.

Secondly, it is necessary to commit significant levels of funding if work with women is to succeed, and I would suggest that much of this funding be used for "action research", consisting of an operational project whose results are carefully evaluated. A large-scale assessment by USAID found that one common problem with "women's projects" is that they fail due to underfunding (Carloni 1987). We should instead mobilize and focus resources on a few exemplary projects, whose success would inspire others to try similar activities. Earlier I mentioned cases of research on Moroccan women that were never acted upon. If this were instead designed as action research, some approach would have been tested, and its benefits and faults could be built upon or avoided in the future. An interesting example of this approach is in progress in Morocco concerning women and credit. A semi-public bank has made some funds available for loans for rural off-farm activities. Much of this money is intended to reach females who weave rugs; the bank hesitated to overtly target women as beneficiaries. As a result, male-oriented activities like tractor repair workshops also qualify for loans. This will serve as action research in revealing to what extent this somewhat indirect approach to women and credit does reach that target group. If it works fully, we have a useful new model that may be especially relevant for Islamic cultures. if there are problems, we will have monitored them and can try to eliminate them next round. And in any case, Moroccans will have some sort of action to point to, not just another round of questions and unread reports. A final and essential aspect of adequate funding is that organizations which do some part of their work with women must fund specific staff positions to do this work. It is not surprising that someone

whose main job is program officer does not have the time or energy to pursue projects or funding; her own WID work suffers from the same Western preconceptions about the marginal value of women that limits Moroccan beneficiaries.

The *third* and largest question still remains: how do we get Western donors to commit money for WID staff, action research, and projects? This problem goes back to the Western view that women are not important economically, and thus as actors in development.

Using a novel aproach to understanding this question, Kathleen Staudt took a year away from her job as a political science professor to work in USAID's WID office in 1979. The resultant book (Staudt 1985) combines the anthropological use of participant observation inside USAID with a political/organizational analysis of the problems of integrating WID policy within the agency. This is compared to the more straightforward integration of other directives, for example on project evaluation.

Her analysis highlights two aspects of WID policy that appear to hinder its integration. First, it is seen as a *redistributive* policy, thus as taking assets away from one group to give to another. Secondly, it involves *gender*, which appears to touch sensitive chords with American personnel, mainly male, who feel both that they understood such matters from personal experience and, more importantly, that this means the private, family sphere (in their Western experience) is being invaded by government—and that it should not be.

Staudt's recommendations for change are complex, like the problem itself. They include having an advocacy office like WID within the agency, infiltrating the bureaucracy itself with sympathetic supporters, generating data through evaluations that projects work less well if women are excluded or limited, and pressure from higher level officials inside the agency, and others outside, including lobby groups (like The Coalition for WID) and members of government, and perhaps project beneficiaries. She notes that if WID work focuses on the instrumentality of including women in projects (e.g., they then work better) it is seen as less threatening, but it also risks losing sight of the initial WID goals.

In a new collection edited by Staudt, *Women, International Development and Politics*, several authors examine WID policy and implementation in various agencies, including the World Bank, the Food and Agriculture Orgoanization (FAO), and Sweden's SIDA. The authors illustrate variation in the acceptance of WID within different national and organizational cultures. The 1989 AWID panel ''Can Bureaucracy Empower Women?'', presented more specific cases, in which the Ford Foundation and Canada's CIDA appeared to be especially responsive to women's development needs. Audience members from the developing world commented that they especially valued CIDA's problem-solving rather than accusatory approach to obstacles and their acceptance of local, grassroots proposals. We can explore, and try to apply, such insights to guide our work.

Although we are developing a better understanding of the bureaucratic process, it is still difficult to convince agency people to commit funds to WID

staff, action research and projects. One possible way to do so is by coming up with examples of good projects, using action research, that document women's economic importance in different cultural settings. How many of us have heard the Grameen Bank spoken of again and again? Admittedly this is still a chicken-and-egg problem: we need the money to do the good projects to cite in order to get money. We can all be on the lookout for good projects, encourage them whenever possible, and then publicize them. Perhaps organizations like The Association for Women in Development (AWID) could help with the publicity aspect, funding publication of a few especially relevant case studies and publicizing them in the Newsletter. Collections like this one focus attention on what is effective and what is not in development work with Muslim women in different areas. Once reports are available, it is up to us, as practitioners, scholars and policy-makers to bring them to the attention of those who need convincing to fund more such work.

If, in our work with development agencies, we can recognize and try to overcome their limited and limiting views of women's importance, we will add to the empowerment of women...in the developing world and also at home.

NOTES

1 An earlier version of this paper was presented at the Meetings of the Association for Women in Development (AWID) in Washington, D.C. in November 1989.

2 While "outsiders" have done much development work in the past, local organizations and grassroots groups are multiplying rapidly.

3 Staudt's work on the generality of these views is discussed in the conclusion.

4 It is not only Moroccan men who take pride in providing for and protecting their wives; see Rubin's *Worlds of Pain* (1976).

5 Mohamed Salahdine, University of Fes, personal communication. El Belghiti (1987) also found Moroccan men often denying the value of their wives' labor, although it made economic survival possible.

6 Both ministries, especially Handicrafts, also encourage women in the traditional female skill of weaving rugs, which is potentially more rewarding. However, a minority do this work.

7 Research on women textile workers in Nablus on the West Bank shows that they endure poorer pay and working conditions than do male workers because they are less able to find alternate jobs (Moors 1989). Similar factors would likely affect Morocan women.

8 For example, some generalize about Arab/Berber differences in Morocco, with Berber women often described as "freer". Yet there are three Berber groups in Morocco, and the northern Rifis and the southern Shluh or Soussis are often more restricted than their Middle Atals Berber sisters *and* than Arab women.

9 The dissertation is now a book, *Patience and Power* (1983).

10 In fact, Gilligan cites data from Braun indicating that American girls also value this type of information, even it it is less readily accessible to them. By age 15, girls said twice as many of their powerful learning experiences occurred outside as opposed to in a school setting, and with family and friends (Gilligan 1989:14).

11 Literacy is nearly never measured precisely, but rather inferred from level of education; generally it is assumed if a person has been in school for four years.

12 Abu-Lughod's 1989 review of anthropological work on the Arab world contains a section on gender and is a rich source of references. There is also much recent work by and about Moroccan women.

REFERENCES

ABU-LUGHOD, Lila
 1989 "Zones of Theory in the Anthropology of the Middle East", *Annual Reviews in Anthropology*.
ARDENER, Edwin
 1972 "Belief and the Problem of Women", in J.S. LaFontaine, Ed., *The Interpretation of Ritual, Essays in Honor of A.I. Richards,* London: Tavistock.
CARLONI, Alice Stewart
 1987 *Women in Development: A.I.D.'s Experience, 1973-1985. Volume I. Synthesis Paper,* Washington, D.C.: Agency for International Development.
DAVIS, Susan Schaefer
 1983 *Patience and Power: Women's Lives in a Moroccan Village.* Rochester, VT.: Schenkman.
DAVIS, Susan Schaefer and Douglas A. Davis
 1989 *Adolescence in a Moroccan Town*, New Brunswick, N.J.: Rutgers University Press.
EL BELGHITI, Malika
 1987 *La situation des femmes et des enfants dans la Province d'Essaouira*, Rabat, Morocco: UNICEF.
GILLIGAN, Carol, LYONS, Nona P., and Trudy J. HANMEY, Eds.
 1989 *Making Connections: The Relational Worlds of Girls at Emma Willard School*, Troy, N.Y.: The Emma Willard School.
MOORS, Annelies,
 "Restructuring and Gender: Garment Production in Nablus", Occasional Paper no. 3, Amsterdam: Middle East Research Associates.
MERNISSI, Fatima
 1975 *Beyond the Veil: Male-Female Dynamics in a Modern Muslim Society*, Cambridge, MA: Schenkman.
National NOW Times
 1989 "Resolutions Passed in Cincinnati", July/August/September, p. 12.
Royaume du Maroc
 1989 *Femmes et Condition Féminine au Maroc*, Rabat, Morocco: Premier Ministre, Ministère du Plan, Direction de la Statistique, CERED.
RUBIN, Lillian
 1976 *Worlds of Pain: Life in the Working-Class Family*, New York: Basic Books.
SAID, Edward
 1979 *Orientalism*, New York: Vintage Books.
SALAHDINE, Mohamed
 1989 Personal communication.
STAUDT, Kathless
 1985 *Women, Foreign Assistance, and Advocacy Administration*, New York: Praeger.
STAUDT, Kathleen, Ed.
 1990 *Women, International Development, and Politics: The Bureaucratic Mire*, Philadelphia: Temple University Press.
UNESCO,
 1985 *Statistical Yearbook*, Paris: UNESCO.

The Female Brain Drain, the State, and Development in Egypt

MONA L. RUSSELL*

ABSTRACT

Education meets both individual and state needs in developing societies. However, permanent migration to the West may deplete a country's resources of educated persons. Few studies have addressed the female component of the brain drain. A survey of Egyptian women emigrants to the U.S. and study of other materials show that Egypt has lost more than it has gained through its policy of encouraging emigration to relieve the pressures resulting from too few jobs for too many graduates.

Introduction

EDUCATION IS CLEARLY an important facet of the development process. Accoording to a 1980 World Bank policy paper, education is "related to development in three important and interrelated ways: as a basic human need; as a means of meeting other basic needs; and as an activity that sustains and accelerates overall development."[1] At the same time, education can also serve as a powerful means of social control. By "impos[ing] a collective sense of being"[2] and integrating graduates into society, states can effectively impose social change within the parameters specified by the ruling elite. In other words, education can both bring about an awareness of the need for development while simultaneously legitimating changes which have already taken place.

Traditional definitions of development have all too often dealt with only the political or industrial facets of development or have focused on the level of the state.[3] I prefer to follow a definition which is geared more towards "human resources" such as the one provided by the United Nations Women's Decade: "a process involving total development—in the political, economic, social, cultural, and other dimensions of human life as well as in the physical, moral and intellectual growth of the human person."[4] Unfortunately, as Nadia Hijab has pointed out, development in these various interrelated spheres is extremely difficult to measure, particularly given the problem of the brain drain from the Middle East to the West.[5] Exact statistics on the magnitude of the problem are nearly impossible to estimate. Only figures for the total number of immigrants and temporary visitors are available. Between 1953 and

* Middle East History, Georgetown University, Washington, DC 20057, U.S.A.

1973 over one million immigrants came to the US from the Middle East, almost 30,000 of whom came from Egypt. Ninety-nine percent of these Egyptian immigrants came from the mid-1960s on, and their numbers reflect a vast depopulation of certain fields.[6] Over the last twenty years a lively discourse has emerged regarding the Egyptian brain drain; however, it has focused almost exclusively on the experience of men, and recently, it has also tended to concentrate on the regional brain drain.[7]

Temporary regional migration does not represent the same sort of loss to development that migration to the West results in. Nazih Ayubi offers three major differences between the two types of migration.[8] First, by definition the former is merely a temporary loss, while the latter tends to be permanent. The recent Iraqi invasion of Kuwait and the subsequent return of Egyptian workers demonstrates the ephemeral nature of regional migration. Second, the output of regional migration remains within the domain of the Middle East. As we approach the twenty-first century, regional cooperation appears to be a logical solution to the economic woes of many areas of the world.[9] Meanwhile, the fruits of expatriate labor in the West are predominantly, although not exclusively, enjoyed by the West. Third, intraregional migrants send significant portions of their incomes home in the form of remittances, while their counterparts in the West tend to spend most of their income in the area in which they settle.[10] In 1983, Egypt's officially recorded remittances equalled the combined revenue from both oil and the Suez Canal, totalling $3.3 billion or nearly nine percent of the Gross National Product.[11] Obviously, a heavy reliance on such remittances can have a negative impact on development since they contribute to inflation and the currency black market; however, these are structural problems in the Egyptian economy rather than a problem with the remittances per se.[12] Thus, my focus will be on the negative impact of Egyptian labor migration to the West, specifically the United States.

The available literature on the Egyptian brain drain to the West deals almost exclusively with the problem of male migration and/or it does not consider the negative implications of female migration. For example, in her research on the motivations of scientists for leaving Egypt, Saneya Saleh indicates that she could find no females wishing to emigrate to the United States. She cites the conservative social background of Egyptian women as the reason for women not emigrating on their own.[13] Nevertheless, some women do emigrate on their own, and many of the women who emigrate with their husbands are active participants in the decision to leave Egypt. This neglect of women as a significant force is typical of traditional scholarship on the Middle East. As Judith Tucker has aptly pointed out, "women are indeed numerically significant, but an apreciation of their role in society must be expanded to include the numerous, and oftentimes subtle ways in which their activities and status reflect and affect the organization of production and social interaction in any given society."[14] Thus, one must ask three question: Where do women fit in the brain drain configuration? How does their experience differ from that of men? What impact does the female brain drain have on Egyptian development?

The majority of Egyptians who come to the United States are highly educated academics, engineers, scientists, and professionals.[15] This profile represents the type of woman who would appear in official statistics on labor force participation in Egypt. In 1976, 47 percent of the women who were classified as "economically active" in official labor statistics had a high school education or better, compared with only 12 percent in 1960. This small group of women, about five percent of the female population age 10 and over, makes up almost half of the female "working" population.[16] The higher the degree of education, the more likely a woman is to be economically active in Egypt. Almost 90 percent of women with masters degrees or doctorates in the gover- nates of Cairo, Alexandria, and Port Said were classified as economically active in 1976.[17] Earl Sullivan has cited higher education as "one of the most reliable predictors of future success and of the likelihood of a significant future contribution to the development of Egypt."[18] Thus, the female Egyptian emigrant, in all likelihood, would be a contributing member of the work force. Furthermore, she represents a loss in the economic, social, and educational, spheres of development. In order to better understand the ramifications of the female brain drain, one must first examine the history of women, education, and development in Egypt. According to Aida Beshara, "since ancient times, Egyptian women have had a higher status and more independence than women in other parts of the Arab world." Moreover, this tradition provides the foundation for the contribution of women in modern Egypt.[19] Indeed, the history of women, education and labor force participation in Egypt is quite impressive.

History of Women, Education and Development

The education of upper class women has been a common trend in Egyp- tian history since ancient times. However, this education has served a variety of purposes, running the gamut from state service to spiritual life to motherhood. The role of the state in women's education contracts and expands according to its own developmental need and/or its need to develop individuals through hegemonic leadership via unified education. For total development to take place, there must be equal emphasis on both macro developmental con- cerns, e.g. economic development, and micro concerns, i.e. the individual needs of citizens.

The history of women and education dates back as far as the third millenium B.C. In ancient Egypt educated women played an active role in both government and religion.[20] The state did not become an active force in women's education again until the nineteenth century. The Persian, Roman and Byzantine empires did not encourage the education of women. Although the various rulers of Egypt during the classical Islamic age did not encourage women's education either, the religion itself enjoined all adherents to seek knowledge.[21] Women were important contributors to and transmitters of Muslim learning during this period by becoming benefactors of schools;

administering *awqaf* which controlled schools; distinguishing themselves as purveyors of *hadith*; and teaching in and managing *ribats*, sufi hospices which provided for the physical, intellectual, and spiritual needs of women without families.[22]

This trend in female education continued right through the pre-nineteenth century Ottoman age. The education of women was by and large limited to women of the upper classes and was associated with traditions which some families established for the education of their daughters. There was no official mechanism which allowed for girls' education, and likewise women were excluded from traditional structures of power.[23]

At the turn of the nineteenth century, the school system in Egypt had changed little since the Ayyubid period. This is not to say that education and intellectual endeavor were stagnant, as some have argued,[24] but that the overall structure of the system of education had not changed. Muhammad ʿAli, who came to power in 1805, sought to create an independent dynasty through industrialization and modernization, and educational reform was necessary to implement these developmental goals. He built a secular educational system alongside the existing religious one, working his way from top to bottom.[25] In addition to the men needed as engineers, clerks, military leaders, and doctors, Muhammad ʿAli saw the need to train women in medicine. Thus, he opened the School of Midwifery (*madrasat al-wiladah*) in 1831-32.

The state encountered a number of problems in finding both students and teachers for the new school. State sponsorship of women's education was a thing of the distant past, and no class of women seemed particularly interested. Women of the lower classes had to work in order to support their families, and women of the upper classes who sought an education received instruction in their own home. The problem of finding students and teachers would plague the Egyptian state for another century.

The same forceful methods which Muhammad ʿAli employed to find male recruits for the army, industry, and public works projects could not be used with women. Therefore, the first batch of students consisted of ten palace slaves of Sudanese and Abyssinian origin. The training of slaves was only a temporary measure. The government soon turned to orphans as a more reliable source of students and teachers. The heavy-handed conscription and corvee policies of Muhammad ʿAli left many girls fatherless, and the School of Midwifery provided institutional support.[26]

European opposition grew to Muhammad ʿAli's industrialization policies. The British, in particular, did not want to see the rise of a new economically and militarily powerful state in the Mediterranean, especially one which threatened their own textiles industry.[27] By 1840 the Europeans had effectively crushed Egypt's industrial base. Egypt's economy then shifted to the cultivation and exportation of cotton. The spread of capitalism in Egypt rigidified the lines between the sexes and between the domestic unit and the unit of production. These changes had a negative impact on women of the lower classes, and their roles and status contracted. Meanwhile, the women of the upper classes

experienced a widening of horizons and opportunities.[28] This theme would continue through the twentieth century. Although both the quantity of opportunities and the women with access to them would increase, the position of the lower class women would remain contracted.

The spread of education was clearly the most important change affecting women of the upper classes. By the last quarter of the nineteenth century three types of education were available for women: home education, private education, and government education. The highest level of society continued to educate their daughters in the home; however, now, they began to recruit European governesses as instructors.

Other upper class women, as well as upper middle class women chose private education, of which missionary schools were the most common form. The missionary movement took root in the second half of the nineteenth century, and the French, Scots, English, Americans, Greeks, Italians and Copts opened schools throughout Egypt. Between 1863 and 1879, 129 private schools opened in Egypt, the majority of which were Presbyterian or Catholic; and there are records for 152 such schools during these years.[29]

The first government primary schools for girls opened in 1873, and once again there were problems with recruitment of students and teachers. The solution again came in the form of slaves and orphans; however by the late nineteenth century, government schools began to attract some middle and lower middle class women. Thus, from early on, the status of women graduating from government schools and entering the teaching profession was not high since the only women who would fill these positions were women with relatively few options.

The women's education issue was part of the larger ''women's question'' which in turn was part of the Islamic reform movement. The intellectual debate focused on how to come to grips with this era of rapid change and how women would fit into the new picture. There was some agreement on the need to expand women's educational horizons as an important component of national development. According to Mervat Hatem, ''the only difference between the conservatives and the liberals was that whereas the conservatives...wanted to restrict women's public space the liberals...wanted to expand it.[30] Neither faction, however, would take a strong stand on the position of women's personal status, with the result being ''a new Egyptian patriarchal system that allowed women increased public participation in education, employment, and social work, but kept the Islamic patriarchal mechanism of personal and sexual control within the family...''[31] A women's press arose in the last decades of the nineteenth century to address these issues of contemporary interest, and the most recurrent one was women's education.[32] The women writers were staunch advocates of education as a means to solving the larger ''women's question,'' and like male intellectuals, they linked the issue to the process of national reform and development. Alexandra Avierino, writing in 1898, stated that ''the nation is a collection of families made up of individuals. When women have improved, families improve; and when families improve, the nation improves.''[33] In other words, women could

best contribute to overall Egyptian development by educating themselves for their roles as wives and mothers, rather than to serve the development needs of the state more directly by working. According to Hatem, the result of the debate in Egypt was a patriachal alliance between middle and upper class men and women, beginning at the turn of the century and continuing until the present day, whereby change for women has been incumbent upon changes introduced at the top by men.[34] Furthermore, this patriarchal, hierarchical alliance has maintained itself in spite of the changes in the orientation of the economy.[35] Thus, the women's movement, almost from its inception, was subsumed under the rubric of the nationalist movement.

Educational opportunities continued to expand for women of the middle and upper classes; however, the British system did not necessitate the education and employment of women. Education became geared towards training male clerks and technicians for low-level positions in the British administration. To meet the increasing demand for women's education, the British relied heavily on the missionary schools.

The 1919 revolution galvanized women of all classes to act together in support of their country against British colonialism. The revolution took the upper class woman out of the *harim* and placed her squarely in public life. Once the revolution was over, however, these women did not return to seclusion, but they redirected their energies toward philanthropic organizations.[36] Their experience as managers of large households equipped them with the skills necessary to organize and manage health and welfare projects. In addition to providing a useful service for the state, these women also opened the doors of opportunity for other Egyptian women. The nurturing role of the mother was expanded to allow women to serve the state.

Meanwhile their male counterparts in government, who had been blaming the British for the poor state of girls' education, were forced into action. The 1923 Constitution called for compulsory primary education for all Egyptian children.[37] Although legislation proved easier than execution, the governments of the liberal age supported the expansion of educational opportunities for both of the sexes.

There was also an increased demand for higher education for women. When the Egyptian University was established in 1908, women were not formally enrolled; however there were special lectures for them and separate facilities available after 1911.[38] Apparently these lectures created a great deal of public opposition, and the administration cancelled the women's section in 1913. It took another fifteen years for the university to officially open its doors to women.[39]

Even before the university opened to women, the government had been sending small numbers of women abroad. In 1925 minister of education Ali Mahir chose Doraya Fahmy as the first Egyptian girl to study in France. She had no formal education, but had been taught French by a live-in Governess. After her father's death, Fahmy's family expected her to get married; however she objected to the idea. To vent her frustrations she wrote a number of anonymous editorials in Egyptian French language papers, confiding in only

one family friend, who showed them to Mahir. In other words, she had both
the right educational background and a family situation conducive to studying
abroad. She first received a teaching certificate from the Ecole Normale
Supérieure of Sèvre and went on to complete her education at the Sorbonne,
receiving a doctorat d'état in French language and literature in 1935.[40]

The case of Dr. Fahmy is worthy of note because it represents a number
of the problems inherent in the question of women, education, and integration
in Egypt. First, there were relatively few women who were both fluent in
French and willing to study abroad. Second, when Dr. Fahmy returned to
Egypt in 1935, the government literally did not know what to do with her. It
had created this highly educated woman, but there was no place in society for
her.[41] The government put her on salary when she returned, but did not find
her a position for another six months. Ahmad Lutfi al-Sayyid, rector of Cairo
University, was instrumental in finding her a position at the university.
Interestingly enough, Dr. Fahmy did not encounter large-scale resistance from
the mainstream university faculty. It was only in her own department where
she encountered resistance. The French department had, up until this time,
been staffed by French nationals who had been upgraded from private secon-
dary schools when the university opened. These men resented the fact that an
Egyptian, no less a woman, with a higher level of education than they had, was
infiltrating their territory.

The third interesting point about Dr. Fahmy's case is that she never
became involved in the women's movement in Egypt. She said that when she
returned to Egypt, the women's movement had become tangled up with
politics, which did not interest her. In spite of the fact that she was willing to
study abroad and to oppose her arranged marriage, she did not consider
herself a "feminist" [her words] nor did she see a place for herself in the move-
ment. Her experience seems to reinforce Hatem's theory of the enduring
alliance of patriarchy and nationalism, except that she had arrived on the scene
before the government was quite sure how to fit women into the development
picture. It was only beginning to remove obstacles to education and work. The
number of women in the labor force increased sixfold from 1927-1937,[42] and
the number of girls attending school doubled between 1945 and 1951.[43]

The Revolutionary government established in 1952 continued and
expanded upon the trends set in motion by the post-independence politicians.
Education became a tool for restructuring society and meeting the demands of
the new state. Reforms centered around eliminating illiteracy, expanding
technical education and vocational education, and eventually making all
education free of charge. The numbers of children in elementary school
increased from 1.5 million in 1952 to 3.5 million in 1966, with 1,300,000 of
the latter female.[44] The expansion of education continued under Nasser's suc-
cessors, Sadat and Mubarak, with the percentage of children in elementary
school increasing from 75 to 85 between 1965 and 1988, and the percentage
of children in secondary school increased from 26 to 62 during the same years.
The percentage of girls increased from 60 to 76 and 15 to 52, respectively, for
these categories during these years.[45]

This process was particularly important to the government because it sought to increase the national income through industrialization, as well as commercial and agricultural development. This need increased after the nationalization of the Suez Canal and the expulsion of British and French technicians. Between 1953/54-1978/79 the ratio of increase in enrollment in technical secondary schools was 3,369 percent overall, with the ratio of girls increasing by 4,882 percent.[46]

Nowhere did expansion spread more rapidly than in higher education. Legislation in the early 1960s opened university admissions to all students free of charge and obligated the government to employ all graduates of universities and higher technical institutes.[47] The spread of higher education of women is perhaps even more noteworthy than the spread of higher education in general. Between 1960 and 1976 the number of women in higher education increasd sixfold, while the number of women in primary and secondary education increased only threefold.[48] The expansion of women in higher education took place more rapidly than that of men in the 1970s. While the overall level of higher education increased by 17.6 percent per year between 1971 and 1976, the female enrollment rate increased by 21 percent.[49] Furthermore, since the revolution, there has been a startling increase in the numbers of women in the sciences. Between 1952 and 1973, the number of female university students enrolled in the sciences increased from 32 percent to 57 percent.[50]

The expansion of women's education afforded women more opportunities to take part in Egypt's development. The government solicited women's support, and it codified this support in the National Charter (1962). This document addressed women's educational, occupational, and civil rights. However, within three years after its promulgation, Egypt began to lose large numbers of its most talented academics, engineers, doctors, and scientists.

The Female Brain Drain from Egypt to the United States

The scope of the brain drain in general is nearly impossible to measure. Exact numbers are difficult to determine, and the loss of human potential cannot be quantified. We are left with only the statistics from the Immigration and Naturalization Service. As previously mentioned, almost 30,000 immigrants came from Egypt between 1953 and 1973, most of whom came after 1965. The immigration statistics indicate only those individuals who declare their intention to become permanent residents before they leave home. In addition to these permanent immigrants, many temporary visitors change their status to permanent resident.

The overwhelming majority of declared immigrants fall into the professional/technical (33 percent) or housewife/dependent/non-classified (47 percent) occupational categories.[51] The relative ease with which a spouse can get permanent resident status probably accounts for the high numbers of immigrants falling into this category. About 43 percent of the incoming immigrants are women, and like men, they are clustered most heavily in the 20-29 and 30-39 age group categories.[52]

Temporary visitors form another important component of the brain drain. Some of these temporary residents return to Egypt to find that not only have conditions changed, but perhaps they have changed, too. Consequently, they come back to the US as immigrants. In other cases, temporary residents arrive in the US with no intention of remaining; but after completing their business, they end up changing their status. Egyptian aliens who adjust their status increase the number of incoming permanent residents by about 25 percent.[53]

Egyptians who come here as students often fall into both of these categories. Many Egyptian students come to the US to study on Egyptian government scholarships (Egypt Mission) and Fulbright scholarships, as well as fellowships from American universities.[54] Once in the US these students often develop strong friendship, professional, and marital ties.[55] Although there are no indicators which reveal how many immigrants had originally studied in the US, there are some statistics available on the numbers of students who change their status from temporary visitors to permanent resident. In 1969, 1970, and 1971, about 32 percent of Egyptian aliens seeking a change in status were either students or spouses/dependents of students.[56] This figure raises the question of how many students end up becoming permanent residents either through immigration or change of status. In 1969, A.B. Sahlan estimated that 10-20 percent of the Arab scientists who studied outside the Middle East and one percent of those studying within it ended up migrating.[57] More recently, Ayubi estimated that 40% of Egyptians who study abroad do not return.[58]

Understanding the motivations for immigration is of prime importance in combatting the brain drain. It demonstrates that in spite of the fact that the state sponsored the educational development of these individuals, it ignored other aspects of their individual development. To gain a better understanding of this problem, I surveyed[59] 35 Egyptian women living in the United States. Although the sample is not random, the respondents vary with respect to original motivation for coming to the US, year of arrival, current status in the US, and field of specialization. They arrived in the US between 1949 and 1985, and they represent a near even balance between the theoretical fields and the practical sciences (see Table 1). All of the women are highly educated, with

Table 1
Educational Background of Respondents

Theoretical	Practical	Both
19	13	3

almost 62 percent of the respondents having a Ph.D., M.D., or pharmacy license; about 33 percent, a master's degree; and the final five percent, a bachelor's degree. By and large the respondents are now American citizens or permanent residents; however there are at least two women here only temporarily. I will be comparing my group of respondents to the 45 emigrant men

and women whom Saneya Saleh surveyed in the late 1970s. Saleh's respondents all hold Ph.D.s or D.Sc.s in the natural and social sciences.[60]

According to Saleh, the phenomenon of brain the drain can be explained by understanding the series of push factors, which operate in the country of origin and serve as direct causes of dissatisfaction and frustration, and pull factors, which operate in the country of immigration and serve to attract immigrants.[61] These factors take shape at both the macro level of the nation, and the micro level of the individual. As for the former, up until the mid-1960s, the Egyptian government implemented an exceedingly restrictive policy toward migration.[62] The government required that students who studied in the West complete a specified period of work in Egypt. Furthermore, exit visas, as well as passports, were difficult to obtain; and travel permission was required from both one's supervisor at work and the security office. This stringent policy changed in the mid-1960s as Egypt's debt mounted and the government committed itself to hiring all university graduates. The government eased restrictions on emigration in order to syphon off surplus labor and to attract remittances. Furthermore, it reduced the amount of bureaucratic red tape involved in the emigration process. By 1969, it had created a Migration Department within the Ministry of Foreign Affairs and a Committee on Emigration and Work Abroad, chaired by the Minister of Labor. The response to these measures was tremendous. In 1969, the government received 28,000 applications for emigration, which in turn, compelled the government to establish quotas for each profession.[63]

Meanwhile, in the United States, it was simultaneously becoming easier to immigrate. The 1965 amendments to the Immigration and Nationality Act of 1952 abolished the national-origin quotas and established 170,000 as the annual limitation of visas for immigrants, with 20,000 being the maximum for any one country. Under this new system, the immigration service set up a seven category preference system which favored close relatives of citizens and permanent resident aliens, as well as professionals and other workers whose services were required by the US. In other words, emigration for the Egyptian professional or student had become relatively easy.

With respect to the individual level, it is difficult to reduce the push and pull factors to a single motivating cause, but rather it is easier to see the decision as an amalgam of personal, professional, and socio-political reasons, e.g. lack of individual development in certain areas.[64] Interestingly enough, I found that surveying women alone yielded similar results to Saleh's survey, although she was not able to find women who wanted to emigrate on their own. In contrast, about one half of my respondents came either to study here on their own and ended up staying, or came here alone specifically for the purpose of working (see Table 2). Furthermore, if one includes the decision of the couple to come to the US either as students or immigrants, the figure moves up to 66 percent. Finally, a number of the women who came with their husbands, who were either studying or working, had already studied in the United States themselves and agreed to accompany their husbands on that basis. Thus, I find it both misleading and erroneous to state that Egyptian women do not

Table 2
Motivation for Coming to the US

Woman		Couple		Husband		Other
Study	Work	Study	Immigrate	Study	Work	Other
15	2	1	5	4	5	3

emigrate on their own or are only compelled to do so with their husbands. In fact, one respondent, an engineer, indicated that she came here first to study, and her husband was the one who followed her.

At the personal level of motivation, my respondents yielded similar results to those of Saleh and a survey conducted by the National Science Foundation.[65] A majority of respondents in all three surveys expressed a desire for a higher of living and increased opportunities, either for themselves or for their children. However, a significant minority of my respondents indicated that they wished their children could have received the same type of education which they had received in Egypt. By and large these were women who had attended private French and American schools in Egypt and who were overwhelmed by the manifold problems of public schooling in the US. Furthermore, a number of women also expressed frustration over the lack of support mechanisms for working (or studying) mothers. In Egypt, these women could rely on family and neighborhood support networks, whereas in the US they had to face expensive and often inferior childcare alternatives.

The Saleh survey also dealt with questions and hesitations that emigrants had about rearing their children in the US. She summarized her respondents' feelings as follows:

> Respondents in Category III [people who already emigrated] missed the close family ties, the feeling of belonging to the community, the primary, personal relationships, the Eastern values and the intimate human contact with people. Their children's future was their greatest concern. At first, they thought life would be better abroad, but later, had second thoughts. Their biggest fear was of differences in cultures. Most were bothered with the question of the future of their childlren's language, religion, and social customs. This was the unhappy part, but they knew that their children would have a better education and would be better off materially. This underlying normative orientation flows out of all the responses and points to the remaining strength of norms and traditions in Middle Eastern cultures.[66]

My respondents reinforced the picture painted by Saleh's respondents; however they did not seem "bothered" as much as they were precautionary. Many of the women stated that they take their childlren to visit Egypt frequently, some of them for extended periods, in order to expose them to their cultural heritage. Others stated that they tried to bring Egyptian culture into their home by maintaining the language and traditions, including holidays and religion. Still others found it difficult to maintain the language connection

either because they married a non-Arab or because their children had become thoroughly "Americanized."

Another major feature of the Saleh survey was what she described as "anxiety about daughters' socialization," particularly with respect to marriage choice. Saleh emphasized that this was a major prohibiting factor for emigration.[67] None of my respondents expressed this concern when asked if they had any concerns regarding raising their children here in the United States. This occurrence is partially attributable to the fact that many people with such concerns do not emigrate, but perhaps it also indicates that these patriarchal concerns are associated more with men.

With respect to their own feelings upon migration, the respondents to Saleh's survey implied "problems of accomodation, assimilation and cultural amalgamation."[68] In contrast, about 68 percent of my respondents found it either relatively easy or very easy to adjust to life in the US. Many of these women had attended American or British private schools and already had a high level of language proficiency and had been exposed to Western culture through school or travel. Almost none of the respondents had trouble dealing with "culture shock" per se, but instead had problems with language, finance, adjusting to the exigencies of graduate school, and/or finding appropriate care for their children. Timing also created certain fears, particularly for women who, arriving in the wake of the 1967 and 1973 wars, had to confront negative stereotypes.

On the professional level, my respondents differed more from Saleh's than in personal motivations. There was some similarity between the two groups in the concern over job availability, quality of work environment, and problems of reassimilation in Egypt [after studying in the US]; however, in some respects the women who came to the US gave up some opportunities in Egypt. One respondent put it best when she stated that those [women] who suffered through all of Egypt's problems now had key positions in the universities and the government. By staying in Egypt they had become very powerful women. Furthermore, in the 1960s, it was perhaps easier for a women in a non-traditional field (in Western terms) to obtain a job in Egypt than in the US. The government commitment to hire university graduates, the articles in the National Charter dealing with women's rights, and the relatively gender-blind state examination system perhaps afforded the Egyptian women more opportunities. One of my respondents, an engineer who was working to put her husband through school, found it difficult to find a job in her field in the US. For several years she ended up doing work far below her level of expertise.

At the socio-political level my respondents' concerns could, for the most part, be summarized as "things had changed in Egypt." For those women who came to study in the 1950s, they returned to find a completely different political environment; and for those who came to the US later, their experience in the US revived their memories of a pre-revolutionary Egypt or they simply decided they could not return to such a system.[69] Although women were not enfranchised during Egypt's liberal age, these respondents felt that the old parlimentary system was far more democratic than having the right to vote for

a rubber stamp assembly. Freedom of speech was another factor which many of the women cited. The respondents with children were careful to point out that they wanted their children to grow up in a democracy with freedom of speech and freedom of the press.[70] Others stated that it was not so much the political system as it was the general level of economic misery in country. Saleh's respondents yielded similar answers regarding their general dissatisfaction, although there was less of the hearkening back to pre-revolutionary Egypt and less concern over raising their children in the right environment.

Overall the results from my survey were similar to Saleh's; however they tended to emphasize the dual role of the woman in both her productive and reproductive capacities. By using the word reproductive I do not merely mean bearing children. I am using it in the broader sense of the term, meaning that they are concerned with doing all that is necessary to bring the next generation to maturity. In other words, they demonstrate a higher regard for their children's socialization and education. Rather than just mentioning their concern for preserving their children's cultural heritage, they also discussed the concrete measures which they have taken to circumvent such problems.

On the other hand, unlike Saleh's respondents, they did not appear to be as concerned over controlling the sexuality of their daughters. Whereas Saleh's respondents showed concern over the socio-sexual implications of rasing their children, particularly their daughters, in the US, my respondents did not even raise the issue. This does not necessarily mean that they are not concerned with this problem, but they perhaps do not subscribe to what Deniz Kandiyoti has called the concept of "corporate control over female sexuality" in the Muslim Middle East.[71] Instead, they attached greater importance to instilling their children with proper values so that they could themselves make the appropriate decisions.

My respondents differed most radically from Saleh's in the category dealing with professional interests. According to Abraham Maslow, one's physiological and basic needs (safety and security) must be met before other higher level needs, e.g. professional satisfaction, can be met. Furthermore, it is the presence of unsatisfied needs which has the greatest influence on behavior.[72] Patriarchal Middle Eastern society derives its strength from its ability to satisfy these basic needs,[73] as well as the higher level needs of love and belonging. Given the ample opportunities for women in Egypt[74] and the wide variety of support mechanisms available, it might seem strange for women to emigrate. Nonetheless, most of the women studied in the US or in Western Europe, which perhaps awakened their needs for esteem, growth, and self-actualization. These needs are not easily met by men or women in Middle Easten society. Moreover, Maslow also stipulated that freedom, justice, orderliness, and challenge were preconditions for higher level need satisfaction. The state is responsible for these needs, but they were not a priority for the post-revolutionary governments. Thus, in spite of certain advantages which Egypt might have held, these women found that the preconditions for higher level needs satisfaction were not present in an amount necessary to achieve growth; and consequently they emigrated to the US.

The Negative Implications of the Female Brain Drain

The counter-argument to the brain drain and its negative implications has based its case on the existence of surplus labor in Egypt and the government hiring policy. By exporting large numbers of university graduates, the Egyptian government would avoid having to hire employees who would merely be underutilized in the bureaucracy of public sector and simultaneously would be able to siphon off sources of political discontent. There is, in fact, some truth to the argument; however, it overlooks two significant factors.

First, the problem of unemployment and underemployment of university graduates existed before the government committed itself to hiring university graduates. An editorial from an Egyptian paper in 1953 demonstrates this concern:

> Thousands of them may remain unemployed and the problem may remain uncompletely solved, unless work could be found for them by the various committees and individual organizations...It is extremely necessary that a sound economic policy should be drawn up and adopted, and that our education policy should be revised in light of our requirements.[75]

This article also raises a second problem with the surplus labor argument: Egypt's developmental needs and the composition of the emigrant labor force.

Although Egyptian universities graduated over 600,000 students in 1985 (approximately one-third of whom were women),[76] there were still tremendous shortages of labor in certain fields. These shortages arose in four occupational categories: managers and professionals, technicians, clerks, and skilled labor.[77] Most Egyptians who immigrate to the US fall into precisely these categories. Thus, in spite of the fact that there is rampant underemployment in Egypt, many of the country's brightest and most needed workers end up in the US.

In addition to the counter-brain drain arguments, there are also arguments against greater female participation in the labor force due to the problem of underemployment.[78] The idea that removing one-half of the country's potential workers would solve Egypt's economic and developmental woes is absolutely ludicrous. Nevertheless, this debate has resurfaced in Egypt in the form of a draft law presented to the People's Assembly in 1985. It called for women, i.e. the educated middle class women in the bureaucracy and public sector, to quit their jobs and retain half salary. This campaign was, of course, waged under the rubric of the mother-educator ideal. In the face of large-scale economic, political, and bureaucratic problems, the state once more looked to women to solve the problem. Obviously, this is not a solution to Egypt's problem. Instead, the main sources of economic waste in the bureaucracy, i.e. parallel organizations with similar functions; inter- and intra-ministerial competition; and lack of personnel trained in management as well as in a field of specialization, remain unresolved.[79]

In short, Egypt's loss of talented and educated men and women is not a blessing in disguise. It is merely a short-term palliative which not only fails to solve current problems, but also hinders their solution. Loss of human capital, especially educated human capital, must have a negative impact on develop-

ment. Some economists have even concluded that human capital has been a more important determinant of economic growth than physical capital.[80] Developing countries need a balance of both physical and qualified human capital. The loss of educated Egyptian women hinders the economic and educational facets of development as does the male brain drain; however, the loss of women also creates additional problems in the social sphere of development.

The economic costs of the brain drain are unquantifiable because lost human capital cannot be measured. Two scholars have nonetheless attempted to posit a random estimation by stating that if 10,000 workers, whose marginal worth was $30,000 return to a given country, then that country's productive capacity would increase by $300 million annually.[81] Additionally, there is also the more quantifiable loss in the money that went to educating these immigrants. Educational missions abroad cost the Egyptian government over $8 million every year. According to the Five Year Plan (1978-1982), this figure has been about double the total annual budget for all scientific research in Egypt itself until 1977.[82] Considering that 40 percent of these students do not return, that is an immense loss.[83] The students who do return and complete only the minimal requirement of state service still respresent a large outlay of resources. The average cost per Ph.D. candidate was about $47,000 in 1979 (about $20,000 in 1969), and this figure assumes only a five-year course of study.[84] Many of the students who end up staying in the US are in highly technical fields which often require a longer course of study.

In addition to the tremendous outlay for missions abroad, the Egyptian government has also made education at all levels free to students. Although this process was not complete until the early 1960s, even before the revolution free education was available to qualified students as well as to students in certain fields. For example, teacher education was free in the late 1940s and early 1950s because of the shortage of qualified teachers. Thus, this loss must also be factored in as a cost of the brain drain.

With respect to women, this economic loss has not been as great as for men; however, it is increasing. Women represent only 20 percent of the students who come here on Egyptian government scholarships, a figure slightly less than their proportion of university students overall. Of the 35 women whom I interviewed, three came here on government scholarships. Two of the women repaid their debt to the government through service or payment, and one broke her contract mid-way through her program without any remuneration whatsoever for the government. The remainder of the women who studied in the US came here on Fulbrights, at their own expense, or by obtaining scholarships at American universities. Women, particularly of the generation that came to the US in the 1950s and 1960s, were also more likely to have gone to private schools and private colleges in Egypt. However, this situation changed by the late 1960s, especially for women in the practical fields.

With respect to education, both the male and female brain drains have been particularly detrimental. The mass mobilisation of education after the revolution has not occurred without great cost to the educational process itself.

In order to accomodate larger numbers of students, the government created a system of external students in the theoretical faculties, established more post-secondary institutes, and later opened regional faculties and universities; however, as the numbers of students increased, the amount of money spent on education and the number of educators did not increase correspondingly. By the late 1960s, professor-student rations climbed to 1-30/50 in medicine, engineering, and science, and 1-45 in other faculties.[85] This ratio meant that students have had a heavy lecture load, often 21 or more hours per week, leading to the problem of passive learning and rote memorization.[86]

These problems with the university system are both symptoms and causes of the brain drain. First, many of the country's greatest minds came to the US and ended up staying; and second, many who returned to Egypt found the conditions intolerable. Salaries have been low, academic facilities few in number and poor in quality, and the quality of students has lowered with the increase in quantity. Professors have found themselves with two alternatives. They can either teach additional courses at regional campuses to make extra money, or they can migrate to the West or the Gulf. The shortages and the lowering of the educational process at the top have created problems throughout the educational system. The quantity and quality of teachers at all levels has decreased. Moreover, since education is not one of the prestige faculties, many of the most gifted students are steered away from education. Within the remaining pool of teaching candidates, many of the most qualified ones also migrate to the West or the Gulf. The situation is only getting worse since 40 percent of Egypt's population is under the age of 15 and demand for teachers is expanding. With the absence of many of Egypt's most qualified instructors and many of the people most capable of reshaping Egypt's educational process, it looks as though things are going to get worse before they get better.

The most serious ramification of the female brain drain is in the social sphere of development. The nineteenth century intellectuals who argued that the education of the woman spreads education to the nation were absolutely correct in their assessment. The educated woman, in her reproductive capacities, spreads both her own knowledge and her high estimation of education to her children; and Egypt's future course of development depends upon the development of these human resources.

According to Nagat al-Sanabary, literacy of the mother is correlated with the literacy rate of both male and female offspring, as well as to a decreased likelihood of female drop-out in primary school.[87] A recent survey of university students (male and female) in the Arab world demonstrated that this trend holds through to higher education, with 95 percent of the respondents stating that their mothers had a high school education or better.[88] The results of my survey reinforced this point. The mothers of a majority of my respondents completed a secondary education or better, and their fathers had completed a university education or better. Indeed education had been established as a tradition in many of these families. One respondent's mother was among the first women sent to England on an educational mission in 1916. Even those mothers who had a much more modest education were more literate than the

majority of women in Egypt. Over respondent, who grew up in the 1930s and 1940s, recollected her mother reading mail for neighbors who were not able to do so themselves.

In spite of the fact that the female literacy rate has doubled over the course of the twentieth century, as of 1976 it was still only 14 percent.[89] The absence of educated women as role models in Egypt most certainly has a negative impact on development. Moreover, since women comprise almost half of the immigrants (43%) but represent only about a third of university graduates, their proportional loss is greater. These are the women who appear in Egyptian labor force participation statistics (see Table 3), and women who work are more likely to have daughters who work.

Table 3
Percentage of Economically Active Women in the Governates of Cairo, Alexandria, and Port Said

	Cairo	Alexandria	Port Said
illiterate	4.20	3.66	1.76
literate	4.38	4.30	2.55
primary school	3.48	0.02	2.01
primary-second.	6.89	6.39	4.20
secondary	35.24	34.54	54.00
second-univ.	70.83	67.67	75.42
university	72.28	70.02	74.25
post univ.	80.37	72.00	83.33
master's	89.33	88.10	100.00
doctorate	89.80	87.10	-
unclassified	4.40	2.26	1.63

Source: Population Census, CAPMAS as cited by Papanek and Ibrahim, "Economic Participation of Egyptian Women: Implications for Labor and Industrial Policy," Report to USAID, 1982.

The exigencies of Egyptian development have necessitated a more highly educated work force, and thus the educated female has an important role to play in the overall development process, as well as in the individual development of her children.[90]

To direct development back upon course, the government must address the issues which push educated women and men out of Egypt. At the sociopolitical level, it must create a more democratic climate, address the problem of bureaucratic inefficiency, and improve the educational system. Recent trends in liberalization and democratization, as well as increasing the waiting period before hiring university graduates, are steps in the right direction, but change is not coming quickly enough. As for the educational system, more emphasis must be put on primary education. Since the time of Muhammad ꞌAli the state has emphasized education from the top-down, while ignoring the all important base. Literacy of the population as a whole has been an important factor in the development of a number of countries, including Japan. In

higher education, standards for education faculties should be raised in order to attract higher quality teacher candidates and to raise the status of teaching. The government should spend less money on educational missions and more on improving facilities and research in Egypt itself. Once these issues at the socio-political level are addressed, then individuals will less likely be motivated to leave Egypt. In a democratic atmosphere, with greater opporotunities for themselves and their posterity, Egyptians will migrate in much smaller numbers. True development cannot take place without attention to both the micro and macro levels.

With the question of women and integration in society reemerging, Egypt needs well-educated women who are willing to speak out and emphasize the fact that paralyzing half of the potential work force only masks the larger problems inherent in Egypt's educational system and bureaucracy. Many of the women most able to play this role no longer reside in Egypt. The return of these women would both ameliorate some of the existing shortages, as well as provide expertise in resolving the other problems.

NOTES

1 Mary McDonald, "Egyptian Education and Development," *Journal of Arab Affairs* 5 (1986), 61.
2 Robert Bocock, *Hegemony*, Key Ideas Series, Peter Hamilton ed. (New York: Tavistock Publications, 1986), 36.
3 See, e.g., Leonard Binder, "The Crises of Political Development," in *Crises and Sequences in Political Development* (Princeton: Princeton University Press, 1971); Alfred Diamont, "The Nature of Political Development," in *Political Development and Social Change*, Jason Finkle and Richard Gable, eds. (New York: Wiley & Sons, 1966); Manfred Halpern, "The Rates and Costs of Political Development," *The Annals* 358 (March 1965); Lucian Pye, *Aspects of Political Development* (Boston: Little, Brown, & Co., 1966).
4 United Nations, Report of the Secretary General, 1984, as cited in Nadia Hijab, *Womenpower: The Arab Debate on Women's Work* (Cambridge: Cambridge University Press, 1988), 64.
5 Hijab, 64.
6 The percentage of students who graduated from scientific fields and migrated to the US increased from 3.4 percent in 1962 to 51.5 percent in 1969. Central Agency for Public Mobilization and Statistics (CAPMAS), 1972; *al-ahram al-iqtisadi*, 15 June 1969; *al-tali'a*, July 1970, April 1973; *al-ahram*, 12 September 1971, 22 February 1973 as cited in Nazih Ayubi, "The Egyptian 'Brain Drain': A Multidimensional Problem," *International Journal of Middle East Studies* 15 (1983), 431; H.G. Askeri and J.M. Cummings, "The Middle East and the United States: A Problem of 'Brain Drain'," *International Journal of Middle East Studies* 8 (1977), 67.
7 See, e.g., H.G. Askari and J.T. Cummings, "The Middle East and the United States: A Problem of 'Brain Drain'," *International Journal of Middle East Studies* 8 (January 1977); Nazih Ayubi, "The Egyptian 'Brain Drain': A Multidimensional Problem," *International Journal of Middle East Studies* 15 (1983); J.S. Birks and C.A. Sinclair, "Egypt: A Frustrated Labor Exporter," *Middle East Journal* 33 (1979); Ali Dessouki, *Development of Egypt's Migration Policy, 1952-1978* (Cairo: Cairo University/Massachusetts Institute of Technology, 1978); Saad Eddin Ibrahim, "Oil Migration and the New Social Order," in *Rich and Poor States in the Middle East*, Malcom Kerr and El Sayed Yasin eds. (Boulder: Westview, 1982); Robert LaTowsky, "Egyptian Labor Abroad: Mass Participation and Modest Returns," *MERIP Reports* 123 (May 1984); Ann Lesch, "Egyptian Labor Migration," in *The Political*

MONA L. RUSSELL

Economy of Egypt, Ibrahim Oweiss, ed. (Washington, DC: Center for Contemporary Arab Studies-Georgetown University, forthcoming); Suzanne Messiha, *Export of Egyptian School Teachers*, The Cairo Papers in the Social Sciences, Vol. 3, No. 4 (Cairo: American University, April 1980); Alan Richards and Philip l. Martin, eds., *Migration, Mechanization and Agricultural Labor Markets in Egypt* (Boulder: Westview, 1983); Saneya Saleh, *The Brain Drain in Egypt*, The Cairo Papers in the Social Sciences, Vol. 2, No. 5 (Cairo: American University, May 1979); Naiem Sherbiny, "Expatriate Labor Flows to the Arab Oil Countries in the 1980s," *Middle East Journal* 38 (1984).

8 Ayubi, 437-39.

9 Michael Simpson argues that "no single Arab country combines the key requirements of a strong industrial entrepeneurial class or state elite committed to technological development, the necessary level of scientific and technological manpower, and the resources for this development." Thus, regional cooperation is the only means for technological growth and development in the Middle East. See his "The Prospects of Technological Growth in Arab Societies: An Analysis of the Potential for Progress Toward Technological Autonomy in the Arab World, 1985-95," in *The Next Arab Decade: Alternative Futures*, Hisham Sharabi, ed. (Boulder: Westview Press, 1988), 142.

10 One scholar has even suggested a 10 percent tax on the disposable income of professional and technical immigrants from developing countries. See J.N. Bhagwati, "Taxing the Brain Drain," *Challenge* (July-August 1976). According to Bhagwati, in 1971 such a tax could have raised $231.7 million.

11 Ann Lesch, "Egyptian Labor Migration," in *The Political Economy of Contemporary Egypt*, Ibrahim Oweiss, ed. (Washington, DC: Center for Contemporary Arab Studies-Georgetown University, forthcoming), 99.

12 Lesch, 100-101.

13 Saneya Saleh, *The Brain Drain in Egypt*, The Cairo Papers in the Social Sciences, Vol. 2, No. 5 (Cairo: American University, 1979), 25; 123.

14 Judith Tucker, "Problems in the Historiography of Women in the Middle East: The Case of Nineteenth Century Egypt," *International Journal of Middle East Studies* 15 (1983), 322.

15 Ayubi, 431; Askari and Cummings, 71-72.

16 Both Nadia Youssef and Judith Gran cite 7.4 as the total percentage of women involved in non-agricultural work. See Youssef, *Women and Work in Developing Societies* (Berkeley, 1974), 37; and J. Gran, "Impact of the World Market on Egyptian Women: *MERIP Reports* 58 (June 1977), 4. Hanna Papanek and Barbara Ibrahim "Economic Participation of Egyptian Women: Implications for Labor and Industrial Policy," Report to USAID, 1982. There are numerous problems with the collection of official statistics on labor force participation, particularly with respect to agricultural labor. See Judith Tucker, "Egyptian Women in the Work Force," *Merip Reports* 50 (1976).

17 Population Census 1976, CAPMAS, as cited by Papanek and Ibrahim, 113.

18 Earl Sullivan, *Women and Work in Egypt*, The Cairo Papers in the Social Sciences, vol. 4, No. 4 (Cairo: American University, 1981), 37.

19 Aida Beshara, "The Role of Women in Integrated Development in Egypt," in *Geography of Gender in the Third World*, Janet Momsen and Janet Townsend, eds. (Albany: State University of New York Press, 1987), 337-38.

20 Hind Abou Khattab and Aydad Brein el-Daeif. "Female Education in Egypt: Changing Attitudes Over a Span of 100 Years," in *Muslim Women*, Freda Hussein, ed. (New York: St. Martin's Press, 1984), 169; Beshara, 338.

21 Ignacz Goldziher has recorded an early *hadith* which calls upon both men and women to seek learning. See *Muhammedanische Studien*, II, 300, as cited by Fanny Davis, *The Ottoman Lady: A Social History from 1718-1918* (Westport: Greenwood, 1986), 46.

22 For an interesting discussion of women and education in the late medieval period, see Jonathan Berkey, "Education and Society: Higher Religious Learning in Late Medieval Cairo," Ph.D. dissertation, Princeton University, 1989.

23 According to evidence elsewhere in the empire, upper class women perhaps wielded a great deal of power in palace politics, art and architecture, and the control of property. Furthermore, women of all classes were protected by the Islamic court system. For an interesting

discussion of women and palace politics, see Fanny Davis, *The Ottoman Lady*, particularly chapters one and ten, "The Palace" and "Intrigue," respectively. Davis also includes a chapter entitled "Architecture and the Arts." However, Ulku Bates provides a more insightful analysis in her "Women as Patrons of Architecture in Turkey," in *Women in the Muslim World*, Lois Beck and Nikki Keddie, eds. (Cambridge: Harvard University Press, 1978). For a discussion of women as controllers of property see Abraham Marcus, "Men, Women, and Property: Dealers in Real Estate in 18th Century Aleppo," *Journal of the Economic and Social History of the Orient* XXVI (1983); and Gabriel Baer, "Women and Waqf: An Analysis of the Istanbul *Tahrir* of 1546," *Asian and African Studies* 17 (1983). For a discussion of the ability of women to seek redress for their grievances in court, see Ronald Jennings, "Women in Early 17th Century Ottoman Judicial Records—The Shariah Court of Anatolian Kayseri," *Journal of the Economic and Social History of the Orient* XVIII (1975).

24 For a lively discussion of the vitality of intellectual life in 18th century Egypt, see Peter Gran, *The Islamic Roots of Capitalism* (Austin: University of Texas Press, 1979), particularly chapters 2 and 3; and for the opposing viewpoint, see Charles Issawi, "Economic Evolution Since 1800," in *The Political Economy of Contemporary Egypt*.

25 ᶜAbd al-Rahman ar-Rafᶜi, ᶜAsr Muhammad ᶜAli (Cairo: Maktabat al-Nahda al-Misriyya, 1951), 464, as cited by Amira Sonbol, "The Creation of a Medical Profession in Egypt During the Nineteenth Century," Ph.D. dissertation, Georgetown University, 1981.

26 Not only did the state provide for these women with no other means of support, but it also expanded medical services by sending the women to the provinces upon graduation. The administrators encouraged arranged marriages between graduates of the School of Midwifery and the College of Medicine. Thus, the women would not have to be sent to the provinces unaccompanied. James Heyworth-Dunne, *An Introduction to the History of Education in Modern Egypt* (London: Cass, 1968); Clot Bey, *Aperçu général sur l'Egypte* (Paris: Fortin, Massoneticie, 1840), 425-427 as cited by Sonbol, 89-91; Clot Bey, "La création d'une école d'instruction médicale pour les femmes," *Cahiers d'histoire égyptienne* 1:3 (1948), 245-259 as cited by Papanek and Ibrahim, 166.

27 Afaf Lutfi al-Sayyid Marsot, *Egypt in the Reign of Muhammad Ali* (Cambridge: Cambridge University Press, 1984), 177-178.

28 J. Gran, 4.

29 Heyworth-Dunne, 406.

30 Mervat Hatem, "Egypt's Middle Class in Crisis: The Sexual Division of Labor," *Middle East Journal* 42 (1988), 412.

31 Hatem, "Egypt's Middle Class," 412.

32 See Beth Baron, "The Women's Press of Egypt," Ph.D. dissertation, University of California at Los Angeles, 1988, for a complete discussion of this topic.

33 Alexandra Avierino, "islah wa al-hukuma," *anis al-jalis* 1:7 (July 1898), 214 as cited by Baron, 163.

34 Hatem, "Egypt's Middle Class," 422.

35 Hatem, "The Enduring Alliance of Nationalism and Patriarchy in Muslim Personal Status Laws: The Case of Modern Egypt," *Feminist Issues* (Spring 1986), 39.

36 For an excellent discussion of this process, see Afaf Lutfi al-Sayyid Marsot, "The Revolutionary Gentlewomen in Egypt," in *Women in the Muslim World*.

37 Khattab and el-Daeif, 171.

38 According to Khattab and al-Daeif there were 19 women admitted to the university between 1909-1910, Kattab and el-Daeif, 172. These women were probably foreign residents. Hagai Erlikh, *Students and the University in Twentieth Century Egyptian Politics* (London: Cass, 1989), 35; Arab Republic of Egypt, *Egyptian Women: A Long March from the Veil to Modern Times* (Cairo: State Information Service, 1975); H.A.R. Gibb, "Universities in the Arab-Muslim World," *The University Outside Europe*, E. Bradby, ed. (London: Oxford Press, 1939), 285-86.

39 Erlikh, 39. There were, however, a small number of women admitted to the humanities faculty as early as 1925.

40 Not only was Dr. Fahmy the first women to receive such an honor, but according to her, the first French woman to receive that degree did so at roughly the same time. Interview with Dr. Fahmy, September 1990.

41 She was originally supposed to be a secondary school teacher, much to the dismay of her older sister, who found the whole idea humiliating.

42 Hatem, "Egypt's Middle Class," 412.

43 Georgie Hyde, *Education in Modern Egypt* (London: Routledge and Kegan Paul, 1978), 4.

44 Robert Stephens, *Nasser, a Political Biography* (London: 1971), 365 ff. as cited by McDonald, 62.

45 CAPMAS, *Statistical Yearbook*, 1973, 1988; USDS, Bureau of Public Affairs, 1987 Publication; World Bank, *World Development Report*, 1971, 1989, as cited in *The Political Economy of Contemporary Egypt*, A10.

46 During the same period the ratio of increase for boys was 3,006 percent. *Women and Education in the Arab Republic of Egypt* (Cairo: Dar al-Alam al-Arabi fil Taba‘ah, 1980), 34, as cited by Khattab and el-Daeif, 195.

47 John Waterbury, *The Egypt of Nasser and Sadat: The Political Economy of Two Regimes*, (Princeton: Princeton University Press, 1983), 234-36. Even before these laws were passed, students could get exempted from tuition through superior academic standing, economic need, parents who were educators, distinction in athletics, or by being children of martyrs. Amir Boktar, *The Development and Expansion of Education in the United Arab Republic* (Cairo: American University Press, 1963), 113.

48 Hatem, "Egypt's Middle Class," 413.

49 Bikas Senyal, et al., *University Education and the Labor Market in the Arab Republic of Egypt* (Oxford: Pergamon Press, 1982), 21-22.

50 CAPMAS, *Statistical Yearbook 1973* and *Statistical Yearbook 1977* (Cairo: CAPMAS, *The Egyptian Woman* (Cairo: Population and Research Studies Center, 1974), 44, as cited by Kathleen Howard-Merriam, "Women, Education, and the Professions in Egypt," *Comparative Education Review* 23, 2 (1979), 261.

51 Clerical workers ranked third (7 percent) after these two categories, followed by craftsmen and managers (both 4 percent).

52 These figures are based on the statistics from the years 1962, 1963, 1969, 1970, 1971, and 1976. United States, Immigration and Naturalization Service, *Annual Report* (Washington, DC).

53 This figure is based on averages from the years 1962, 1963, 1969, 1970, 1971, and 1976. United States, Immigration and Naturalization Service, *Annual Report* (Washington, DC).

54 There is also the more recent Peace Fellowship program started in the late 1970s, which allows Egyptians to come to the US for one year to study or receive training in a specialized field. Egyptian women, although somewhat underrepresented given their numbers in the university, have represented somewhere between one fifth and one seventh of the students coming to the US. For example, during the academic year 1954-55, 11 of the 54 Egyptian Fulbright recipients were women; USDS, 511.743/1-1855. The Cultural and Educational Bureau of the Egyptian Embassy was unable to provide me with statistics on women studying in the US since the revolution, however, they did offer figures for the last three years: 153 out of 926 students were women in the academic year 1987-88; 149 out of 971 in 1988-89; and 137 out of 900 in 1989-90. I appreciate the help of Mr. Azmy Rakha and Dr. Abdel Aziz Hammouda of the Cultural and Education Bureau.

55 Askari and Cummings, 70.

56 United States, Immigration and Naturalization Service, *Annual Report* (Washington, DC).

57 The figures which Zahlan was using were collected just as large-scale migration began to pick up. A.B. Zahlan, *Migration of Scientists in the Arab World*, as cited by Saleh, 10.

58 Ayubi, 444.

59 The surveys were conducted by means of telephone interviews.

60 Saleh also interviewed five people who wished to emigrate and eleven who did not want to emigrate.

61 Saleh, 104-105.

62 Ann Lesch outlines three stages of Egyptian government policy toward labor migration, and she maintains that currently Egypt is entering a fourth. Lesch, 93-95. She cites Ali E. Hillel Dessouki's *Development of Egypt's Migration Policy, 1952-1978* as her source for the background on labor migration.

63 Lesch, 93.
64 In her study on *The Brain Drain in Egypt*, Saneya Saleh referred to these as personal motives, professional and institutional factors, and political reasons. I feel, however, that ''political'' is too specific a term to deal with issues relating to the social, political, economic, and cultural factors which tend to push Egyptians toward the United States. Thus, I have substituted the term socio-political to help convey this meaning.
65 National Science Foundation, *Immigrant Scientists and Engineers in the United States: A Study of Characteristics and Attitudes* (Washington, DC, 1973) as cited by Askari and Cummings, 83.
66 Saleh, 107.
67 Saleh, 92; 107.
68 Saleh, 107.
69 When asked about their family background, most of the respondents placed themselves in the upper middle class, the class of most of the liberal age politicians.
70 About 74 percent of the respondents had children.
71 See Islam as more than just a religion, but a socio-cultural system which permeates the boundaries of religion. In other words, Islamic values have also shaped Coptic values in Egypt, and in turn, have been shaped by them. For a dicussion of women, Islam, sexuality, and the state in Middle East history, see Deniz Kandiyoti, ''Emancipated but Unliberated? Reflections on the Turkish Case,'' *Feminist Studies* 13, 2 (Summer 1987).
72 See his *Motivation and Personality* (New York: Harper & Row, 1954).
73 Hisham Sharabi, *Neopatriarchy: A Theory of Distorted Change in Arab Society* (New York: Oxford University Press, 1988), 35.
74 Several of the women indicated that they had jobs waiting in Egypt while they were here in the US as students or with their husbands who were here studying or working temporarily. Furthermore, these jobs often remained open for these women for a number of years.
75 This editorial from *al-akhbar al-jadida* was translated and placed into an article in *The Egyptian Gazette*, USDS, ''Unemployed University Graduates,'' 874.43/7-153.
76 CAPMAS, *Statistical Yearbook*, 1973, 1988; USDS, Bureau of Public Affairs, 1987 Publication; World Bank, *World Development Report*, 1971, 1989 as cited in *The Political Economy of Contemporary Egypt*, A11.
77 Suzanne Messiha, *Export of Egyptian School Teachers*, The Cairo Papers in the Social Sciences, Vol. 3, No. 4, (April 1980), 6-7; Bikas Senyal et al., *University Education and the Labor Market in the Arab Republic of Egypt* (Oxford: Pergamon Press, 1982), 77; Askari and Cummings, 65.
78 Tucker, ''Egyptian Women in the Work Force,'' 9.
79 For an excellent discussion of these problems, see Denis Sullivan, ''Bureaucracy and Foreign Aid in Egypt,'' in *The Political Economy of Contemporary Egypt*.
80 Askari and Cummings cite T.W. Shultz and E.F. Denison as supporting this viewpoint, 65.
81 Askari and Cummings, 90.
82 Ministry of Planning, *The Five Year Plan 1978-1983*, Vol. 1, The General Strategy for Economic and Social Development (Cairo: 1977), 74 ff. as cited by Ayubi, 444.
83 Ayubi, 444.
84 Ayubi, 444.
85 Harvey Smith, et al., *Area Handbook for the UAR* (Washington, DC: American University, 1970), 142.
86 Smith, 142; Gu, 378.
87 Sanabary, 430.
88 Julinda Abu Nasr, et al., *Women, Employment and Development in the Arab World* (Berlin: Mouton, 1985), 137.
89 Papanek and Ibrahim, 6.
90 See Julinda Abu Nasr, et al.

CONTRIBUTORS

DR. SORAYA ALTORKI is currently Chair of the Department of Sociology, Anthropology and Psychology at the American University in Cairo. She is a specialist on Saudi Arabia and has written extensively on Saudi women. Her most recent publication is *Women in Saudi Arabia: Ideology and Behaviour Among the Elite*, which was published by Columbia University Press in 1986.

Dr. SUSAN SCHAEFER DAVIS received her doctorate in Anthropology from the University of Michigan in Ann Arbor. She has taught at Trenton State College and Haverford College and is currently an independent scholar and development consultant working for organizations including the World Bank and USAID. Her major scholarly research interests are women and adolescents in Morocco and the changes currently affecting their lives.

DR. NANCY HATCH DUPREE has had experience in the field of development with the United Nations and in other international programs in India, Afghanistan, Pakistan, Sri Lanka, Mexico and Costa Rica. Since the 1950s, she has lived in Afghanistan and Pakistan where her present focus concentrates on Afghan refugees in Pakistan. Her publications include five guidebooks on Afghanistan and numerous articles and chapters in books highlighting the role of women in Afghan society. She is currently Executive Director of the ACBAR resource and information centre in Pakistan.

Ms. YOLANDE GEADAH is of Palestinian origin, born in Egypt and living in Canada. She is a consultant in international development, specializing in women and development, particularly in the Arab world. She is a founding member of CEAD, a study center for development. She is the President of the Women and Development Committee of AQOCI (Assocation Québécoise des Organismes de Cooperation Internationale). Ms. Geadah has completed a master's degree in industrial relations at the University of Montreal and a bachelor's of commerce at McGill University. She has worked for several years in Canadian non-governmental organizations concerned with education and development in Third World countries. She has written several articles and given talks on women in Islam, on racism, and on Palestinian human rights.

Dr. AMAL RASSAM is Professor of Anthropology at the Graduate Center in Queens College of the City University of New York. She was born in Iraq and educated in Lebanon and the United States. She obtained her Ph.D. in Anthropology from the University of Michigan. She has done field work in Yemen, Iraq, and Morocco, concentrating on issues of state ideology, cultural resistance and social change. Her published work includes a book on rural Morocco, numerous articles, and *Peoples and Cultures of the Middle East*, a book co-authored with Daniel Bates. She has worked with a number of international development agencies on the design and evaluation of projects concerned with improving the status of women in Yemen, Egypt, Morocco, Mali, and Chad, among others.

Dr. EVA M. RATHGEBER is Coordinator, Gender and Development, International Development Research Centre, Ottawa, Canada. She has written and lectured extensively on research trends in women and development in different regions of the world including Latin America and Asia. She has also written and lectured on research on gender in Africa focusing specifically on research done by Africans with IDRC Support. From September, 1990, to March, 1991, Dr. Rathgeber was affiliated with the Department of Research and Specialists Services of the Ministry of Agriculture in Zimbabwe, and from March, 1991 to June, 1991, was affiliated with the Division of Science and Technology at UNESCO in Paris, France.

Ms. MONA L. RUSSELL is currently a doctoral candidate in Middle East history at Georgetown University. Her areas of research interest include education, gender issues, comparative history, and U.S.-Egyptian relations during the 1950s.

DR. ELIZ SANASARIAN is an Assistant Professor of Political Science at the University of Southern California. Her areas of speciality are Middle East politics and women in politics. She is the

author of *The Women's Rights Movement in Iran: Mutiny, Appeasement and Repression from 1900 to Khomeini* (Praeger 1982) and several articles on women in Iran.

DR. RACHID TLEMÇANI was educated in Algerian schools and received his first degree from the University of Algiers in Political Science. He received his M.A. and Ph.D. from Boston University. His doctoral dissertation, State and Revolution in Algeria, was published by Westview Press in the United States and by Zed Press in Britain. He is currently doing research on the Intifadah uprising in the West Bank and Gaza while continuing his ongoing research into the political economy of modern Africa. He is presently an Associate Professor of Political Science at the University of Algiers where he is head of the Middle East study group.

DR. JOSEPH G. JABBRA (Guest Editor) received his Licence in law from St. Joseph University (Beirut) in 1965 and his Ph.D. in political science from the Catholic University of America, Washington, D.C., in 1971. He is Professor of Political Science and Academic Vice President at Loyola Marymount University in Los Angeles, California. Until 1990 he served as Vice President, Academic and Research, Saint Mary's University, Halifax, Nova Scotia, Canada. He has published several books and monographs and over twenty articles and book chapters, and presented over thirty papers all dealing with the Middle East and Canada. His latest books include *Voyageurs to a Rocky Shore: the Lebanese and Syrians of Nova Scotia* co-authored with his wife, Dr. Nancy W. Jabbra, and published by the Institute of Public Affairs, Dalhousie University, 1984; *Public Service Accountability: A Comparative Perspective*, co-edited with Dr. O.P. Dwivendi, Kumarian Press, West Hartford, Connecticut, U.S.A., 1988; Guest Editor, *Journal of Asian and African Studies, Bureaucracy and Development in the Arab World*, Volume XXIV (1-2), January and April, 1989. He has been the recipient of several research grants from the Social Sciences and Humanities Research Council of Canada and the Office of the Secretary of State of Canada. He is active in the International Association of Schools and Institutes of Administration. His current research interests involve law and development in the Middle East and North Africa.

DR. NANCY W. JABBRA (Guest Editor) received her B.A. in Anthropology from the University of California at Santa Barbara, her M.A. in Anthropology from Indiana University, and her Ph.D. in Anthropology from the Catholic University of America. her Ph.D. dissertation was entitled ''The Role of Women in a Lebanese Community''. She taught for 13 years at Dalhousie University in Halifax, Nova Scotia, serving as Director of International Development Studies and member of the Women's Studies Executive Committee. She also served as President of the Canadian Ethnic Studies Association. At present she is the Director of Women's Studies at Loyola Marymount University in Los Angeles, California. She is the author or co-author of numerous publications in the fields of international development, ethnic studies, and women's studies.

INDEX

INTERNATIONAL STUDIES
IN
SOCIOLOGY AND SOCIAL ANTHROPOLOGY

EDITED BY K. ISHWARAN

21. FUSÉ, T. (ed.). *Modernization and Stress in Japan.* 1975.
ISBN 90 04 04344 6
22. SMITH, B.L. (ed.). *Religion and Social Conflict in South Asia.* 1976.
ISBN 90 04 04510 4
23. MAZRUI, A.A. (ed.). *The Warrior Tradition in Modern Africa.* 1977.
ISBN 90 04 05646 7
25. SMITH, B.L. (ed.). *Religion and the Legitimation of Power in South Asia.*
1978. ISBN 90 04 05674 2
31. LELE, J. (ed.). *Tradition and Modernity in* Bhakti *Movements.* 1981.
ISBN 90 04 06370 6
32. ARMER, J.M. *Comparative Sociological Research in the 1960s and 1970s.*
1982. ISBN 90 04 06487 7
33. GALATY, J.G. & P.C. SALZMAN (eds.). *Change and Development in
Nomadic and Pastoral Societies.* 1981. ISBN 90 04 06587 3
34. LUPRI, E. (ed.). *The Changing Position of Women in Family and Society. A
Cross-National Comparison.* 1983. ISBN 90 04 06845 7
35. IVERSON, N. (ed.). *Urbanism and Urbanization. Views, Aspects and Dimensions.* 1984. ISBN 90 04 06920 8
36. MALIK, Y.K. *Politics, Technology, and Bureaucracy in South Asia.* 1983.
ISBN 90 04 07027 3
37. LENSKI, G. (ed.). *Current Issues and Research in Macrosociology.* 1984.
ISBN 90 04 07052 4
38. ADAM, H. (ed.). *South Africa: the Limits of Reform Politics.* 1983.
ISBN 90 04 07484 8
39. TIRYAKIAN, E.A. (ed.). *The Global Crisis. Sociological Analyses and
Responses.* 1984. ISBN 90 04 07284 5
40. LAWRENCE, B. (ed.). *Ibn Khaldun and Islamic Ideology.* 1984.
ISBN 90 04 07567 4
41. HAJJAR, S.G. (ed.). *The Middle East: from Transition to Development.*
1985. ISBN 90 04 07694 8
43. CARMAN, J.B. & F.A. MARGLIN (eds.). *Purity and Auspiciousness in Indian Society.* 1985. ISBN 90 04 07789 8
44. PARANJPE, A.C. *Ethnic Identities and Prejudices.* 1986.
ISBN 90 04 08111 9
45. ABU-LABAN, B. & S. MCIRVIN ABU-LABAN (eds.). *The Arab
World. Dynamics of Development.* 1986. ISBN 90 04 08156 9

46. SMITH, B.L. & H.B. REYNOLDS (eds.). *The City as a Sacred Center. Essays on Six Asian Contexts.* 1987. ISBN 90 04 08471 1
47. MALIK, Y.K. & D.K. VAJPEYI (eds.). *India. The Years of Indira Ghandi.* 1988. ISBN 90 04 08681 1
48. CLARK, C. & J. LEMCO (eds.). *State and Development.* 1988. ISBN 90 04 08833 4
49. GUTKIND, P.C.W. (ed.). *Third World Workers. Comparative International Labour Studies.* 1988. ISBN 90 04 08788 5
50. SELIGMAN, A.B. *Order and Transcendence. The Role of Utopias and the Dynamics of Civilization.* 1989. ISBN 90 04 08975 6
51. JABBRA, J.G. *Bureaucracy and Development in the Arab World.* 1989. ISBN 90 04 09194 7
52. KAUTSKY, J.H. (ed.). *Karl Kautsky and the Social Science of Classical Marxism.* 1989. ISBN 90 04 09193 9
53. KAPUR, A. (ed.). *The Diplomatic Ideas and Practices of Asian States.* 1990. ISBN 90 04 09289 7
54. KIM, Q.-Y. (ed.). *Revolutions in the Third World.* 1991. ISBN 90 04 09355 9
55. KENNEDY, C.H. & D.J. LOUSCHER (eds.). *Civil Military Interaction in Asia and Africa.* 1991. ISBN 90 04 09359 1
56. RAGIN, C.C. (ed.). *Issues and Alternatives in Comparative Social Research.* 1991. ISBN 90 04 09360 5
57. CHOUDHRY, N.K. (ed.). *Canada and South Asian Development. Trade and Aid.* 1991. ISBN 90 04 09416 4
58. RAZIA AKTER BANU, U.A.B. *Islam in Bangladesh.* ISBN 90 04 09497 0
59. JABBRA, J.G. & N.W. JABBRA (eds.). *Women and Development in the Middle East and North Africa.* ISBN 90 04 09529 2, in the press

ACW-5172

DATE DUE

NOV 1 8 '93	OCT 2 1 1998	
MAY 2 3 1994		
NOV 2 7 1994		
NOV 1 4 1995		
MAY 0 2 1996		
GAYLORD		PRINTED IN U.S.A.